exploring

3D ANIMATION

with **MAYA 6**

F

| *exploring* |

3D ANIMATION
with MAYA 6

Patricia Beckmann
Phil Young

THOMSON

—————★————— ™

DELMAR LEARNING

Exploring 3D Animation with Maya 6
Patricia Beckmann and Phil Young

Vice President, Technology and Trades SBU:
Alar Elken

Editorial Director:
Sandy Clark

Senior Acquisitions Editor:
James Gish

Development Editor:
Jaimie Wetzel

Marketing Director:
Dave Garza

Channel Manager:
William Lawrensen

Marketing Coordinator:
Mark Pierro

Production Director:
Mary Ellen Black

Production Manager:
Larry Main

Production Editor:
Thomas Stover

Cover Design:
Steven Brower

Cover Art:
Dawn of a New Season
oil on canvas
© David Arsenault

Library of Congress
Cataloging-in-Publication Data:

Beckmann, Patricia.
Exploring 3D animation with Maya 6 /
Patricia Beckmann, Phil Young. -- 1st ed.
 p. cm.
ISBN 1-4018-4818-4
1. Computer animation. 2. Three-dimensional display systems. 3. Maya (Computer file) I. Young, Phil, 1947- II. Title.

TR897.7.B4435 2004

006.6'96--dc22

2004024765

NOTICE TO THE READER

contents

dedication

For the love of Margot and Helmut Beckmann, Scott, Gerta, two great Young kids, Louise, Thelma, Maxine, and one very special goldfish, Arthur. Ducks, we'll get you next time.

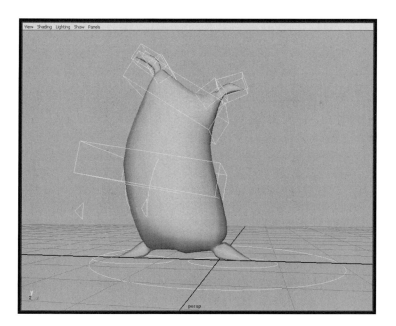

foreword

When first introduced to animation, you learn there are many types. There's clay, paper, puppets, CGI. There's visual effects and character animation. But only when you probe into the highest levels of character do you discover there is a subcategory called *personality animation*. This is the exalted realm of creation that many presume to achieve, but not many do.

Personality animation entails a character creation so believable, a fusion of voice, design, and performance so complete, that the character transcends the film to become alive. Ariel, Bugs Bunny, or Homer Simpson really don't need to be on film to be alive to us. They live in our collective consciousness. We know them better than we probably do our own brother or sister.

For the animation artist, this is the pinnacle. Historian Barbara Tuchman called the creative process when it all works "a moment on Olympus." So it is with personality animation.

Up until recently, digital animation had evolved on a path separate from that of traditional, hand-drawn animation. Beyond a few brave souls who grasped both, digital artists made their own rules and painfully rediscovered, through books, principles of character animation known to traditional artists for decades. Traditional animators would scratch their heads at the confusing machinations of the computer people and stick to their pencils.

But the needs of the modern entertainment industry can no longer allow the luxury of such exclusivity. Not unlike silent film stars of another era, traditional artists have seen job opportunities and lifestyles shrink by not keeping up with the latest digital breakthroughs. Digital pioneers, who previously felt secure in a position they had arrived at early, are now finding themselves competing for jobs with the finest retrained traditional animators. In an earlier time, audiences were forgiving if a digital effect moved crudely because they all knew the field was in its infancy. CGI is no longer

judged on such a curve. And those who once believed it was all merely a matter of supplanting technique by writing a better program now find their work in the dollar bin of the local DVD store. There are no cheap alternatives to good technique. Good grounding in the principles of both digital and traditional animation is the best foundation for creating that finest, highest-quality animation that is personality animation.

Digital animation requires a thorough understanding of the program tools and their capabilities. You are creating light, paper, textures, images, and the illusion of 3D space within the plastic confines of your screen. Traditional animation requires thinking not in analytical terms but in sensual ones. The animator, much like a flesh-and-blood actor, thinks of timing, characterization, body language, natural sciences, cinema, and frame composition as he or she draws. Yet, just as the martial arts expert can distill a lexicon of stances and moves down to lightning intuition to win a bout, the skilled animator does not dwell on the many steps needed to achieve a performance. He or she merely animates. And like the martial arts, this is not a skill that can be achieved overnight, but a state of grace to work toward.

The following book has been written by two of the best artists in the field of animation, Pat Beckmann and Phil Young, to provide the reader with an overview of the techniques of animation employed in Maya, the program widely used today in modern digital imaging. The authors were trained by classic Hollywood animators and worked on many top projects themselves.

Now they have put their knowledge into this book so that you, the reader, can begin your own journey to achieving lifelike personality animation—your own moment on Olympus.

Tom Sito
Animation Director, The Gang of Seven
Adjunct Professor of Animation, University of Southern California
President Emeritus, The Animation Guild Local #839, Hollywood
Vice President ASIFA/Hollywood
www.g7animation.biz
www.g7animation.com

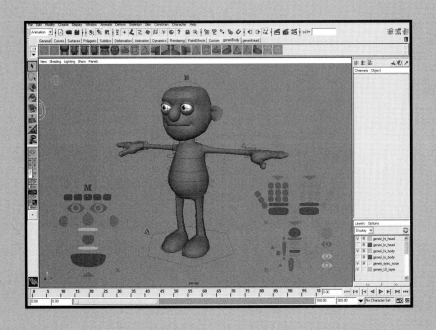

preface

INTENDED AUDIENCE

This book is intended for beginners in animation who want to employ traditional animation technique in their computer graphic films. We take some of the skill sets that have been developed in the last one hundred years of animated film and apply them to the newest animation tool—the computer. The theory remains the same; we just learn how to create with a different tool.

Whether you are new to the field, a traditional animator, or trying to create a more believable movement study in your CG (computer graphic) work, this book will guide you through the basics of character animation in Maya.

EMERGING TRENDS

Computer art is stepping away from the technical and toward the organic. Artists are now finding the medium easier to understand. Digital animation should not be identifiable by its software program; rather, it should serve to achieve the artist's vision using a new pencil. This book strives to bring the technology to the artist in a non-threatening and visual manner.

BACKGROUND OF THIS TEXT

We wrote this book because, as teachers, we found the standard textbooks in use were not addressing the creative interests of our students. We could not find a single book addressing the graph editor and how to employ it to create believable movement. We wanted a book that crossed over the divide from traditional to computer-generated movement with respect to the theory that created animation in the first place. We wanted it to be written by industry professionals with credentials.

Phil Young joined Patricia in this cause, bringing valuable traditional experience gleaned from over 25 years as a lead animator at Disney. Together we analyzed our tools and synthesize the subjects a beginner should practice to achieve a solid foundation.

The information presented can be used in all 3D software programs, but is specifically targeted at training the beginner animator in Maya 6.0. For effective use of this text, you should have a basic understanding of Maya and have a three-button mouse attached to your computer.

TEXTBOOK ORGANIZATION

Each chapter of *Exploring 3D Animation with Maya 6* asks an essential question and then answers it with clearly thought-out goals and tutorials. The tools included in each chapter are listed on the opening pages. Each chapter is organized in this manner to clearly identify what you are learning and why.

This text will allow you to practice animation by creating thumbnails and key poses and editing motion curves. We introduce simple CG animation techniques for creating believable movement and study theory shaped by years of development at Disney.

Basic primitive motion will lead you to a flour sack animation, then to a complex biped rig, and finally a phoneme project on lip synch. You will create a walking, talking character by the end, and will have completed studies in follow-through, weight, arc, and the principles of animation applied.

We will also lead you through basic Graph Editor functions and how they relate to believable motion. We will advance through more complex motion theory and rigs to achieve desired motion in a biped character.

The topics covered are as follows:

- Chapter 1 introduces you to the Maya interface and explains how to save files.

- Chapter 2 introduces the main components of Maya for editing movement in the Graph Editor. It covers working with different curves, and how movement relates to a tangent.

- Chapter 3 covers the production process of setting up a shot, as well as basic editing techniques in CG. Animation principles are also explained.

Chapter 4 explains how to use reference images and import them into Maya. The first character animation piece is created involving a flour sack. It demonstrates how to depict a variety of emotions.

Chapter 5 discusses working with timing charts and setting key poses for the flour sack character. The goal is to create personality through solid pantomime acting.

Chapter 6 introduces a complex biped rig that has multiple controls built in for creating personality and movement. This chapter teaches how to identify what is available, and what controls to use to move the model.

Chapter 7 studies wave theory and how to create a practical CG study. Follow-through and overlapping action, and their influence on the believability of a character, are discussed.

Chapter 8 focuses on theory and practical application in a CG environment. The walk cycle is explored in detail.

Chapter 9 explains animation theory as it relates to lip synch.

FEATURES

The following list provides some of the salient features of the text:

Learning goals are clearly stated at the beginning of each chapter.

The book was written to meet the needs of design students and professionals for a visually oriented introduction to basic design principles and the functions and tools of Maya.

Client projects involve tools and techniques that a designer might encounter on the job.

The full-color insert section provides stunning examples of design results that can be achieved using Maya.

The Exploring on Your Own sections offer suggestions and sample lessons for further study of the content covered in each chapter.

Review questions are provided at the end of each chapter to quiz understanding and retention of the material covered.

A CD-ROM at the back of the book contains tutorials and exercises.

HOW TO USE THIS TEXT

The following features can be found throughout the book:

◢ Charting Your Course and Goals

The introduction and chapter objectives start off each chapter. They describe the competencies that you should achieve after completing the chapter.

◢ Don't Go There

These boxes appear throughout the text, highlighting common pitfalls and explaining ways to avoid them.

◢ Review Questions and Exploring On Your Own

Review Questions are located at the end of each chapter and allow you to assess your understanding of the chapter. The Exploring on Your Own sections contain exercises that reinforce chapter material through practical application.

Adventures in Design

These spreads contain assign-ments, showing readers how to approach a design project using the tools and design concepts taught in the book.

Color Insert

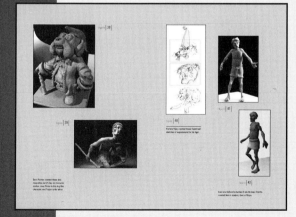

The color insert demonstrates work that can be created when working with Alias/Wavefront Maya.

E.RESOURCE

This electronic guide was developed to assist instructors in planning and implementing their instructional programs. It includes sample syllabi for using this book in either an 11- or a 15-week semester. It also provides answers to the end-of-chapter Review Questions, PowerPoint slides highlighting the main topics, and additional instructor resources.

ISBN: 1-4018-4819-2

ABOUT THE AUTHORS

Patricia Beckmann

Patricia Beckmann earned her MFA in cinema and animation from the University of Southern California while working as a traditional animator with Phillips Media and holding a fellowship at Silicon Studios in Los Angeles. As a computer graphics artist for Warner Brothers, she created computer graphic

effects and animation for the films *Batman* and *Mars Attacks* using high-end software such as Maya. For Film Roman (producers of The *Simpsons* and *King of the Hill*), she managed the computer graphics development department. She was an art director on interactive cartoon projects for Dreamworks (*Chicken Run*), ABC (*Norm*), Newline Cinema, E!Online, and Coca-Cola. Her short *Matilda* won the Playboy Animation Festival in 2000 and led to a television pilot for Oxygen Media entitled *Gertrudah and Her Grandmothers*.

Patricia has received a number of awards, including the Emerging Artist Award at the Rico Gallery Fine Arts Competition in 1999, and was chosen as one of the Top 25 Women of the Web by the San Francisco Women of the Web. Her work can be seen at www.bunsella.com. She has been selected to serve as the Educators Program Chair of the 2005 SIGGRAPH, to be held in Los Angeles.

Patricia is a Certified Maya Instructor and presently serves as chair of animation at the Savannah College of Art & Design. Savannah College's computer animation facility hosts many award-winning artists and sponsors an international film festival every fall. Patricia is currently working on her own shorts films and sculpture in Savannah, with husband Scott Wells.

Phil Young

Phil Young is a professor of animation at Savannah College of Art and Design. Phil previously worked at Walt Disney Feature Animation and Dreamworks Animation on popular films such as *The Little Mermaid, Beauty and the Beast, The Lion King, Dinosaur, Tarzan,* and *Sinbad*—among many

others. He has worked as a lead traditional animator with these companies for over 25 years and is a well-known artist in the animation community.

Phil has traveled the world on behalf of Disney and his artistic efforts. He is presently completing his masters in sculpting, and has created a series of bronze sculptures currently on exhibition.

Phil is currently working on his own short films and sculpture in Savannah, where he lives with his wife Gerta and goldfish Arthur.

ACKNOWLEDGMENTS

The authors would like to thank Andrew Silke (www.cane-toad.com) for providing the Generi rig used in this book and Scott Wells (www.animax design.com) for providing the flour sack rig.

A sincere thanks also goes to all of the students who contributed work to the interior color pages. Each is credited where their work is displayed.

Thomson Delmar Learning and the authors would also like to thank the following reviewers for their valuable suggestions and expertise:

Cecilio Acosta
Digital Media Design Department
Texas State Technical College
Waco, Texas

Royal Winchester
Art Department
Digipen Institute of Technology
Redmond, Washington

Marc Hess
Chair, Multimedia Department
College of Westchester
White Plains, New York

A very special thank you goes to Peter Weishar at Savannah College of Art & Design for his technical edit of this material.

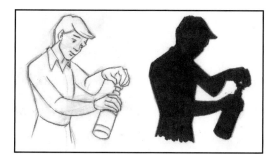

Patricia
Beckmann &
Phil Young
2004

QUESTIONS AND FEEDBACK

Thomson Delmar Learning and the authors welcome your questions and feedback. If you have suggestions that you think others would benefit from, please let us know and we will try to include them in the next edition.

To send us your questions and/or feedback, you can contact the publisher at:

Thomson Delmar Learning
Executive Woods
5 Maxwell Drive
Clifton Park, NY 12065
Attn: Graphic Communications Team
800-998-7498

Or the authors at:

Patricia Beckmann
Savannah College of Art & Design
P.O. Box 3146
Savannah, GA 31402
bunsellapb@yahoo.com

Phil Young
Savannah College of Art & Design
P.O. Box 3146
Savannah, GA 31402
payoung@scad.edu

a discovery tour

 charting your course

The computer is just another pencil; don't let the initial complexity over-whelm you. 3D software can help you build anything you can imagine. Everyone learns the same buttons, but your own individual imagination will create the art.

This chapter will introduce you to the different places where you will find your tools. You must understand the interface. Once you become comfort-able with it, learning will get easier.

 goals

In this chapter, you will:

- Discover the four main modules in Maya Complete and where they lead you.
- Learn the basics of the interface and mouse interaction.
- Set up a file directory to save your work.
- Get comfortable with navigating around.

NAVIGATION

Consider the interface of a giant file cabinet with four main drawers. Inside these drawers are files. These files contain envelopes. The envelopes contain tools. The secret to getting the tool you need is to know which drawer, file, and envelope to look in. This becomes second nature after a bit of practice. Then you will be prepared to look deeper into the cabinet for the smaller folders containing the more complex tools. This chapter will concentrate on the tools you will be practicing in this book.

figure | 1-1 |

The Maya interface.

Before moving ahead, make sure your interface looks like Figure 1-1. Select Display > UI Elements, and make sure there is a check mark next to each interface item (see Figure 1-2).

DON'T GO THERE!

As a student working in a school, many people will have access to the same software and computer that you are working on. Everyone will change the interface and customize it to his or her own work habits. Someone may turn off all interface menus. The next person who logs on will just see the Perspective view and nothing else. You should know how to get all of your navigation windows back by using **Display > User Interface Elements**.

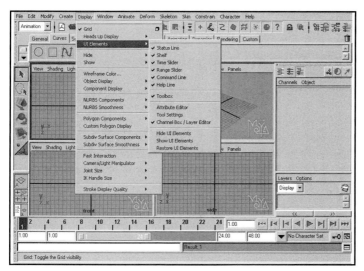

figure | 1-2 |

Display interface
items using the
Display > UI
Elements command.

The Drawers

Maya Complete consists of four base modules: Animation,
Modeling, Dynamics, and Rendering. Consider these your drawers
to the cabinet. These four modules organize the thousands of tools
available in Maya as they pertain to animation, modeling, dynam-
ics, and rendering. When you are in the Animation module, you
will find the tools you need for setting up a skeleton and keyfram-
ing movement. In the Modeling module, you will find the tools you
need to model a ship. The Dynamics module enables you to pro-
gram physics into your models. Rendering gives you access to tools
to process the scene for viewing.

You will find these modules in the upper-left corner of the interface.
Click on the pull-down menu to reveal all four (see Figure 1-3).

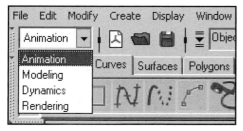

figure | 1-3 |

The four basic
modules in Maya
are Animation,
Modeling, Dynamics,
and Rendering.

Select each module in turn. Nothing really changes on the interface
except for the pull-down menus at the top.

The Main File Folders

The area at the top of the application window is called the menu bar (see Figure 1-4).

The menu bar changes depending on which module you are in. Consider these titles of the names of folders in the drawers of your file cabinet. Make sure you are in the Animation module and then examine the menu bar titles.

Each module has the same six folders beginning the menu (see Figure 1-5). These are File, Edit, Modify, Create, Display, and Window. These menus drive preference features that you can access in any module of the interface.

Following our file cabinet analogy, consider the choices available in these submenus to be the envelopes inside your folders.

The Tools

Pull down a menu bar and tear off a dialog box. To do this, highlight a menu item and look for the double blue line (see Figure 1-6). Click on the lines, and the menu will float in the interface.

LMB click on one of the directory arrows. These are your tools. Notice the little boxes to the right of the tools? Click on one of them. A new box opens up (see Figure 1-7).

NURBS Sphere Options

Edit Help

Pivot ⊙ Object ○ User Defined
Pivot Point [0.0000] [0.0000] [0.0000]
Axis ○ X ⊙ Y ○ Z
 ○ Free ○ Active View
Axis Definition [0.0000] [1.0000] [0.0000]

Start Sweep Angle [0.0000]
End Sweep Angle [360.0000]
Radius [1.0000]
Surface Degree ○ Linear ⊙ Cubic
Use Tolerance ⊙ None ○ Local ○ Global
Number of Sections [8]
Number of Spans [4]

Create Apply Close

figure | 1-7 |

The Options box allows you to modify the settings of your tools.

These are called Options boxes, and they allow you to modify the creation settings for that command. When you have done so, you are ready to use your tool.

The Workspace

The rest of the interface assists you with using your tools.

The Status Line

The status line contains tools to edit your scene as a whole, by object, or by detail (see Figure 1-8).

At the far left is the mode selector. Look to the right of it, and you will see the Collapser icon. LMB click on it. The menu collapses or expands, depending on its present state. This is used to hide a section of the status line and eliminate clutter. When the Collapser shows an arrow, something is hidden (see Figure 1-9). When it shows a box, you can hide the items on the right.

figure | 1-8 |

The Status line.

figure | 1-9 |

The Collapser with an arrow and with a box. It is found on the status line.

figure | 1-10 |

Hierarchy mode,
Object mode
(selected), and
Component mode.

figure | 1-11 |

Snap to Grids, Snap
to Curves, Snap to
Points, Snap to
Planes.

figure | 1-12 |

The Construction
History icon.

figure | 1-13 |

The Render icons.

The next important area to discover is the Hierarchy/Object/ Component modes (see Figure 1-10). This very important group determines how you select objects in the scene for edit. Hierarchy mode selects an entire grouped object, such as a model of a car and all its elements. Object mode will pick a piece of the car, such as a tire. Component mode enables you to select the points in space that make up the tire.

As you click on each of these, you will notice that the section to the right on the status line changes. These icons represent what can be edited while in that mode. Hierarchy icons manipulate the grouped objects as a whole. Object mode icons affect base objects like primitives. Component Mode icons affect smaller components of the model such as lines, hulls, and vertices.

The next section is Snap modes (see Figure 1-11). When you snap to something, it is as if the object has a magnet luring your object to the selected Snap mode. We will explore these later in this book.

Construction History is the next important icon. It looks like a scroll and feather (see Figure 1-12).

Construction History records all of the commands used to create an object. The history is used as reference so that when you edit an object, all related information updates with it. Don't always leave it on; only use it when you need to. It uses a lot of RAM.

On the left side of the interface is the Tool Box (see Figure 1-13). These tools are the most often used and relate to positioning objects in the scene.

The Select tool allows you to select an object by LMB clicking on it. The Lasso tool allows you to draw a shape around an object to select it. The Move tool allows you to move an object in x, y, and z space. The Rotate tool allows you to rotate an object in x, y, and z space, and the Scale tool allows you to scale in x, y, and z space. The last two tools are the Show Manipulator tool and Last Item Used. We will talk about these later.

The Scene icons represent the different rendering modes in Maya (see Figure 1-14). A render is the final graphic output of the scene showing model, lighting, texture, and possibly animation. It is as if you are shooting a reel of film with your camera as you model, light, texture,

figure | 1-14 |

The Tool Box.

and animate, and then you take the reel of film to the one-hour-photo place for developing.

The View buttons are below the Tool Box (see Figure 1-15), and they allow you to pick different views of your model. Click through them to get comfortable with finding your Perspective view, Four-Panel view, and others.

We have finally gotten to the largest portion of real estate on our interface. The View Panel is the stage used to construct your artwork (see Figure 1-16).

figure | 1-15 |

The View buttons.

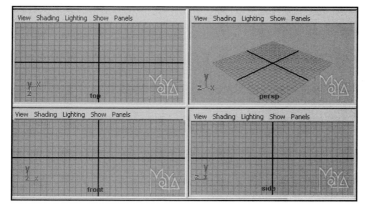

figure | 1-16 |

The View Panel in Four-Panel view.

The Perspective view is a true 3D view. The other kind of view offered in Maya is orthographic. Front, Top, and Side views are orthographic. The way they differ is that lines do not converge at a distance in Orthographic view, but they do in Perspective view.

Now look at your mouse. Notice that it has (or should have) three buttons (see Figure 1-17). The three buttons each have a unique purpose in Maya. Try the following combinations of buttons and keyboard controls for navigating the view window.

Put your mouse cursor in the Perspective view. Press the left mouse button (LMB) and the Alt key at the same time and hold them

figure | **1-17**

LMB (rotate), MMB (pan), BMB (dolly).

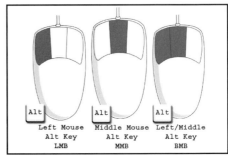

down. By moving your mouse, you rotate around the window. This method only works in the Perspective view.

Hold down the middle mouse button (MMB) and the Alt key at the same time. By moving the mouse, you pan around the window. This method works in all window views.

Hold down the left and middle mouse buttons (BMB) and the Alt key. By moving your mouse, you dolly in and out of the window. This method works in all window views.

On the right side of the window, you should have your Channel Box. Channel box is empty if there is no object selected (see Figure 1-18).

figure | **1-18**

The Channel Box with nurbs Sphere1 selected.

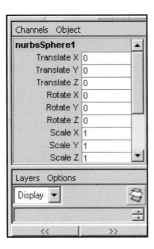

figure | **1-19**

Attribute Editor, Channel Box, and Tool Settings icons.

This window allows you to put in mathematical values for Translate, Scale, and Rotate. You may also make adjustments to newly created objects. You can also change this window to the Attribute Editor or Tool Settings window by selecting one of these icons in the upper-right corner of the interface (see Figure 1-19). We will use this area often.

At the bottom of your interface, you will find the Time slider, Playback controls, and Range slider (see Figure 1-20). When you animate, these controls will identify at what point in time you are adding information.

The command line allows you to type Mel commands directly into Maya (see Figure 1-21). Maya operates through script commands. Every icon on the interface merely represents a script command. If you want, you can bypass the icons and type in the commands to create artwork in Maya.

figure **1-20**

Time slider, Playback controls, and Range slider.

If you are uncertain of what an icon represents, mouse over it and look at the Help line (see Figure 1-22). This will give you a written definition.

figure **1-21**

The command line.

New Project: Create a new project and make it the current project

Setting Up Your Account

figure **1-22**

Saving files correctly will save you from getting ulcers later in the semester. Along with the following guidelines, please remember to do a double backup of your files. Many students have lost beautiful work because of misplaced disks, corrupted media, and computer crashes. No teacher, production manager, or client will accept the excuse that you lost your file when the project is due.

The Help line.

Setting Up Your First Project

Follow along to set up your project directory. Do it again and again until you have it memorized. In fact, if you ever feel you haven't absorbed a lesson, do it again. Repetition will help you memorize. Select **File > Project > New** (see Figure 1-23).

A new window pops up. This is your New Project window (see Figure 1-24).

figure | 1-23 |

Creating a new
project.

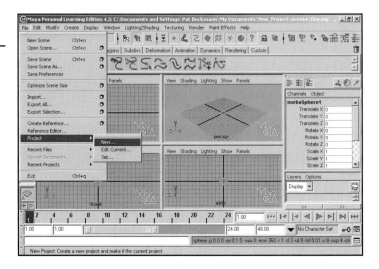

figure | 1-24 |

The New Project
window.

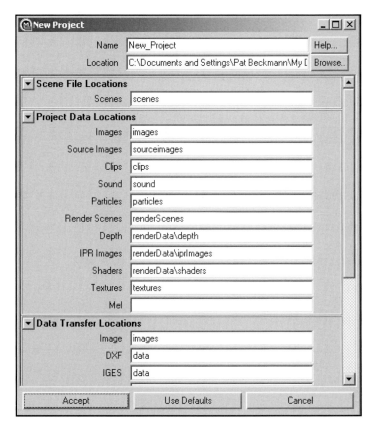

It creates a directory holding all the folders for this project. In this
directory you will store your textures, scene files, rendered pictures,
and all other data. This is where you will look for information per-

taining to your project. Also, this is the directory that you should make sure is backed up onto your personal backup media when you are done.

In the Name box, put your name or the word "Tutorials." In the Location box, click on Browse. This opens your computer, and you can locate an area on your computer disk to store this directory. You can store directly to your personal media disk. Choose the location you want and click OK. The location you have chosen will show up in the Location path.

At the bottom of the box, click on Use Defaults. Folders will be named with default directory names. Click on Accept. You now have a directory in the location specified. Search for the directory you have created to make sure you know where it is.

Now save your first file. Go to the main pull-down menu and Select: **File > Save Scene As.**

A new window pops up. These are your Save settings. Look in the window under Current Scenes. This is the directory path leading to where your file will be saved (see Figure 1-25). You can navigate away from this directory in special circumstances, but for now leave it here. Name the file **One** and select Save. Save your file with the .mb extension. This stands for "maya binary" file.

figure | 1-25 |

Finding the new project.

Look at the top of the Maya interface. The directory path to your file is presented here. If you need to access files from your directory, you can find them using this path. All data created in your scene will be found in the folders in this directory.

When you back up this directory, remember to back it up entirely. Your textures and scripts will be linked from different folders contained in the directory. If you are missing any information, you will have to reconstruct it the next time you consult your project.

DON'T GO THERE !

Don't make the biggest mistake that digital artsits make. Don't forget to double back up your work!

Make two backups of your work at the very least. Keep a backup in a box in a safe dry place. Keep one with you. You will lose your files. You will eventually corrupt. Disks are easy to abuse—and they exact revenge. Once that happens, your competition three states away will be that much closer to getting your dream job. Protect yourself with double backups.

SUMMARY

Congratulations on making it through the introduction. You have absorbed some very important basic material. The interface is your map. If you don't know where you are going, you will get lost. You also now know how to pack your treasures away and take them with you.

Now close this book and think about what you have learned. Play with the software and do the tutorial again. Then come back and go through the reference and homework sections of this chapter.

in review

1. What are the four main modules in Maya Complete?

2. What keyboard entry is required with the left mouse button that allows you to rotate around in the Perspective view?

3. How do you turn on the display of different user interface elements?

4. What is the difference between Hierarchy, Object, and Component modes?

5. How do Orthographic and Perspective views differ?

6. How do you set up a project directory?

7. How often should you back up your work?

➤ EXPLORING ON YOUR OWN

1. Access the Help menu option to view introductory learning materials provided by Alias Wavefront. Here you will find tutorials, a method of looking up unfamiliar terms, and learning movies.

2. View the Essential Skills Movies under Help/Learning Movies. The included PDF files give a nice overview to 3D. (You will need the Acrobat plug-in.)

3. Work on the tutorials listed under Instant Maya in addition to what you will do in this book.

4 Examine the Help file information pertaining to system and document preferences.

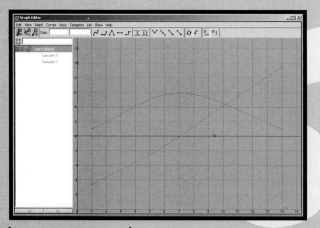

| the graph editor |

 charting your course

The secret to believable animation resides in the Animation Graph Editor. Understanding this graph is the secret to finding out where your animation is going right and where it is going wrong. Knowing how to apply weight, follow through, and anticipation to curves can mean the difference between bad and phenomenal animation.

Animation moves in arcs. Weight is determined by how fast or slow mass moves through these arcs, how it reacts, and so on. The Animation Graph Editor is a visual representation of all arcs in your 3D animation.

 goals

In this chapter, you will:

● Understand the principles of animation.

● Discover the Animation Graph Editor.

● Learn the curve shapes of different kinds of movement.

● Get familiar with editing curves.

THE CLASSIC PRINCIPLES OF ANIMATION

What makes it work?

It is necessary at this time to discuss some of the basic principles that have been developed over the past 100 years or so by the pioneers in the animation industry. Keep in mind that these are not separate concepts. They're interlocking pieces of the whole in creating a piece of animation that communicates ideas to the audience.

Mechanics

The following are some basic concepts on mechanics.

Timing: In the bouncing ball test, timing will be one of the first principles you deal with. Timing is the main determinant in the meaning of your drawings when they're assembled in a series for the purpose of animation. In the case of the ball, the timing is determined by the frequency of each bounce. As you'll learn, each arc in the bounce is designed to be a bit shorter than the one before. In this manner, the timing is regulated by the time it takes to complete each bounce. The second factor in determining the visual elements in the bounce is spacing, which is discussed next.

Spacing: This refers to the way the ball drawings are closely grouped at the top of each arc and incrementally become spaced apart throughout the arc until hitting the widest spacing on either side of each impact point. This principle will be examined with more variation in the beanbag exercise. The principles of timing and spacing that you'll learn in the first two exercises will remain a constant factor in each piece of animation you'll execute from here on.

Hard and soft accents: Throughout our scenes, there will be points of emphasis deriving from the dynamics of weight and speed applied to movements. Each of these accents can be varied through the use of timing and spacing to achieve a varied feeling in the action and prevent a sameness that can detract from visual interest.

Next, referring once more to the way the drawings will be spaced in the beginning exercises, we're able to discuss another term used quite often in animation.

Slow in and slow out: In discussing spacing and timing, you'll become aware that the slowing down of an animated object is

accomplished by the "bunching up" of drawings in a series. By uti-
lizing an extreme slowing down of drawings, you can very nearly
stop a movement entirely. This will be a very handy thing to
remember when you want to slow an action down in order to show
an important point in a scene or to showcase a facial expression
inferring a thought process or a change of emotions in a character.
The terms "slow in" and "slow out" refer to this process as it applies
to movement, as in "slowing in" to a movement from a static pose
or "slowing out" of a movement and into a more static pose.

Moving holds: This term is used for the drawings leading into and
out of those more static poses in our animation. They supply a very
necessary function in that they keep the movement of an animated
object going, regardless of how slight that movement may be. This
is very essential because movement is the only element that keeps
the feeling of reality and life maintained for the audience. As soon
as a series of animation drawings is reduced to one held drawing,
the illusion vanishes; the drawing goes flat, and the viewer is
reminded that he or she is looking at something that is really only a
drawing. There are some actions you can use to keep things lively in
your animation during moving holds, and we'll discuss those later
in this section.

Squash and stretch: This term is among the most well-known
principles when discussing animation. It applies to the most essen-
tial function of movement, the changing of shapes. It is this shape
that is the characteristic that differentiates living things from hard
or inanimate objects.

The use of squash and stretch in the bouncing ball exercise is a min-
imal use of the principle, and in the beanbag exercise it will be used
in more broad applications. There are many ways to use it in the
context of animation.

Think of the crouch of an athlete about to execute a standing broad
jump, then picture the explosive extension of the body as the jump
is executed, and then imagine the bend and flex of knees and waist
as the landing is completed: squash, stretch, and back to squash.

Facial expressions are another place where squash and stretch is not
only helpful but also necessary. Our facial muscles enable us to
convey a complete range of expressions, from a squint-eyed, com-
pressed mouth picture of anger to a wide-eyed and open-mouthed
example of surprise and then to a relaxed, smiling countenance.

Full-body attitudes are another example of where squash and stretch come into play, and several of these will be evidenced in our beanbag exercise (see Figures 2-1 through 2-5):

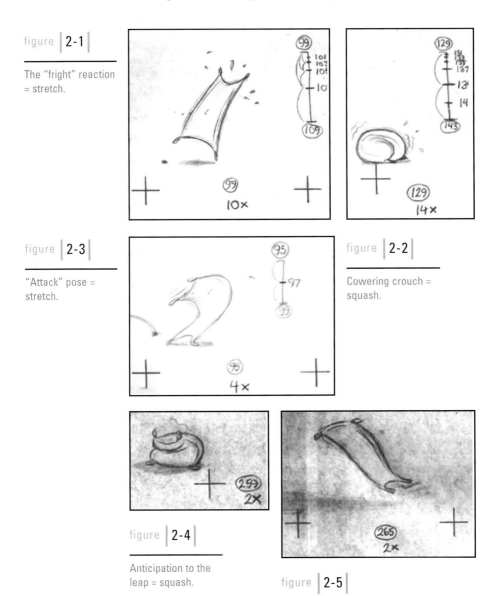

figure | 2-1 |

The "fright" reaction = stretch.

figure | 2-2 |

Cowering crouch = squash.

figure | 2-3 |

"Attack" pose = stretch.

figure | 2-4 |

Anticipation to the leap = squash.

figure | 2-5 |

The leap = stretch.

And so on . . .

Other issues you'll encounter during the beanbag exercise are as follows:

Straight ahead and pose-to-pose action: These are two basic approaches to animating. Most professionals today don't consider either of them as "the only way to work" at the exclusion of the other.

Straight ahead is simply starting with a drawing and then working through the animation a drawing at a time to the end of the scene. The animator is aware of what needs to happen in the course of the scene to advance the story but has no hard, set plan, allowing his imagination to take him onto a kind of stream-of-consciousness path filled with spontaneity and surprises. In the best scenario, the surprises can inject a quirky element into the story that can be an asset.

On the other hand, the down side to this approach may contain several pitfalls. The control factor is thrown more or less to the wind; the size and volume of the drawings tend to fluctuate, creating drawing problems that cause an inordinate amount of time and labor to correct. The timing and movement may become repetitive and assume a uniformity of intensity that can easily become predictable to the viewer.

Now we'll consider the pose-to-pose approach. In this method, the scene is carefully planned out in advance. Thumbnail sketches of the action are defined so that the needed action of the scene is addressed. The size relationships in the drawings are more easily controlled, resulting in less time being spent on drawing corrections, a fact appreciated by the assistants who will handle the work as it moves down the production line.

There are a few drawbacks to the exclusive use of pose-to-pose as well. With everything planned out in advance, spontaneity may suffer or be altogether lacking. Stiffness may result, and the entertainment could be lacking, producing boredom in the audience.

Since there are advantages and disadvantages to either approach, the judicious use of both methods within our animation seems to be the best method for most animators. By taking this course of action, a variety of visual expressions can be attained, producing the element known to animators as "Texture" within our scenes.

The beanbag exercise will be animated using this combined method of pose-to-pose and straight ahead. The use of the initial thumbnails translated into animation poses is an example of pose-to-pose planning. A good example of straight ahead will be found in the "Fright-take" and midair scramble into the crouch position that our character will use in reaction to the spider.

Ones or twos? The standard screen time allotted to an animation drawing is two frames of film. We'll back up a little at this time and explain a bit about frames and how they are fitted into continuity in motion picture technology.

To start at the beginning, a 35mm camera shoots 24 frames for each second of screen time. This produces one and a half feet for each second of picture that the audience sees on screen. As a rule, each animation drawing shot at the 2-frame-per-drawing rate will approximate natural movement. That means 12 drawings are required for each second of screen time.

If the motion being represented in the animation is very fast or complex, the animator may need to resort to making one drawing per frame in order to smooth out the animation and eliminate strobing or jerkiness in the images. This results in the number of drawings for each second increasing by double to 24 drawings for one second of screen time.

In CG, you automatically animate on ones. You can create an interesting look by rendering out the animation done on ones, deleting every second frame, and then duplicating every first. For some, this appears more natural.

Composition

Staging: As in any element of presentation, the staging is primarily dictated by the need to advance the story being told. Each idea needs to be showcased so that its clarity is unmistakable. The shots in sequence should take the audience on a review of the story points, directing attention to each part of the whole with a minimum of distraction.

The camera needs to be at the correct distance for the action or story point being shown in each scene:

- A long shot is used when everything in a large space needs to be seen

- A closeup can feature personality.

- A master shot can start out taking in a large area and then move in for a closer aspect.

- Short cut shots can skip from place to place to feature several important objects or locations.

Clarity is of the essence in staging a scene and includes the elimination of any conflicting movement or element within the composition that might "upstage" or attract the attention of the viewer during the shot.

In the case of animation, clear expression of ideas may be attained through the use of silhouette in the poses. Action is best shown through having the center of attention outside the lines of the character drawings rather than trying to have the action played straight in front of the actor (see Figures 2-6 and 2-7).

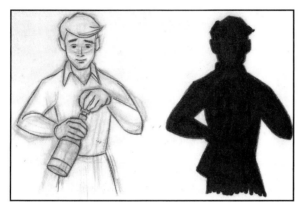

figure | 2-6 |

A bad silhouette.

In this illustration, the actor is removing a cork from a bottle that's right in front of him and in our line of vision.

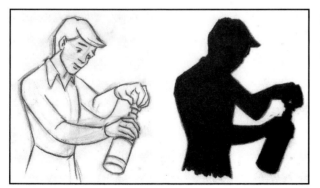

figure | 2-7 |

A good silhouette.

Now we see the same bit of business staged in clear silhouette, resulting in much more easily seen staging of the action.

Using the same idea of clear expression of ideas, the use of carefully planned arcs in the action being animated is of utmost importance. As you'll learn in the bouncing ball exercise, an arc is the natural

line through which most things move, and it is one of the most vital elements in character animation. An arc is the best way of helping the viewer follow an action without confusion, unifying the motions within the animation and eliminating the bumps and rough spots in the movements.

After posing out a piece of animation, the next item of importance should be to check all the arcs within the movement for smoothness and the placement from one to the next in the progression.

Here's an example of the arcs within the animation of a tennis serve and how they should be employed (see Figure 2-8).

Arcs within the
animation of a tennis
serve.

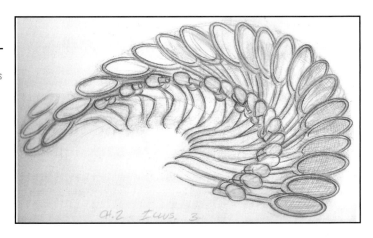

Acting

The following are some basic concepts on Acting.

Exaggeration: The drawings in an animated scene can most often be classified as caricature. By the same standard, the actions being depicted should be caricatured versions of the "real thing"; that is to say, the animator must push reality a bit into the realm of caricature.

This exaggeration of reality can actually enhance the "real" feeling of a mood or action for the audience. In effect, the contact is established more solidly even though we are not necessarily depicting realism.

In summary, the attitude should be to push the broad action as far as possible while keeping it believable.

Anticipation and follow-through: It's difficult for an audience to understand events being depicted on the screen without a planned sequence of actions leading one activity to the next. The proper exposition will set up the audience to expect the next movement before it happens.

The principle here is to precede each action with a specific move that anticipates for the audience what is about to happen. The move may be as small as an expression change or as large as a broad physical action. An example might be the drawing back of an arrow on a bowstring prior to the release of the arrow. It can be the gaze of a character at an object, then raising the hand just before reaching for and picking up the object. Even a surprise gag needs to be set up with anticipation, or the punch may fail to pay off.

The natural result of anticipation is the follow-through that comes after it, the release of the arrow in our previous analogy. The artful employment of the anticipation should make this the easy part, as long as the staging is effective and unhampered by upstaging or other distractions.

The previously mentioned surprise gag can be made effective by setting up the audience to expect a certain follow-through and then introducing a completely different result. If this happens unintentionally, you'd better brush up on your storytelling skills!

Overlap and secondary actions: These terms were developed to apply to some of the means that were discovered to keep animated characters from coming to a complete stop between active modes or when going into a held pose. As was mentioned previously in the section on moving holds, a held single drawing becomes very flat and unnatural.

Overlapping and secondary actions refer to the movements of other elements in a drawing that continue a moving momentum when a character starts or stops a primary action. Examples of these kinds of elements can be appendages such as long ears, tails, hair, and clothing or any articulated objects attached to or being carried by the character.

Any accessory objects or materials used in overlaps or secondaries must have a believable feeling of weight and a movement pattern that is natural looking and doesn't feel self-generated. For example, it is not a good idea to have clothing that appears to have a life of its own.

Body parts on a heavy, fleshy character can stretch, catch up, twist, and contract as internal forms work with and against each other. Any or all of these actions can be used to add a punch line of their own to primary action.

Drawing

A pencil is still a useful tool in 3D.

Design unity: Whether working in a traditional or computer-generated format, design is the prime consideration in constructing a character. One need not get "trapped" in a particular formula in character design, but it's a good idea to be practiced and well versed in many of the styles that have developed over the years, as the reasons for their existence are usually well founded on functionality. That is to say, **they are proven to work!**

The goals are elusive at times, but it is useful to keep certain principles in mind when attempting to come up with a character design that is successful. Design unity is exemplified in a character that blends visual characteristics to add up to a harmonious whole. The starting point leading to this successful application is to learn to draw as well as possible.

Solid drawing: Through the effort of constant practice, we can bring our abilities up to the levels of expertise required to create drawings with weight, depth, and balance. Experience is usually the best teacher, and only through trial and error can we attain that experience. Studies in perspective and anatomy are of equal importance in this combined effort.

The goal, once again, is not simply to replicate reality, but to learn the tangible aspects of realism and use them as a starting point on which to express your individual presentation, exaggerating and de-emphasizing as needed to attain a caricature (there's that word again!) of reality.

Appeal: This term is not reserved for cute kittens and baby duckies; it includes anything in a character that draws our interest in a positive (or sometimes negative) way. Whether dealing with a noble, heroic character or a base villain, both types must have enough appeal, or the audience will lose interest in what they're doing. In a live actor, we use the term "charisma." Here's a list of a few items that give a character appeal:

- Charm

- Pleasing design

- Simplicity

- Communication

- Magnetism

Simple, direct attitudes make the best animation drawings. Delicate expressions are easy to misinterpret; we don't want to confuse our audience! Attempting too much refinement can make the presentation so restrained or involved that it may interfere with communication.

Un-appeal: This is the term we've chosen to represent the flip side of appeal. Unfortunately, we are witness to un-appeal in the movie and TV animated products we see on an almost daily basis. It doesn't mean we need to lower our standard and settle for less, and it certainly doesn't mean we need to emulate it. An ugly drawing may have an initial shock value, but usually it lacks the strength it would need to carry a story, such as character building and audience identification.

Here are some of the things that contribute to un-appeal:

- Weak drawing

- Being complicated, hard to read

- Poor design

- Clumsy shapes

- Awkward moves

Line of action: This aspect is one of the very basic necessities in an animation pose. It represents the main thrust or function of a specific action and is the very first consideration when an animator begins a pose. In a very broad movement, the line of action can point straight into the movement being depicted. Even in a resting pose, the line of action can be evident in the depiction of the center of gravity that balances the figure or the leaning of a figure against a solid object.

The ability of an artist to immediately address the line of action in a pose is a function that is continually sharpened through the

process of life drawing sessions as well as informal sketching of observed subjects in various locations. These activities should be considered an ongoing process, as there is never the need to feel we've learned all there is to learn from observation. It must become a lifelong habit.

YOUR MAIN TOOL—THE GRAPH EDITOR

The Animation Graph Editor can be found by going to **Windows > Animation Editors > Graph Editor** (see Figure 2-9).

figure | 2-9 |

How to find the
Graph Editor.

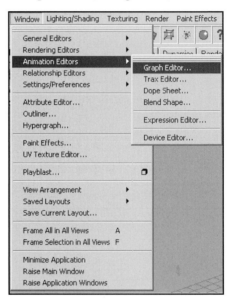

A new window pops up. This is the animation Graph Editor interface (see Figure 2-10).

figure | 2-10 |

Graph Editor
interface.

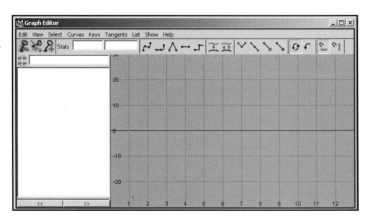

Within this interface, the arcs of movement you create in your animations are represented. You can easily see where problems have developed and can interactively make changes. We won't go through every tool at this beginner stage, but we will give an overview and show you the techniques for using the most active buttons correctly.

The top of the Graph Editor has eight pull-down menus. LMB click over these pull-downs to see the extra tools available (see Figure 2-11).

figure | **2-11**

The pull-down tools available.

These tools are the heavy hitters. Each pull-down menu lists a new set of tools available to you. The titles of each set are self-explanatory, and we will review each set. The individual tools you will use most often in this book are explained later in this chapter. The rest can be read about by going to the Help menu in Maya and typing in their names.

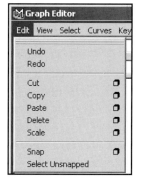

figure | **2-12**

The Edit tools.

Edit Tools

The Edit tools are basic commands much like those found in a word-processing program (see Figure 2-12).

View Tools

The View tools assist with setting up the window for optimal navigation (see Figure 2-13).

figure | **2-13**

The View tools.

figure | 2-14 |

The Select tools.

Select Tools

The Select tools allow you to simplify the selection process (see Figure 2-14).

Curves Tools

The Curves tools provide you with an excellent resource for advanced entire-curve editing and manipulation (see Figure 2-15). Here you are able to bake channels, cycle animation, and alter the weight of tangents, among other things.

figure | 2-15 |

The Curves tools.

figure | 2-16 |

The Keys tools.

Keys Tools

The Keys tools allow you to hone in on the keys themselves and modify specific tangent, spacing, and weight issues (see Figure 2-16).

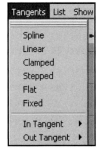

Tangents Tools

The Tangents tools allow you to change how the points on the curve are connected (see Figure 2-17). This greatly alters the movement of your object.

figure | 2-17 |

The Tangents tools.

List and Show Tools

The List and Show tools assist you in organizing objects for viewing within the Graph editor (see Figures 2.18 and 2.19).

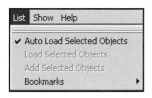

figure | 2-18 |

The List tools.

figure | 2-19 |

The Show tools.

Help

The Help menu leads you to software documentation and online manuals (see Figure 2-20).

figure | 2-20 |

The Help menu.

Graphic Interface

The second line contains shortcut symbols to more commands (see Figure 2-21). They are here because they are used quite often.

Move Nearest Key Picked Tool

This tool moves the nearest key picked (see Figure 2-22). You could have several key frames selected in the graph, but when you MMB click and move the mouse, only the nearest key frame is edited. The mouse needs to be over the selected key frame.

figure | 2-21 |

The graphic shortcuts.

figure | 2-22 |

The Move Nearest Key Picked tool.

Insert Keys Tool

The Insert Keys tool will place new keys on an existing animation curve (see Figure 2-23). LMB-click to select the curve to which you will add a new key.

figure | 2-23 |

The Insert Keys tool.

MMB-drag to set the location of the new key. A black line with a square will appear, locating the insertion point of your new key. Releasing the mouse button places the key. The new key will have tangents that preserve the original animation curve segment's shape.

figure | 2-24 |

Add Keys Tool

The Add Keys tool.

The Add Keys tool inserts a new key frame directly on the curve (see Figure 2-24). LMB click to select the curve, and MMB to create a key frame. This works differently than the Insert Keys tool in that you get fresh tangents that need editing. They are consistent with the tangents of the curves but are in the default placement.

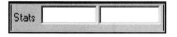

Stats

figure | 2-25 |

The stats window allows you to enter exact placement of your point mathematically (see Figure 2-25).

Stats.

figure | 2-26 |

Spline Tangents

The Spline Tangents tool.

This is the default tangent. This creates a very smooth interpolation (see Figure 2-26).

figure | 2-27 |

Clamped tangents

The Clamped Tangents tool.

These are a combination of linear and spline tangents. Usually your in and out tangents will be spline when using this curve, unless the points are very close. Then they are linear (see Figure 2-27).

figure | 2-28 |

Linear Tangents

The Linear Tangents tool.

A linear tangent creates a curve as a straight line joining two keys. This result in an evenly paced (almost robotic) movement. It is often used in conjunction with the stepped curve for setting the key poses (see Figure 2-28).

figure | 2-29 |

Flat Tangents

The Flat Tangents tool.

The in and out tangents of a flat curve have a slope of 0 degrees (see Figure 2-29).

figure | 2-30 |

Step Tangents

The Step Tangents tool.

This curve is used when creating the key poses. It strobes from pose to pose when played back (see Figure 2-30).

Graph Window

The graph window contains an x,y coordinate of points in space (see Figure 2-31).

The main section of the Graph editor is the graph window. At the bottom of the window, the Time is represented. Along the left side of the window is Value.

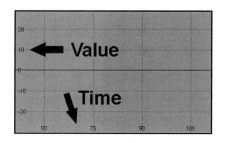

Coordinates.

You can read the window by looking at the bottom to see what frame you are on. You can also see the change in the Translate, Scale, or Rotate value by looking at the Value Line. These changes over time are represented by the curves. The movement of the key-framed object is influenced by the tangency of these curves.

If you RMB click in this window, you get a floating pull-down menu of the top interface menu.

Your Turn to Play

Make sure your interface looks like Figure 2-32.

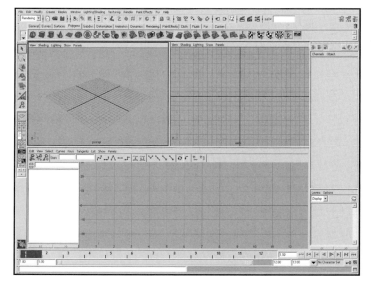

figure | **2-32**

The correct interface for this chapter.

If it is different, go to Display > UI Options and make sure the options shown in Figure 2-33 are checked off.

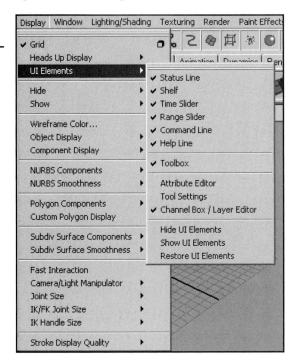

Set your panels by going to **Panels > Layouts > Three Panes Split Top** (see Figure 2-34).

Make the bottom panel your Graph Editor. Close any open Graph Editor windows and then go to **Panels > Panel > Graph Editor** (see Figure 2-35).

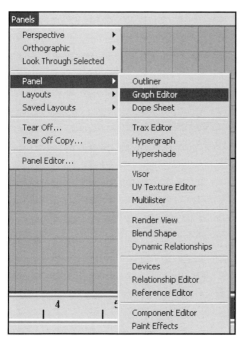

figure | 2-35 |

The Graph Editor.

Open the file "ball_keyed" and use it to experiment with while learning the following basics about the Graph Editor. Examine the following curves in the Graph Editor.

What Motion the Curves Represent

Figure 2-36 shows the default motion that Maya gives you when you animate a ball bouncing straight up and down.

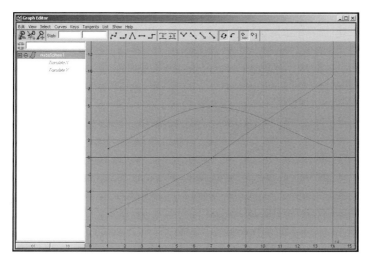

figure | 2-36 |

The default spline curve.

When an animation looks floaty, this is the usual culprit. Maya assigns a default spline curve to all movement. It spaces all interpolation evenly between key frames. Figure 2-37 shows what the animation will look like.

The default
animation.

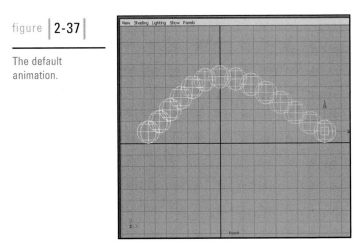

No real weight or timing exists. Learn what information the different curves, channels and tools provide, and you will create more believable animation.

Figure 2-38 shows the animation you want. It shows weight and timing. It involves some understanding of curves and editing tools to get this correct.

figure | 2-38 |

The *correct* ball
bounce.

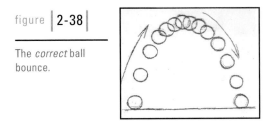

The curves for a ball bounce like this resemble those in Figure 2-39.

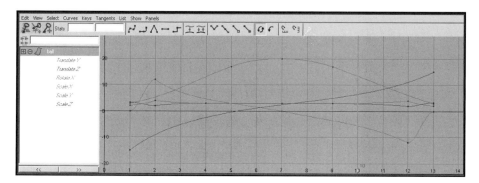

Let's find out what all the curves represent.

figure | 2-39 |

Each curve is the color of the coordinate it represents. X is red. Z is blue. Y is green. Look for the Coordinate icon in your Camera view (see Figure 2-40), and you will be able to understand where each curve is moving you.

The curves for an unedited ball bounce.

Here we are working in Y up space, meaning Y is the up and down axis. These curves are being explained as they react in a Front view window.

figure | 2-40 |

The coordinate icon.

X, Y, Z Translate

Translate stands for the amount of movement in space. A movement from the left to the right of the screen would be represented here, as would a movement up and down or toward you. It represents the spacing generated by the Move tool (see Figure 2-41 and 2-42).

| NOTE |

Interpolation is the term used for the motion "in between" the key frames you set. The software creates this motion. This interpolation is represented by the curves in the Graph Editor.

X moves left to right across the screen.

figure | 2-41 |

The default X
translate and its
effect on the sphere.

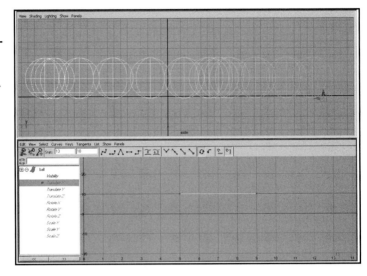

Y moves up and down.

figure | 2-42 |

The default Y
translate and its
effect on the sphere.

Z moves forward and back.

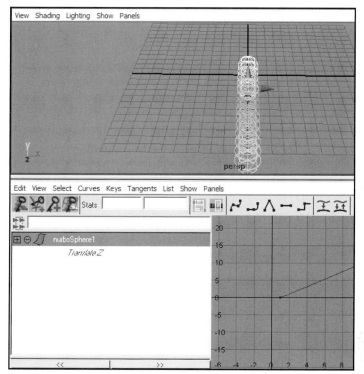

figure | 2-43 |

The default Z
translate and its
effect on the sphere.

X, Y, Z Rotate

Rotate stands for rotation around an object's
pivot, which is the local coordinate system for
the object.

X rotates the object towards you. Y rotates the
object like a spinning top on the floor. Z rotates
the object like a pinwheel.

X, Y, Z Scale

Scale stretches the object on one or two channels,
or increases and decreases the size of the object
as a whole (see Figures 2-44 through 2-46).

| NOTE |

Don't understand pivot? Take a
piece of paper and lay it on your
desk. Place your finger in the
middle of the sheet and press
against the table. Spin the sheet.
The paper rotates around your
finger. Move your finger to the
bottom of the paper. Rotate again.
In Maya, the pivot will have the
same effect against the object as
your finger does against the
paper.

X scale

figure | 2-44 |

X scale.

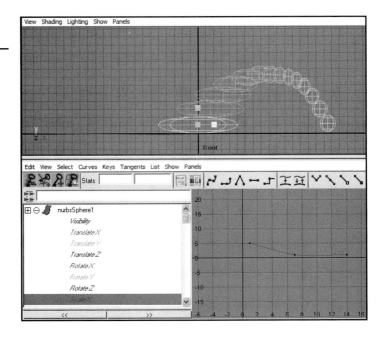

Y scale

figure | 2-45 |

Y scale.

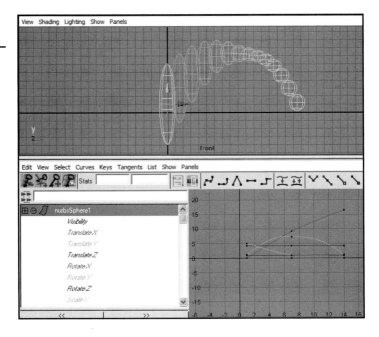

Z scale

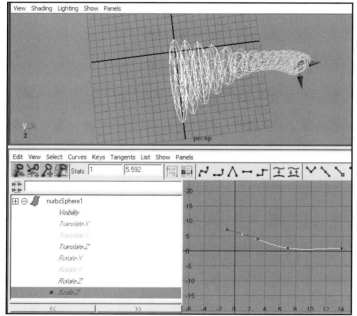

figure | 2-46 |

Z scale.

Can I See the Motion of My Object by Looking at the Curve?

Yes. Once you understand your curves and the production process well enough, you will be able to see motion without playing the animation. Know your tangent shapes and how they affect Translate, Rotation, and Scale values.

To demonstrate the impact of tangency, let's use a basic primitive sphere and a simple animation. Open 14framebounce_worker.mb to work along.

figure | 2-47 |

View > Frame All.

Select the Y translate curve. Then select **View > Frame All** in the Graph Editor interface (see Figure 2-47). You want the Y translate curve to fill the window.

Maya will assign default curves and animation (see Figure 2-48).

figure | 2-48 |

The default spline curve.

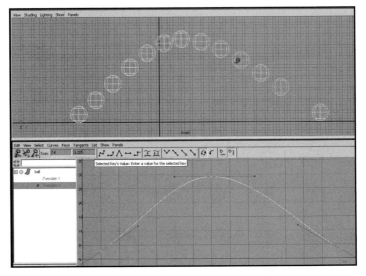

Notice how each sphere is spaced. This animation would appear robotic if it were played because of this fairly even spacing and limited ease in/ease out. For the animation to appear believable, you must decide how heavy the ball is, what kind of material it is made of, what the atmosphere it is responding to is like, and any other emotional statements you want to make.

DON'T GO THERE

I never want to keep the default information assigned to me by Maya. This is only a starting place. From here on, I need to understand my options and apply them toward my desired outcome.

Available Tangents

The following are the tangents available. We will use them on the Y translate curve in the ball by bounce animation.

Clamped

A clamped tangent has features of both the spline and linear tangents. Keys less than two frames apart will be treated as a linear tangent, while keys greater than two apart will be treated as a spline tangent. This is and is not a good thing. We will explore the proper usage.

Spline

A spline is a curve that is smooth between the key before and the key after the selected key (see Figure 2-49). The co-linear tangents of the curve (both at the same angle) ensure that the animation curve smoothly enters and exits the key.

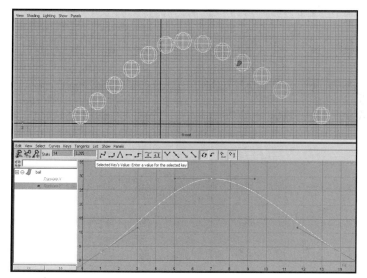

Linear

A linear tangent creates a straight line joining two keys (see Figure 2-50). The curve segment before the key is a straight line. The curve segment after the key is a straight line. A sharp angle connects them.

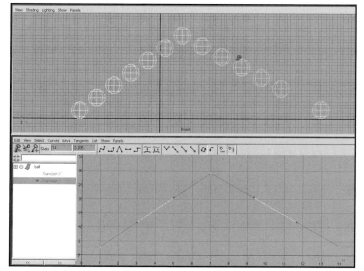

Flat

Flat sets the in and out tangents of the key to be horizontal, with a 0 slope (see Figure 2-51).

figure | 2-51 |

Flat tangent.

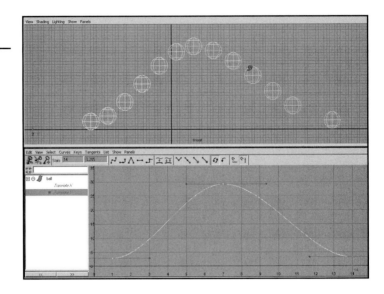

Stepped

A stepped tangent creates a flat curve on the out tangent of the key frame (see Figure 2-52). The curve segment is flat.

figure | 2-52 |

How the ball is spaced.

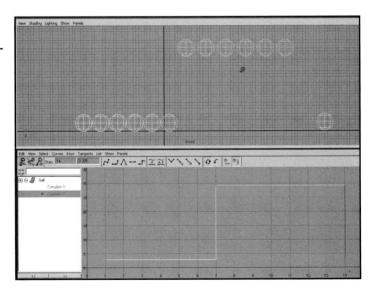

Fixed

Fixed retains the slope assigned when edited. This is a good option when you want to edit the value but retain the slope you had adjusted before the edit.

MINI TUTORIAL: EDITING

You will first try to make a proper bounce in the Y translate by changing the ease in and ease out of the Y translate curve.

You can use the file 14framebounce_worker.mb on the enclosed CD. Open the Graph Editor by going to **Windows > Animation Editors > Graph Editor.**

Select the Translate Y curve in the left-hand column so that only the Y translate curve is viewable in the window (see Figure 2-53). LMB-select the first key frame on the curve.

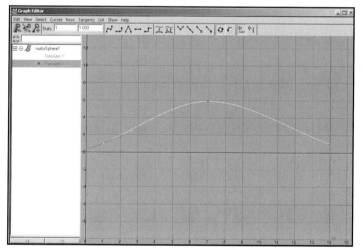

figure | 2-53 |

The Y translate curve in the Graph Editor.

Select View > Frame All to get the best view of this curve.

LMB-select the first key frame on the green Y translate curve. Now look at the round-tipped arrows on the key frame. They point in opposite directions. These are your tangents (see Figure 2-54), and the arrows are called "control handles."

figure | **2-54**

Tangents on key frame one.

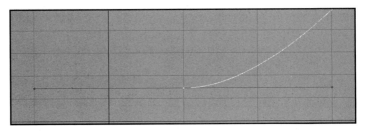

Tangents describe the entry and exit of curve segments from a key. Manipulating these tangents enables you to change the shape of curve. Thus, the spacing of the ball will change as it enters and leaves a key, allowing you to infer weight, timing, and other movement choices.

A typical bouncing ball in a traditional animation looks like Figure 2-55.

figure | **2-55**

How the ball is spaced.

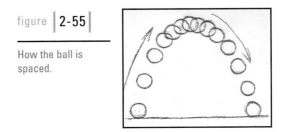

Notice that there are fewer spheres close together immediately after leaving the ground, but many balls are close together when the ball "floats" in midair. The spacing between the balls infers speed. If there is a wide gap between two images, the ball moves quickly. If there is a small gap between images, the ball moves slowly.

To emulate this effect in Maya, you will change the ease in and ease out of the Y translate curve. In the Graph Editor, choose Select > Out Tangent (see Figure 2-56).

figure | **2-56**

Select > Out Tangent.

Select the arrow to the right of the key frame in the Graph Editor (see Figure 2-57).

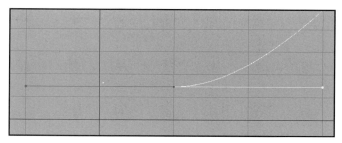

figure | 2-57 |

The out tangent for frame 1.

Click on the Move Nearest Key Picked tool at the very left of the Graph Editor (see Figure 2-58).

figure | 2-58 |

Move Nearest Key Picked tool.

Hold down your middle mouse button and select the tangent. Move your mouse, and the tangent changes. Make your curve look like Figure 2-59.

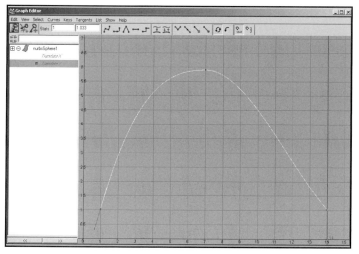

figure | 2-59 |

Here is a curve with the in tangent edited.

Do the same with the key frame at 14 (see Figure 2-60).

figure | 2-60 |

Here is a curve with
the out tangent
edited.

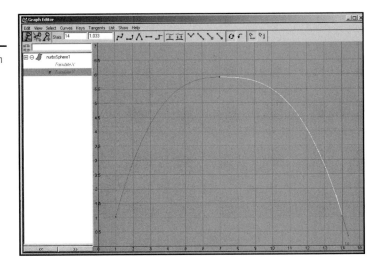

Notice that the spacing of the ball has changed. When you play the
animation, it will appear to leave the ground quickly, float in
midair, and then approach the ground quickly (see Figure 2-61).

figure | 2-61 |

The new spacing.

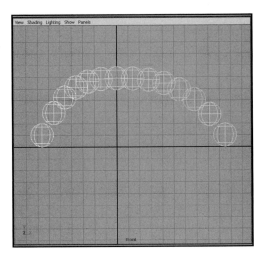

Now let's make the curve a little more believable. I am not happy
with the float position. I think it should happen at 7.5 instead of at
key frame 7. Let's edit the position.

LMB-select the key frame at 7. Turn off Time Snap On Off in the
Graph Editor. In the stats window in the upper-left of the Graph
Editor, type in **7.5**. The key frame is now at 7.5.

Play your animation.

Suppose you want the float to last longer and the ball to leave the ground even more quickly. The tangent won't let you do it. You need to use another tool to weight the tangent.

LMB-select the key frame at 7.5. **Select Curves > Weighted Tangents** (see Figure 2-62).

The tangents change a bit.

| **NOTE** |

Tangent weights dictate the amount of influence a tangent has over a curve segment. Curves are non-weighted by default.

Nonweighted tangents have short tangent handles that only control the angle of the tangent.

Weighted tangents have long tangent handles that control the angle and weight of the tangent. Weighted tangents provide finer control over your animation curves.

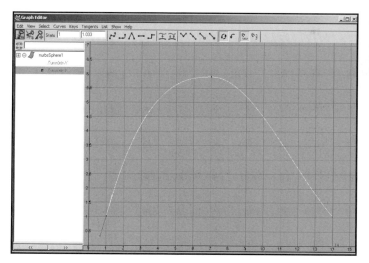

figure | 2-62 |

Select Curves > Weighted Tangents.

Now select the Free Tangent Weight button (see Figure 2-63). The tangents now have boxes at their ends.

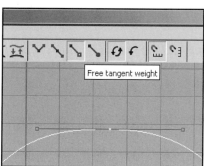

Free tangent weight

figure | 2-63 |

Free Tangent Weight.

LMB-select one of the tangents. MMB the tangent and pull it away from the key (see Figure 2-64).

figure | 2-64 |

The edited curve.

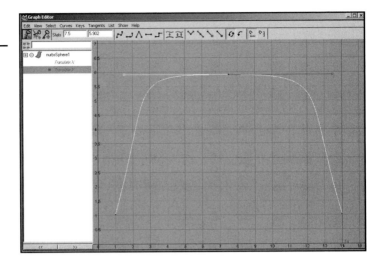

Look at how much float you can have now (see Figure 2-65)! Unfortunately, this doesn't really look good when you play it, but it illustrates how you can edit in the Graph Editor.

figure | 2-65 |

Float.

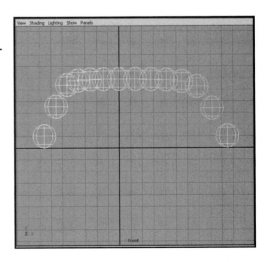

figure | 2-66 |

The Break Tangents tool.

Break the tangent so that you can manipulate either side independently. LMB the key frame at 7.5 and use the Break Tangents button (see Figure 2-66).

Now you can edit either side independently of the other. LMB click the tangent on the left side to select and the MMB to push back toward the key frame (see Figure 2-67).

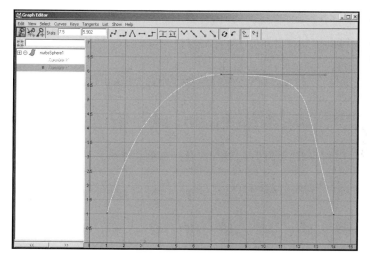

figure | 2-67 |

Edit independently.

The tangent on the right side is unaffected. Weighting the tangents and breaking them gives you dexterity. You can do anything you want with the curves now. Try to match what is shown in Figure 2-68.

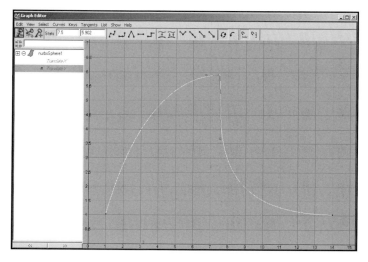

figure | 2-68 |

A new curve.

You are left with the strange animation in Figure 2-69.

figure | 2-69 |

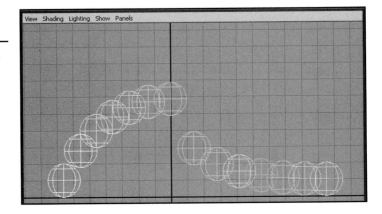

Strange Animation.

I encourage you to play with the curves and get used to what shapes give you what kind of animation result. Your Graph Editor is the root of all great motion. Get to know it like the back of your hand.

Now edit the points in space and look at your sphere while doing so. Let's try this with the Y translate.

Select the key frame at 7.5 and move it up in the Graph Editor. You can do this manually with the middle mouse button and the Select Nearest Key Picked button and slide the key frame to a new position, or you can type a new value into the Key Value box (see Figure 2-70).

figure | 2-70 |

The Key Value box.

Play your animation. The ball bounces higher. Lower the value and make your ball bounce lower. Edit the other curves, tangents, and keys to see what happens.

Why Doesn't This Object Move the Way I Key-Framed It?

Two points in space create a curve based on the appointed tangency. A third point can greatly affect the previous two.

Here are two points for the Y translate of a sphere (see Figure 2-71).
At frames 1 and 7, I key-framed a value of 1.

figure | 2-71 |

Two key curve.

At frame 10, I key-framed a value of 2. Notice how the new key
frame affects how the curve reacts to frames 1 and 7 (see Figure 2-
72).

figure | 2-72 |

Overshoot.

It creates an overshoot. This is why I have the Graph Editor open as
I animate. I like to keep an eye on how new key frames are affecting
my curves. An overshoot will affect any animation, because the
object is now moving past the key pose I chose.

Don't over key-frame your animations. You should be in control of
the curves and use as few key frames as possible to complete the
action. Too many can distort the curves and cause jarring jumps
and flaws in motion.

Common Software–Inspired Mistakes

1. Most beginning animators accept the default curve and do not
 modify it.

2. Figure 2-73 shows a curve muddied by too many key frames.

figure | 2-73 |

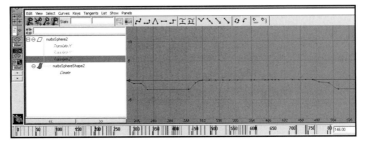

Too many
unnecessary frames.

3. Figure 2-74 shows a curve that hyperextends before the next key frame.

figure | 2-74 |

Overshoot.

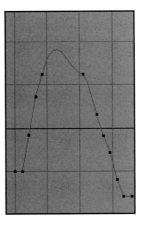

4. Hitting the S key as a shortcut for key frames sets a key frame for every channel. This only serves to clutter your file and make it bigger, potentially lengthening your renders.

ANIMATION TIPS

- When you key a frame, just key the information on the channel where you want motion.

- Delete all static channels (Delete > All by type > Static Channels) when done animating.

- Delete unnecessary keys.

- Use Drop-in key frames when you want to insert a key without ruining your curves.

- Have the Graph Editor open and viewable as you animate, keeping note of overshoots and incorrect keys.

SUMMARY

Animation is a complex art in computer graphics. Not only do you need to understand the principles of animation, you must also understand how to apply them to a software program.

The Graph Editor is the most important tool you have available to you. It details every movement and provides you with the tools to improve it if necessary.

in review

1. What are the "Mechanics" of animation?

2. What is "Composition" in animation?

3. What is "Acting" in animation?

4. What is "Drawing" in animation?

5. Should you make a key frame on every key? Why or why not?

6. Should you have values recorded in every animatable channel?

7. What are the names of the tangents available in Maya, and what motion do they represent?

8. What are some common mistakes made by the beginning animator?

9. What is overshoot?

10. What is tangent weight?

11. What is the Graph Editor used for?

12. Can I see the motion of an object just by looking at the curve?

↗ EXPLORING ON YOUR OWN

1. Make a simple 30-frame, 3-key frame animation with a sphere. Experiment with all of the curves and tangents in this chapter until you feel confident with the differences in each tool.

notes

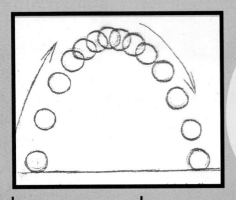

| the bouncing ball |

3

 charting your course

The first assignment that a traditional animator typically receives is the "bouncing ball." Here the animator practices the first principles of animation. If you can add convincing appeal to a mundane object, you are ready to apply those skills to a more complex object. We will try bouncing a ball as our first computer animation.

 goals

In this chapter, you will:

● Animate the motion, scale, and rotation of a primitive object.

● Apply changes in the Graph Editor.

● Learn how to create a pose test.

● Practice timing, squash and stretch, and volume.

TOOLS USED

- **Key Selected.** The Key Selected command captures the placement information of your object in x, y, z space (see Figure 3-1). This information is kept in a node.

figure | 3-1 |

Key Selected.

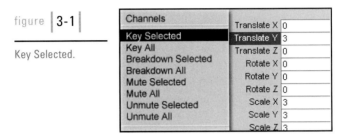

- **Node.** A node is like a file folder for keeping documents tidy (see Figure 3-2). A node rests on top of an object in the hierarchy window. It stores mathematical information relating to the object as attributes. Nodes are attached to an object in a hierarchy, and depending on where the math is placed, an object can move different ways.

figure | 3-2 |

A node in the outliner window.

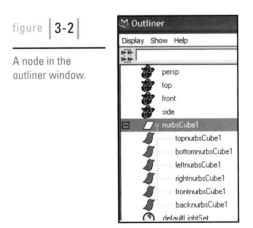

A TRADITIONAL APPROACH

This assignment has been given to beginning animators since the art form first came into its own, and it accomplishes several important things with a minimum of time and difficulty. Using this deceptively simple test, a potential animator is introduced to the mechanics of animating a scene while also learning hands-on about the principles of spacing, timing, and squash and stretch.

There are a couple of things to consider when beginning this exercise. First, there is the shape of the arc that a bouncing object makes. One might suppose that the arc would be a simple half-circle, somewhat like a Roman arch. Actually, the shape is more like the end of an ellipse. (It has to do with inertia and momentum.)

Figures 3-3 and 3-4 show the shape comparisons.

figure | **3-3** |

The half-circle approach (wrong).

figure | **3-4** |

Using an ellipse (right!).

Now you have the shape for the bouncing object to describe. The second consideration as you begin is the spacing of the drawings as the ball goes through the arc. An even spacing would get it moving in the arc pattern, but it would do so with no feeling of weight and believability. On the other hand, if you group the drawings closer together at the top of the arc (the slowest point) and space them out as the ball travels up and down (the fast part of the bounce), you get a natural feeling of a real object with weight. The difference in shaping is shown in Figures 3-5 and 3-6).

figure | **3-5** |

Evenly spaced (wrong).

figure | **3-6** |

Grouping at the top (right!).

Now that you have dealt with the path of travel (the arc) and the spacing and timing of the bounce, you will next deal with the other basic element of animation mentioned earlier: squash and stretch.

Early animators who experimented with the bouncing ball found that in the fast parts of the bounce, the speed of the ball could be enhanced by a slight elongation of its shape into an oval, with the axis along the path of travel. In further tests of this sort, the ball was also flattened at the point of each impact in the bounce. This caused a shape change that enhanced the effect of the ball hitting the ground and rebounding (see Figure 3-7).

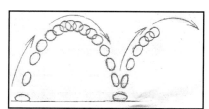

figure | **3-7** |

Impact.

This is a good point at which to introduce one more variable into this experiment: the material used in the ball itself. While the squashy-stretchy example shown up to this point is a good representation of a soft rubber ball, what about something made of a heavy, unyielding type of material, such as a bowling ball or a cannon ball? It's clear you need a slightly different approach for an example of that sort.

Considering the weight of this new object, you know it isn't going to bounce nearly as high as the bouncy little subject of the preceding example. Think of the comparison in terms of something audible. If the rubber ball goes "boing! . . boing! . . . boing!" along the course of its bounce, the heavy ball by comparison would make a sound like "BAM! . . . ba-dum bum." The mass would permit maybe one fairly large rebound, and then the arcs of bounce would rapidly diminish to a couple of "rattles" against the surface (see Figure 3-8.

The arc diminishes.

In addition, you would need to minimize the amount of squash and stretch when animating a ball of heavy, unyielding character to avoid destroying the believability of its weight and hardness.

A 3D BOUNCING BALL

Figure 3-9 shows a bouncing ball drawn in traditional animation.

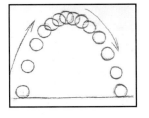

figure | 3-9 |

Animated bouncing
ball.

You will create the preceding animation in Maya, emphasizing timing, squash and stretch, and volume. You will animate over 13 frames. Like traditional animators, you will set up key frames and then add your in-betweens. You will learn the basics of the bounce and then apply it to different bounce situations.

figure | 3-10 |

The Animation
module.

First, make sure you are in the Animation module (see Figure 3-10).

Enter **13** as your playback end time and final end time (see Figure 3-11). Playback end time is the amount of time you will view while working. Final end time is the duration of the entire animation.

figure | 3-11 |

Playback end time
and final end time.

Go to **Create** > **Nurbs Primitives** > **Sphere.**

Do not deselect the sphere. It appears in your Channel Box as nurbsSphere1.

Scale the sphere up using your Channel Box (see Figure 3-12).

Scale X: **3**

Scale Y: **3**

Scale Z: **3**

figure | **3-12** |

The Channel Box with the sphere selected.

Notice how the sphere reacts when you change each Scale option. It squashes and stretches as the values are changed. You will be using the scale options in the squash and stretch portion of your animation.

You now have a sphere of scale (3, 3, 3) at origin. You will animate the Scale option later. With the sphere selected, go to the Channel Box and rename nurbsSphere1 to **ball.** Remember to hit Enter when you are finished.

figure | **3-13** |

Rename the default title.

Now you will move the pivot to the bottom of the ball. This will allow all scale actions to refer to the pivot as the contact point. The contact point is where the ball hits the floor.

Make sure you are in three-panel view, as shown in Figure 3-14.

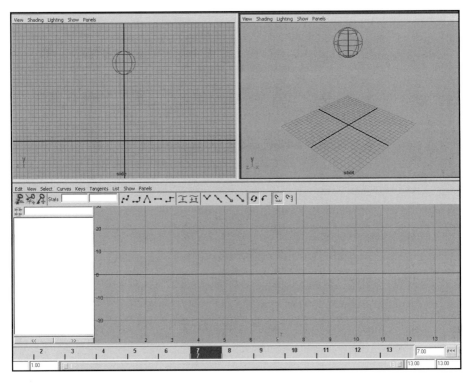

figure **3-14**

Three-panel view.

You can get to the view by using the pull-down menu shown in Figure 3-15: Panels > Layouts > Three Panes Split Top.

figure **3-15**

How to get to three-panel layout.

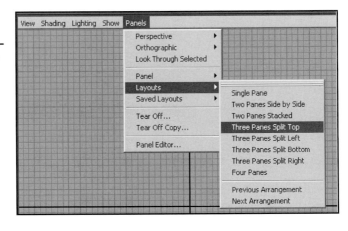

figure | **3-16** |

Three-panel view
with the Graph
Editor.

I like to have a Perspective and Front Camera in my top left and right window view to keep an eye on my movements. I also like being able to keep an eye on my Graph Editor when I animate. So, in the lower panel, I go to the pull-down menu and select **Panels > Panel > Graph Editor** (see Figure 3-16).

Later, I will create a shot camera that will frame my work for final approvals.

Select the Move tool. (The manipulator icon will not show up if you have not selected the Move, Rotate, or Scale tool.)

With the ball selected, press the Insert button on your keyboard. The Insert button can be found above the arrow keys on the right-hand side.

The manipulator is now a pivot and looks like a yellow square with a circle inside (see Figure 3-17).

figure | **3-17** |

The manipulator
changes to a yellow
box icon.

Move this square with your LMB and center it on the bottommost contact point of the sphere (see Figure 3-18).

Press Insert again to turn off the Translate Pivot option. The translate manipulator returns.

figure | **3-18** |

Select yellow axis
only.

Play with different Scale entries to see how the sphere reacts to the new pivot. Changing the Y value in Scale will give you the most interesting reaction (see Figure 3-19).

figure | 3-19 |

Changing the Y value
in the Channel Box.

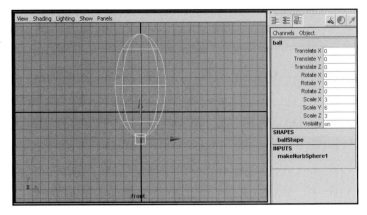

Select the green arrow of the translate manipulator. Move the ball along the Y-axis so that the new pivot rests on top of the origin (0, 0, 0). If you want to continue using the Channel Box, type **3** into Translate Y and keep Translate X and Z at 0.

Before you begin to keyframe, reset the default settings in Maya for your tangents. Go to your preferences: **Windows** > **Settings Preferences** > **Preferences** (see Figure 3-20).

figure | 3-20 |

Here is one way to
get to your
preferences.

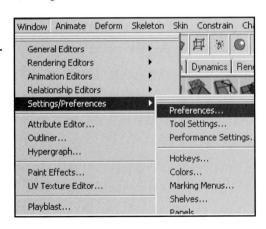

Go to Keys in the Preferences and change the "in" tangents to linear, the "out" tangent to stepped, and turn on weighted tangents (see Figure 3-21). This will allow you to have static poses. Later, you will tweak the curves to create believable movement.

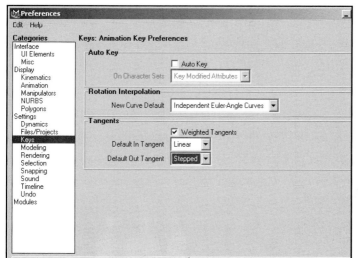

figure |3-21|

Change the tangents
under Keys in the
Preferences.

Save and close.

At this stage, you want to define your key poses. These key poses are
the silhouettes which detemine the acting in the scene. We use
linear and stepped because you want static poses at certain points in
time.

Set a key frame for ball at frame 1, using **Animate** > **Set Key**.

The shortcut for default key-framing is "s."

Notice how all the channels boxes went from white to beige? This
means key-frame animation has been attached to every channel
(see Figure 3-22).

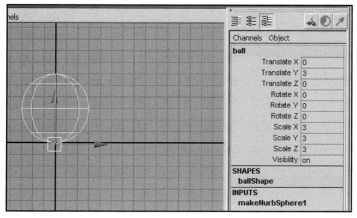

figure |3-22|

The area next to
key-framed channels
should turn beige.

A red tick should now be on your timeline. This indicates that a key frame has been set.

Pressing "s" is the default way of setting a key frame in Maya. Default is bad. See how the beige signifies a key frame in every channel in your Channel Box? You don't want a key frame in every channel. This makes your animation heavy, difficult to edit, and messy overall.

For this part of the tutorial, you will only concentrate on the Y Translate. For a clean slate, go to: Edit > Delete All By Type > Channels (see Figure 3-23).

All the beige should be removed from your Channel Box.

Again, set a key frame for ball at frame 1. Do not use the shortcut "s" key. Instead, go to the Channel Box.

LMB-select the Y Translate channel. It will turn black. Right-click over the Y Translate channel to reveal the menu (see Figure 3-24). Hold down the RMB.

Select Key Selected. Now you will see that only the Y Translate chan-
nel is beige (see Figure 3-25).

figure | **3-25** |

Y Translate is beige.

Go to frame 13. Right-click over the Y Translate and Select Key
Selected again. You will see red ticks on the line at frames 1 and 13.

The first and last frames of a loop must be the
same or else there will be a pop in the animation.
When you get more sophisticated in movement,
you will want to make the last frame precede the
first so that the movement does not slow on con-
tact.

Now, in your timeline, change playback end time
to **12** (see Figure 3-26).

| **NOTE** |

Remember to always go to the
next frame before setting a key
frame. Otherwise, you will likely
overwrite your previous key
frames.

When you loop this animation, you do not want to play the same
key frame twice, or else it will hold. Frames 1 and 13 are the same
key frames right now.

figure | **3-26** |

Change playback
end time to 12.

Go to frame 7. Type **20** into Translate Y. Set a key frame. This is the
"float" position (see Figure 3-27).

figure | **3-27** |

Float position.

Select a window as your playback view. Perspective or Front is your best choice.

Play your animation using the controls (see Figure 3-28). (They look like a VCR window).

figure | **3-28** |

The Controls.

This is a pose test. It is your first opportunity to view the timing. It is supposed to be choppy. Now, to capture the timing found when the ball loses upward momentum and gains downward momentum, you will set two more key frames.

Go to key frames 5 and 9 and set a value of **17** in the Y Translate. Your curve should look like Figure 3-29.

Play the animation. At this stage in production, if you were working in a studio, you must get approval for the timing before you work on movement.

If the animation is too fast to see, check your animation preferences and make sure you are playing at 24 or 30 fps.

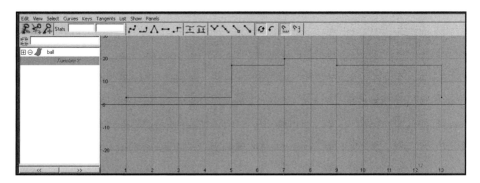

You have created the basic timing of the bouncing ball. Traditional animators call this "setting the key poses."

To see a representation similar to the traditional bouncing ball sketch, turn on ghosting. Make sure the sphere is selected. Then turn on **Animate** > Ghost Selected (see Figure 3-30).

Play the animation. You will see spheres for every frame of animation selected in the ghosting options box. To turn off ghosting, use the command Animate > unghost selected. Open the Options box and check out all of the different ways you can ghost.

Create a shot camera by going to **Panels** > **Perspective** > **New** (see Figure 3-31).

Look for the new camera you just made by going to the outliner: **Window** > **Outliner.**

The new camera is called *persp1* (see Figure 3-32). Rename it **shot.**

figure | 3-29 |

Your curve should look like this.

figure | 3-30 |

The Ghost selected.

figure | 3-31 |

Create a shot camera.

figure | 3-32 |

Find the new camera in your outliner.

You can also change the name in the channel box.

Select the shot camera and set the view you want to see through the camera. You can dolly, pan, and zoom to frame the shot.

Set your shot and lock the camera. You lock a camera by selecting it in the outliner. Then, in the Channel Box, select all the channels. Right-click over the selected channels and choose Lock Selected. Locked channels will appear as gray in the Channel Editor.

At this point, the animator goes to the art director for approvals on timing and staging. Once approved, you go on to adding motion.

Adding Motion

Now you can add motion between key frames. In the Graph Editor, select each key frame and change it to a clamped tangent. To do this, select the key frame and then RMB to get a hidden menu. **Select Tangents > Clamped** (see Figure 3-33).

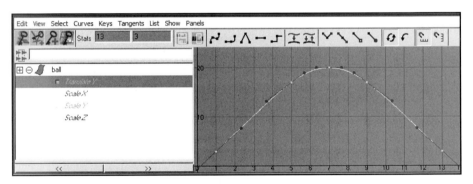

figure 3-33

Select clamped
tangents.

Notice how curvy they are. At this time, you chose the value of the slope to reflect your needs for the ease in and out of the motion. Play the animation to see what I mean. The motion is not very believable.

Select the key frames at 5, 7, and 9 and shape them like the 5, 7, and 9 shown in Figure 3-34.

Remember, to shape them, you LMB-select the key frame (only one at a time for this purpose). Then LMB-select the tangent and MMB-move the tangent up or down.

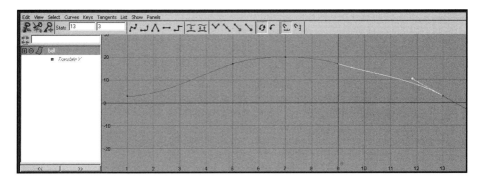

Play the animation. The timing is decent. What do we need next? Squash and stretch.

figure | 3-34 |

Select a key frame, LMB the tangent, and MMB the tangent up or down.

Squash and Stretch

Go to your preferences. You already know how to get there through the pull-down menus, so now use the graphic shortcut. Click on the icon next to your automatic key-frame button on the lower right of the interface (see Figure 3-35).

The Preferences window pops up (see Figure 3-36). Select Keys. In the Keys area, change the default in and out tangents to flat. Keep them weighted. Click save.

figure | 3-35 |

The Preferences icon.

figure | 3-36 |

Key preferences.

You are done with the pose test. Your tweaking from here on will contain movement.

Go to frame 7. Make sure the values for the X, Y, and Z Scale are 3.

Set a key frame for the three Scale channels. Remember to use Key Selected so that only these channels are key-framed (see Figure 3-37).

figure | 3-37 |

Set keyframes for the X, Y, and Z Scale.

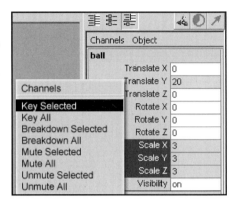

Make sure to set the same values for key frames 5 and 9.

Go to frame 12. Change the Scale values to the following.

Scale X: **2**

Scale Y: **4**

Scale Z: **2**

Set a key frame for the scale values. Do the same at key frame 2. You now have stretch.

Now go to frame 13.

Scale X: **3.4**

Scale Y: **2.2**

Scale Z: **3.4**

Play all 13 frames. You now have squash.

Notice that you shaved .8 off the Scale Y value and added .4 to the Scale X and Scale Z values. Maintain a consistent volume by maintaining a total x + y + z value of q.

The movement is a little like a bag of ooze. Tweak the in and out tangents of the Scale values to give a crisper transition.

Edit your tangents in the Graph Editor. Move the in and out tangents to create believable movement. In the Graph Editor, select only the X, Y, and Z scale curves. Then use the Graph Editor pulldown menu **View > Frame All** (see Figure 3-38).

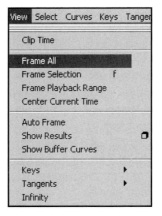

figure | 3-38 |

View > Frame All.

You will now see just the Scale curves close up (see Figure 3-39). It is easier to work this way.

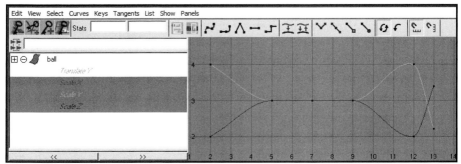

figure | 3-39 |

Sometimes a shift of movement is hidden, so you need to look closely at your curves. I like my scale curves edited this way for this bounce (see Figure 3-40).

Scale curves viewed close up.

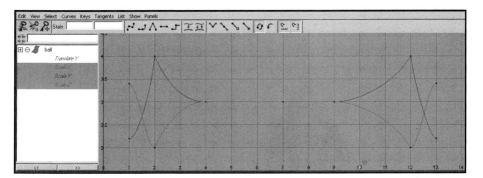

figure | 3-40 |

Be very careful with curves. Look out for overshoots. If the curve extends beyond your key frame, it is hitting a key pose you did not

My Scale curves.

This is what your Z Translate curve looks like (see Figure 3-46). I reversed the ease in and ease out because I wanted the ball to move faster when it landed and took off, slowing at the float position.

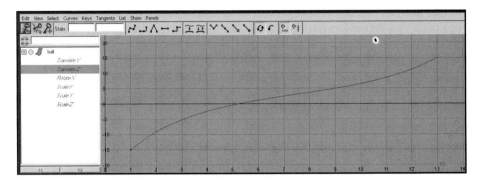

figure | **3-46**

Z Translate curve.

Play the animation. The ball now bounces toward you in the Perspective view.

To add the final beauty to your ball bounce, you will add one small rotation to the X-axis. When your ball moves forward, it must lean forward. When your ball lands, it must land from the trajectory.

Go to frame 1. Set a key frame in X Rotate at **0.** Go to frame 2. Rotate the sphere to the right 12. Set a key frame. Go to frame 7 and set X Rotate to **0.** Rotate the ball to the left, Rotate X–12. Set a key frame. Go to frame 13 and set X Rotate to **0.** Set a key frame.

Figure 3-47 shows my X rotate curve. I edited it so that it would transition more quickly. What did I do? You can figure it out by editing your curve to look like mine.

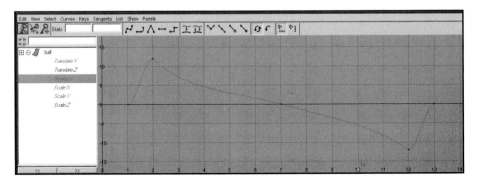

figure | **3-47**

X rotate curve.

Play the animation.

Figure 3-48 shows the final curves for this animation. Yours does not have to look like mine. You only need to have mastered the buttons to achieve the motion you desire. Do this chapter over again until you can do this animation without the book.

You can certainly cycle this animation, but that would be silly to do after all the effort you put in to achieving a believable bounce. Bouncing balls loose height and momentum as they move forward, and cycling keeps all momentum constant. It would take only a few key frames and a few tweaks to create a believable bouncing ball that eventually slows with a roll forward and then ends with a slight tip backwards.

figure 3-48

Final curves.

Edit your ball to bounce forward a few more times. I would move ahead one bounce at a time. Each time, I would shorten the movement in the Y and Z Translates. I would also reduce the squash and stretch.

Now you know all the tools you will need to edit this bouncing ball to look like any kind of ball you want to create. Try your hand at editing the function curves to emulate the motions of two distinctly different balls, like a bowling ball and a ping-pong ball. Make reference footage of the balls you will be working with. You will find believable detail by observing the object first hand.

The Ping-Pong Ball

A ping-pong ball has a hard, inelastic shell. It is light and very responsive to force. When it achieves momentum, it travels much farther than a heavier object like a bowling ball. Which curves would you edit if it bounced on smooth concrete?

It bounces higher and faster than the average ball and floats for a little longer, too. The Translate Y will need to be brought up to a much higher value to allow for a higher bounce. You should lengthen the float in the Z Translate channel, too. It also requires less bounce and stretch because it is made of an elastic substance. Thus, the Scale values would need to be tweaked. Edit the Scale X, Scale Y, and Scale Z to be much closer to the initial Scale value of 3. You may only want a variance of .05 for squash and stretch.

The Water Balloon

A water balloon has a soft, elastic shell. It is heavy and jiggles in response to force. It does not travel up in Y when it responds to momentum; rather, it tends to spread out more and respond internally. Which curves would you edit to create the water balloon bouncing on a shag rug?

There is little or no float time on the bounce. The bounce is low and shallow after the drop. You will need to bring down the Y Translate value to achieve the lower bounce. It will travel less distance, so the Z Translate curve will need to be adjusted. It squashes and stretches more than the average ball and has much more elasticity. You will need to edit the Translate Y, Scale X, Scale Y, and Scale Z again, but in a vastly different direction. The Scale values should be pushed to further extremes. The balloon squashes in more deeply, jiggles, and almost does a double bounce.

Two or three bounces happen in the same space of time as an average ball bounce. You will need to shorten the timeline and edit the frame playback to accommodate the timing change.

SUMMARY

A bouncing ball is the basis for most movement in animation. A frog jumping and landing will require similar arc, bounce, and stretch. The fleshy parts of a larger person jogging will require bounce and stretch, timing and arcs. Knowing how to use your tools to create the principles will make your animation much more convincing.

1. What is the shortcut for setting a key frame?

2. What is a clean and efficient way to set a key frame?

3. Which translate curve represents the up and down motion of the ball in this chapter?

4. What command do you use to delete all of the animated channels?

5. How does volume change when a ball squashes and stretches?

6. When you first set the preferences for your tangents, what is your default "in tangent" when key-framing for the pose test? What is your default "out tangent"? Are tangents weighted or free?

7. What are these values changed to when you are ready to edit the curves?

↗ EXPLORING ON YOUR OWN

1. Collect different balls: ping-pong ball, basketball, bowling ball, tennis ball, playground ball (half deflated), beach ball, volleyball, racquetball, and super ball.

 Take them to different surfaces and bounce them. Take note of the different reactions that each ball gives to each different surface: nubbled concrete, wood, running track, ice, steel, smooth concrete, and stone.

 Now try to re-create the different movements in your animation so that you can visually read what kind of ball you are animating and what kind of surface the ball is reacting to.

2. If you are really good, animate two balls as if they were feet walking forward. This is an excellent way to practice timing. Watch people walking. The feet are kind of like bouncing balls, except they are also responding to a load of weight. Thus, the volumes may be a bit more crucial to giving information. Make one ball the left foot and one ball the right foot. They will spend more time on the ground than a ball, and they will move with a directed purpose when achieving each step.

ADVENTURES IN DESIGN

AID1/THE STORYBOARD

To construct a movie, you must first have a plan. Storyboards are the architectural blueprints of a movie.

The first thing you do when creating a short story is write it out. Make sure you can tell the story in 2 to 3 sentences. If the listener clearly understands, then it is safe to proceed. If you can't get to the point quickly, rethink the story.

Then, create a storyboard. It doesn't need to be more than quick sketches if it is for you. It will need a bit more detail if it is meant to communicate to a team.

The storyboard will help you map out how

you portray the story details. At this stage you choose your camera shots and plan how you manipulate the eye of the viewer towards important information. You have many camera shots to choose from—but first try your hand at using the following:

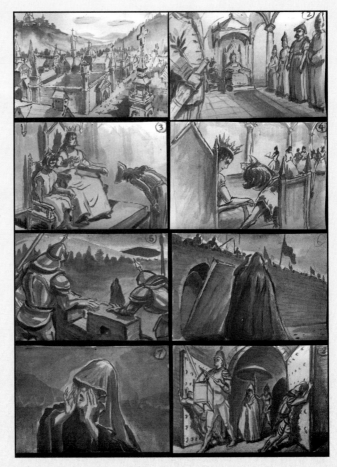

A-1 Storyboard by Cui Jin.

- XCU—Extreme close up

- CU—Close up

- MS—Medium shot

- WS—Long shot

- XWS—Extreme long shot

The Five-Panel Storyboard

The five-panel storyboard is a good way to begin creation of a short film. For your shorts, construct a five-panel storyboard. You are welcome to add additional panels, but have the five outlined below represented in your boards.

The five-panel storyboard is a story told in five panels. You are answering the following questions in each respective panel:

1. Where (Wide shot)

2. Who (Medium shot)

3. What (Close up)

4. Reaction/Conflict (Close up, wide shot, or medium shot)

5. Resolve (Close up, wide shot, or medium shot)

This storyboard illustrates the following:

1. WHERE: Wide shot :03 seconds
Opening shot of a convenience mart and a depressed man walking in.

2. WHO: Medium shot :06
He checks his wallet for his last two dollars.

3. WHAT: Extreme Close up of ticket :05
:05

4. REACTION/CONFLICT: Medium Shot of man :06
He scratches off the numbers on the ticket.

5. RESOLVE: Wide Shot :04
The ticket is a winner and he is now a happy man.

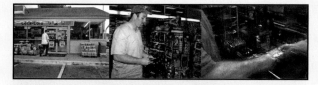

A-2 Shots 1, 2, and 3 of the five-panel storyboard.

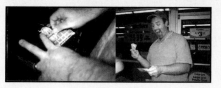

A-3 Shots 4 and 5 of the five-panel storyboard.

When you have chosen the shots, then assign an amount of time to each shot. A few rules of thumb are:

1. Wide shots are generally longer—7 seconds or more, because there is a lot of information for the viewer to absorb. I break this rule here.

2. Generally, shots are no longer than 9 seconds (although editing has pushed this shorter and shorter in recent days)

3. Close ups tend to be shorter in duration, though typically no less than 1.5 seconds.

4. Do not make all of your shots the same length of time.

5. Editing is like writing music—be aware of rhythm

These are not absolute rules. You will find many music videos have incredibly short edits. On the other extreme, Director Robert Altman (*The Player, Ready to Wear*) starts many of his movies with a several minute opening shot.

Follow these rules for the creation of the five-panel storyboard. Try to keep your five-panel storyboard to exactly 25 seconds. This will force you to budget your time, like they do in commercial production.

If you want to make a Hollywood story, add a sixth/seventh panel. This is the "twist." To the five-panel storyboard above, I will add two panels.

6. Wide shot (:05)
 Man runs away joyfully with his winnings.

7. Medium shot (:07)
 Man is hit by bus.

To make your own five-panel storyboard, do the following:

1. Write down a one- to three-sentence description of the story encapsulating the main essence of the action.

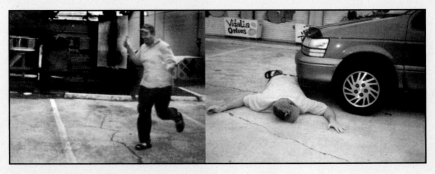

A-4 Shots 6 and 7 added for the Hollywood story.

2. Draw your five boxes and label them *where, who, what, conflict/reaction,* and *resolve* in the upper left hand corner of each box.

3. Transfer your ideas to these boxes, translating your story to answer the five labels. Write the action below the boxes.

4. Time out your scenes, and label each scene with how many seconds will be awarded the shot underneath the box.

5. Draw sketches in each box illustrating the primary activity in that shot. Frame it as you want the camera to frame it.

6. Label your camera shot in the upper right hand of the frame.

This is a great way to churn out ideas for a short film. Start with a simple story, then plot out the major elements this way. On your second pass, you can add more details and shots, but you will start out with a basic story that answers the questions your audience will want answers to.

Now that you have a five-panel storyboard, you will need to create an animatic. The next Adventures in Design (see pages 150–153) will give you advice on how to create one.

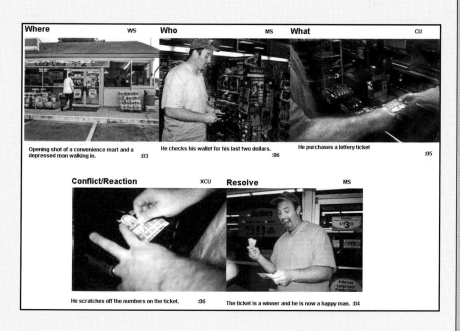

Where WS **Who** MS **What** CU

Opening shot of a convenience mart and a depressed man walking in. :03

He checks his wallet for his last two dollars. :06

He purchases a lottery ticket :05

Conflict/Reaction XCU **Resolve** MS

He scratches off the numbers on the ticket. :06

The ticket is a winner and he is now a happy man. :04

A-5 Final storyboard.

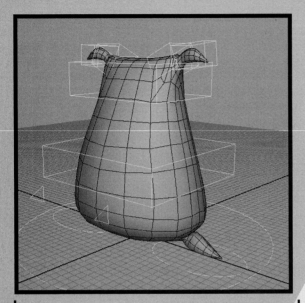

preparing your source reference material

4

 charting your course

With this chapter, you will move into the realm of true character animation. You'll work with a simple beanbag shape, endowing it with a personality and putting it through a range of separate attitudes. In this process, you'll begin to deal with the most effective ways of conveying ideas to an audience in visual form.

 goals

In this chapter, you will:

- Look at an exposure sheet.
- Learn how to import background images into Maya to use as reference for animation.
- Prepare to animate a rig against source images.

TOOLS USED

- **Multilister.** Reference images for an animation can be linked to a plane using the Multilister (see Figure 4-1).

figure | 4-1 |

Materials Editor.

- **Targa image files.** Maya likes Targa files and imports them easily (see Figure 4-2). We will learn the proper naming convention.

figure | 4-2 |

Targa files

- **Shaded view/hardware texturing.** You can see image files in your 3D work area when the right parameters are turned on in our window (see Figure 4-3).

figure | 4-3 |

Shaded
view/hardware
texturing.

● **The Attribute Editor.** The Attribute Editor contains details per-
taining to an object (see Figure 4-4). It is a file cabinet of links
and mathematical information.

figure | 4-4 |

The Attribute Editor.

Using a Beanbag to Express Some Physical Attitudes

You'll now be introduced to your "performer," a half-full beanbag that's able to assume a full range of forms that imply attitudes and emotions. Using a simple and direct line of action running through the form, you can express enough varying shapes to act out a simple storyline in pantomime.

Let's start with a series of thumbnail sketches to outline the story points of the presentation (see Figures 4-5 and 4-6).

figure | 4-5 |

Thumbnails 1–10.

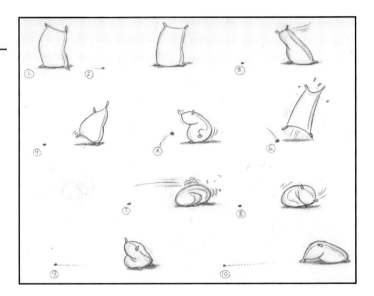

1. Here is your star, a respectable young beanbag named Clyde. You see him here in a "neutral" pose, waiting for the beginning of a situation in which he can perform.

2. A spider enters stage left.

3. The spider attracts Clyde's attention; he turns to take a look.

4. Clyde is curious and takes a cautious step to look at the spider.

5. The spider jumps toward him, perhaps realizing that the best defense is an offense.

6. Clyde reacts with a big "fright take" . . .

7. . . . and then zips into a crouch and cowers in terror.

8. After recovering a little of his nerve, he takes a tentative peek back at the spider.

9. The spider begins to walk away.

10. Picking himself up off the ground, Clyde watches the spider walking in the other direction.

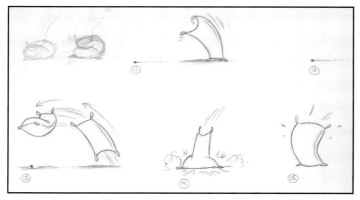

<figure>figure | **4-6**

Thumbnails 11–15.</figure>

11. Gaining courage, Clyde goes into "attack" mode . . .

12. . . . and then into anticipation . . .

13. . . . and then a lightening-fast leap into the air toward the doomed spider.

14. He lands with a hefty "stomp."

15. Having overcome his fears and defeated his foe, Clyde strikes the "hero" pose.

Now that you have a set of thumbnail poses to outline your story, it's time to begin the actual animation. The thumbnails were used in the actual process of animating the ideas. Each drawing will have a number indicating the number of frames that were assigned to it in the sequence (see Figure 4-7). The notation "x" means frames (example – 12x = 12 frames).

There are also charts on the right side of each drawing to indicate the way in-between drawings would be used to break the animation down to either one

figure | **4-7**

Timing chart example.

or two frames each, which is the standard for presenting full animation. As you learned in the first exercise with the bouncing ball, grouping drawings closer together slows them down, and spreading them further apart speeds them up. Therefore, when you want to slow a pose down enough to allow the viewer to see it clearly, you group the drawings very closely. The timing charts reflect that sort of spacing and allow you to replicate the motion on your own, even adding the in-between if you wish.

The marks along the bottom of each drawing (see Figure 4-8) allow for the proper registration of each succeeding drawing to the one before.

So here we go!

Drawing 1 is held for 24 frames. How can you tell? Look at the chart on the side of the drawing (see Figure 4-9).

figure | **4-8**

Drawing 57 timing chart.

figure | **4-9**

Drawing 1 timing chart.

figure | **4-10**

Drawing 25 timing chart.

Drawing 25 begins the movement of Clyde (see Figure 4-10). He has 18 frames until he hits drawing 43.

You'll notice that the poses from the thumbnail sketches were utilized and then "fleshed out" to describe the full movement for the execution of the ideas as an animated presentation (see Figures 4-11 through 4-46). Many times, with more complex characters, there will be a few sets of timing charts on your sheet. You may have them for hair, arms, legs, and body—as well as any other objects in the scene.

figure | 4-11 |

Drawing 1.

figure | 4-12 |

Drawing 25.

figure | 4-13 |

Drawing 43.

figure | 4-14 |

Drawing 57.

figure | 4-15 |

Drawing 67.

figure | 4-16 |

Drawing 75.

figure | 4-17 |

Drawing 79.

figure | 4-18 |

Drawing 87.

figure | 4-19 |

Drawing 95.

figure | 4-20 |

Drawing 99.

figure | 4-21 |

Drawing 109.

figure | 4-22 |

Drawing 113.

figure | 4-23 |

Drawing 117.

figure | 4-24 |

Drawing 121.

figure | 4-25 |

Drawing 129.

figure | 4-26 |

Drawing 143.

figure | 4-27 |

Drawing 155.

figure | 4-28 |

Drawing 167.

figure | 4-29 |

Drawing 179.

figure | 4-30 |

Drawing 189.

figure | 4-31 |

Drawing 199.

figure | 4-32 |

Drawing 211.

figure | 4-33 |

Drawing 219.

figure | 4-34 |

Drawing 223.

figure | 4-35 |

Drawing 229.

figure | 4-36 |

Drawing 235.

figure | 4-37 |

Drawing 249.

figure | 4-38 |

Drawing 255.

figure | 4-39 |

Drawing 259.

figure | 4-40 |

Drawing 261.

figure | 4-41 |

Drawing 265.

figure | 4-42 |

Drawing 267.

figure | 4-43 |

Drawing 269.

figure | 4-44 |

Drawing 271.

figure | 4-45 |

Drawing 273.

figure | 4-46 |

Drawing 275.

This exercise has demonstrated some basics of animation theory and has done it with a minimum of embellishment. Although the beanbag was a deceptively simple character presentation, it contains most of the elements that are fundamental principles in animation (see Figures 4-47 through 4-51).

figure | **4-47**

Drawing 277.

figure | **4-48**

Drawing 279.

figure | **4-49**

Drawing 283.

figure | **4-50**

Drawing 287.

figure | **4-51**

Drawing 291.

IMPORTING IMAGES INTO MAYA TO USE AS RESOURCES

First, make sure you are in the Animation module (see Figure 4-52).

You will find the images listed in Figure 4-52 on the enclosed CD. You now need to transfer these images from the CD to your animation file in Maya.

figure | 4-52 |

Thumbnail images you will import as a reference.

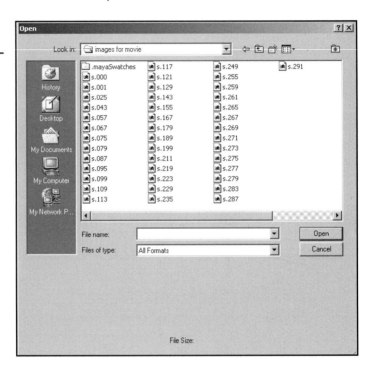

Notice how the images are named (see Figure 4-53).

figure | 4-53 |

Targa naming convention.

Each image is a Targa, beginning with a name (s), a period to separate, an image number (057), another period to separate, and file convention identification (tga) (see Figure 4-54).

s.057.tga

figure | **4-54** |

Maya needs sequenced image files to be named this way so that it can import the images in order. The name, S, identifies the target group of images. There period separates the group from the sequential placement. The number identifies the image place in the sequence. The text period separates the number from the file identity. The file identity identifies the format as acceptable to Maya.

The naming convention.

Create a plane by going to Create > NURBS Primitive > Plane (see Figure 4-55a).

figure | **4-55a** |

How to create a plane.

Rotate the plane 90 degrees in X so that it is visible in the Front window (see Figure 4-55b).

figure | 4-55b

Open the Multilister to create a shader by going to Window > Rendering Editors > Multilister (see Figure 4-56).

The plane in the Front window, rotated 90 degrees in X.

figure | 4-56

How to open the Multilister.

Create the shader in the Multilister using Edit > Create (see Figure 4-57).

figure | 4-57 |

Edit > Create.

A new interface window pops up called the Create Render Node (see Figure 4-58). Here it lists all the many shaders you can pick. These are outlined in our book entitled *Exploring 3D Modeling in Maya*. For your uses here, pick lambert because it has no highlight and thus is a flat shader.

figure | 4-58 |

The Create Render Node window.

After you have selected lambert, close the create render node window and look at your Multilister. A new icon is present. Rename this icon by double-clicking on the title lambert2SG and renaming it **Source** (see Figure 4-59).

figure | **4-59**

Rename the icon
Source.

Double-click on the Source icon to bring up the Attribute window (see Figure 4-60).

LMB on the black-and-white Checker icon to the right of Color to attach our series of animated reference images to the color channel of the shader (see Figure 4-61).

figure | 4-60 |

The Attribute
window.

Color figure | 4-61 |

The black and white
Checker icon.

You will then have the Create Render Node Window shown in
Figure 4-62, where you can select a texture for your node.

figure | 4-62 |

The Create Render
Node window.

LMB the File button in the right column, below the word Checker (see
Figure 4-63).

figure | 4-63 |

The File button.

Your Attribute Editor will reflect your selection (see Figure 4-64).
Under File Attributes, LMB-select the file icon to the right of Image
Name.

figure | 4-64 |

The Attribute Editor.

A new window pops up. This window is your navigator to the file holding your reference images (see Figure 4-65). LMB click on the file folder on the far right of Image Name. A new window will pop up (see Figure 4-63). Your images can be found on the attached CD under the heading for this chapter. I suggest you pull them off of the CD and place them in the source image folder under your project directory before completing this step.

figure | 4-65 |

The reference images.

Find your first image in the sequence and LMB-select it.

Select Open. You should see that image on your source node in the Multilister (see Figure 4-66).

The node with image attached.

Now you will need to make some changes in the Attribute Editor.

Make your Attribute Editor look like Figure 4-67 by selecting Use Image Sequence and Interactive Sequence Caching Options. Sequence Start is 1, and Sequence End is 291.

figure | 4-67 |

List Selected Focus Attributes Help

| file1 | place2dTexture1 | expression1 |

file: file1

Focus
Presets

Texture Sample

File Attributes

Filter Type Quadratic

☐ Pre Filter

Pre Filter Radius 2.000

Image Name G:\Maya_Animation_book\chapter 4\imag

Reload File Texture

☐ Use BOT
☐ Disable File Load
☑ Use Image Sequence

Image Number 1

Frame Offset 0

Interactive Sequence Caching Options

☑ Use Interactive Sequence Caching

Sequence Start 1

Sequence End 291

Sequence Increment 1

▸ Color Balance
▸ Effects
▸ UV Coordinates
▸ Node Behavior
▸ Extra Attributes

Activate the Front Window camera view in your main Maya inter-
face by clicking the LMB anywhere in the window. In the window,
select from the drop-down windows at the top:

Shading > Smooth Shade All

Shading > Hardware Texturing

Now attach the new shader to your plane. MMB-select the Source
icon that you just made from the Multilister window. Drag this
icon over to your plane, making sure to drop the icon onto the
actual geometry.

Close the Multilister window.

You should now see your plane with the image sequence attached (see Figure 4-68).

figure | 4-68

Plane with image attached.

Set your control playback window like Figure 4-69. Enter 1 as the first frame and 292 as the last.

figure | 4-69

Control playback window.

Press Play. You will notice that many of the images are blank. That is okay—you only want the key poses and a visual of the timing chart as your reference (see Figure 4-70).

Make a playblast of your front window view of the image plane and save it for reference.

SUMMARY

Reference imagery may not seem important to you now and certainly not worth all the trouble. However, as you get more experienced, you will find it invaluable. There is a character and looseness available in the drawn image that is tougher to conjure in 3D. Drawing is faster and easier to push. 3D can easily become stale without good thumbnails.

in review

1. What are thumbnail poses?

2. What is a timing chart?

3. If poses are close together, are they moving quickly or slowly?

4. What is the proper naming convention for a reference image if it is to be used as a sequence shader in Maya?

5. How do you key-frame a sequence shader?

↗ EXPLORING ON YOUR OWN

1. Thumbnail out an animation scene and determine the key poses. Make timing charts.

2. Draw a series of images and try to import them into Maya using the methods described in this chapter.

3. Watch animation on a frame-by-frame playback and re-create the timing charts for the scene. Make charts for hands, feet, facial movements, and clothing.

notes

View Shading Lighting Show Panels

persp

animating the flour sack

 charting your course

Theory and practice will converge in this chapter as you explore a basic Maya rig applied to a simple flour sack. You will learn to work with a variety of Maya controls. You will also practice editing your Graph Editor curves and reading timing charts.

 goals

In this chapter, you will:

- Gain exposure to a simple rigged puppet.

- Read Timing Charts.

- Master the advanced controls used on this puppet.

- Edit curves to achieve the principles of animation.

- Animate Clyde.

TOOLS USED

- **Inverse kinematics.** Inverse kinematics (IK) uses something called an end effector to move the bones. This is attached to a skeleton inside the character. It works like a marionette by attaching a string-like end effector to a skeleton. Imagine that an animator attaches a string to the hand of a puppet. The animator moves this string, and the puppet arm follows. The arm rises and bends according to where the hand is placed (see Figure 5-1).

figure | 5-1 |

Skeleton arm
animated with IK.

- **Graph Editor Transformation tools.** Maya 6 has introduced new tools for scaling and translating the Graph Editor curves. Transformation tools in the Graph Editor now let you work with a lattice to scale entire portions of curves (see Figure 5-2).

figure | 5-2 |

Transformation tools.

- **Sculpt deformer.** The sculpt deformer will be used to provide additional character details and squash/stretch (see Figure 5-3). The sculpt deformer is useful in displacing geometry that is difficult to deform within the rig.

figure | 5-3 |

Sculpt deformer tools.

INVERSE KINEMATICS

Open the file ArmIK.mb on the enclosed CD. This is a basic IK skeleton for an arm (see Figure 5-4). You are expected to animate it using inverse kinematics in this exercise. Late in Chapter 7 we will practice Forward Kinematics. There is a line present on the model itself and an IK handle in the Outliner.

figure | **5-4**

The arm with an IK handle.

First, select the ikHandle in the Outliner (see Figure 5-5). Go to the Camera view of the arm, and you will see a manipulator icon. Select the move tool from your toolbox. Move the manipulator (the IK handle) around with your LMB. Notice how the entire arm follows along.

figure | **5-5**

The IK Handle.

Enter values of **0** for Translates X, Y, and Z in the channel box(see Figure 5-6). Set a key frame at frame 1.

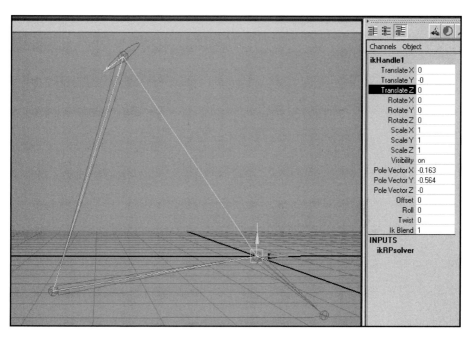

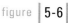

Go to frame 30 and enter a value of **4** for Translate X and **14** for Translate Y (see Figure 5-7). Set a key frame for the Translate Values.

figure | 5-6 |

Enter Translate Values.

figure | 5-7 |

Enter Translate Values.

Play the animation, and you will see a simple move of the arm. Notice how the elbow and upper arm follow the hand.

Close this file. You do not need to save it.

SCULPT DEFORMER

Open the file BallSS.mb on the enclosed CD.

There is an added control present in this skeleton that you have not seen before. It is called the sculpt deformer. It looks like a sphere (see Figure 5-8). Look in the Outliner. You will see an item called sculptor1 and another called sculpt1StretchOrigin.

Sculpt Deformer.

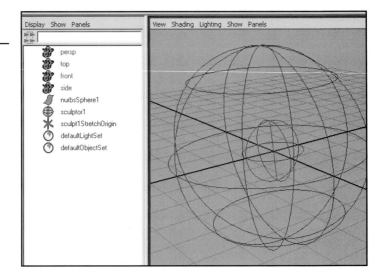

| NOTE |

Select sculptor1. Use the Scale tool and enlarge the icon so that it is no bigger than the original sphere in your Camera view. See how the sphere reacts? Now move the icon left and right using the Translate tool. The sphere distorts when the icon crosses the exterior of the sphere.

Experiment with this control by setting key frames for it.

Close the file.

Clyde the Flour Sack

Open the file FlourSack.mb on the enclosed CD.

This is a fully rigged puppet to accompany the following material (see Figure 5-9). This rig employs the advanced animation tools explained at the beginning of this chapter.

Close the file FlourSak.mb. Open the reference file you made in the last chapter. If you don't have this file, open and use Animation reference.mb on the enclosed CD. Make sure each of your camera views is set to Smooth Shade All and Hardware Texturing (see Figure 5-10).

figure | 5-9 |

FlourSack.mb.

figure | 5-10 |

Camera view port
set so that you can
see the images.

Clyde and the Spider

Enter 300 as your playback end time and final end time (see Figure 5-11).

figure | 5-11 |

Playback end time
and final end time
set to 300.

Set the automatic key-frame toggle to "on" (see Figure 5-12). If is on if it is red. You will go ahead and set a key frame for every animatable channel in this exercise. In this chapter, you should be more concerned with understanding poses and how to create a successful in between.

Make sure your curve tangents are set to Linear and Stepped with weighted tangents, as in the bouncing ball animation (see Figure 5-13). Make sure Auto Key is set to Key All Attributes in the Animation preferences Dialog box.

figure | 5-12 |

The automatic key-
frame toggle turns
red when it is on.

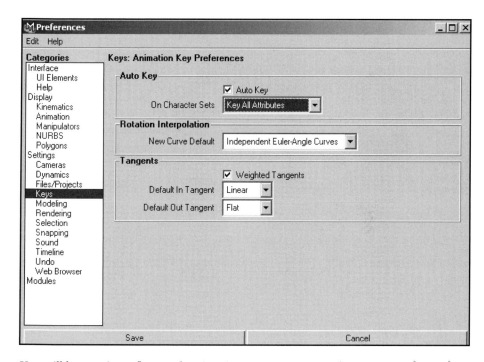

You will be creating a flour sack animation to express some physical attitudes.

Your setup should look like Figure 5-14.

figure 5-13

The Preferences window.

DON'T
GO THERE!

You do not need to use the same rig for every scene in an animation.

Very often, several rigs will be available for one puppet. Animators will work closely with riggers to create characters that can perform the movement requested by the director. Rigs may vary from shot to shot, depending on the movement required.

There are many ways to rig a puppet, and you will experience ones that work—and ones that break.

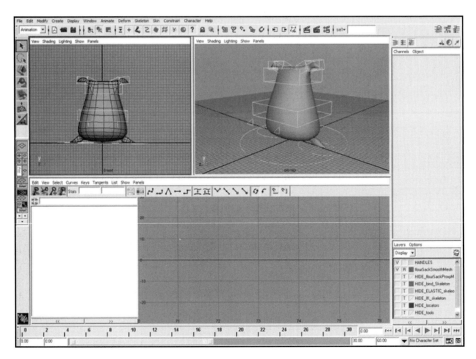

figure | 5-14 |

Window Setup.

Locate the file FlourSak.mb you had open earlier. You will import the flour sack into your present scene using the File > Import command (see Figure 5-15).

figure | 5-15 |

Import Clyde.

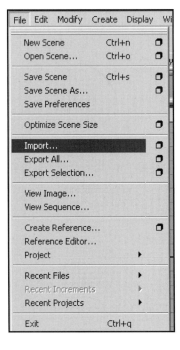

Import the file (see Figure 5-15) and locate it in your directory.

Press open. Your window should now look like Figure 5-16. You have just imported Clyde the sack and are now able to work with him against the reference images you imported in the last chapter.

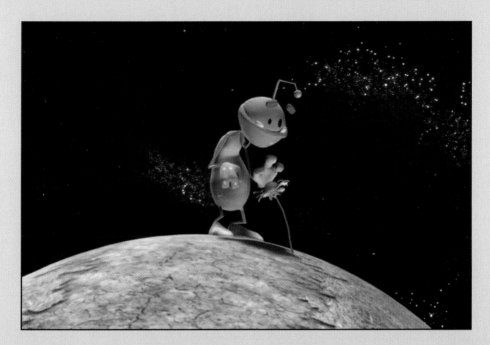

figure |1|

Benjamin Willis created "Quark" in Maya. Quark has been featured in many film festivals.

figure |2|

figures | 3–6 |

Mathew Munn created this thumbnail of action in Maya.

figure | 7 |

Mathew often reuses his characters in different acting scenarios.

figure |8|

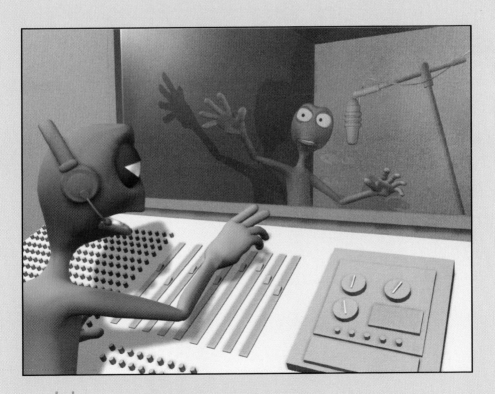

figure |9|

Mathew Munn won the 10 Second Club contest on www.10secondclub.com for the month of December with this entry.

Elden.

figure | 10 |

DUSTIN●RYLAND

figure | 11 |

figure | 12 |

Here we have storyboards (Figure 11) and final art based on the storyboards (Figure 12). Andrea Lira creates textures outside of the computer, then scans them. She imports them as textures onto flat planes in Maya to create an interesting collage effect. The end result looks a lot like cut-out animation.

Patricia Beckmann worked with Mark Mothersbaugh from the rock band DEVO to create an animation based on Mark's art. Mark is a wonderful visual artist (as well as a musician) and paints gorgeous mixed media/textural paintings. Much of his work was scanned and captured into the animation shown in Figure 13. You can see it online at http://www.mutato.com/mindlessbob.html.

Figure 14 is a sample of the original art (by Mark) that was used as reference for the animation.

figure | 15 |

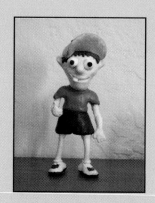

figure | 16 |

figure | 17 |

figure | 18 |

figure | 19 |

figure | 20 |

Mark Gelfuso wanted a childlike look for his characters. He created character studies as drawings and maquettes prior to modeling them in Maya. He then created storyboards with low-resolution models, building up the look slowly as he worked with his characters.

figure | 21 |

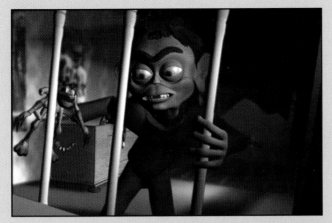

figure 22

figure 23

figure 24

Ryan Campbell created a dark animation about children learning to pattern themselves against others.

figure | 25 |

figure | 26 |

figure | 27 |

Patricia Beckmann uses a variety
of styles in her work. More of her
projects can be seen at
www.bunsella.com.

figure | 28 |

figure | 29 |

Jian Cui created these storyboards for an adaptation of "The Princess and the Pea."

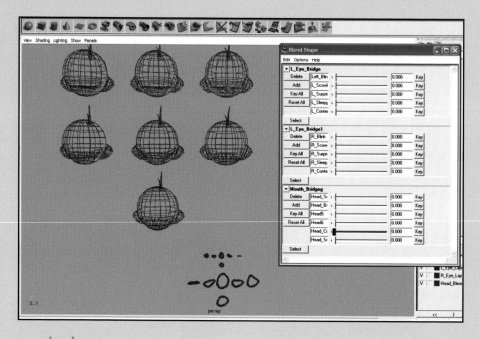

figure | 30 |

figure | 31 |

Sean Danyi created a delightful simple character using deformations. The heads in the Maya interface picture are obviously the character, but below them you can see ring-like shapes. These are the eyes of the character. "Billy" is the name of the character featured in the short.

Samir Lyons used the Generi rig to create this hilarious animation about skateboard punks. He used original music from his band for the soundtrack.

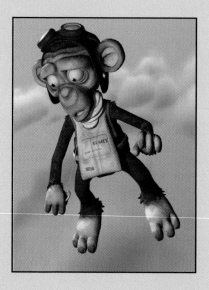

figure | 35 |

figure | 36 |

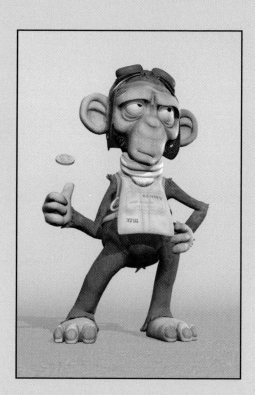

Travis Gentry created this very fun monkey animation. Notice all of the expressions on his head deformations. More of his work can be seen at www.travisgentry.com.

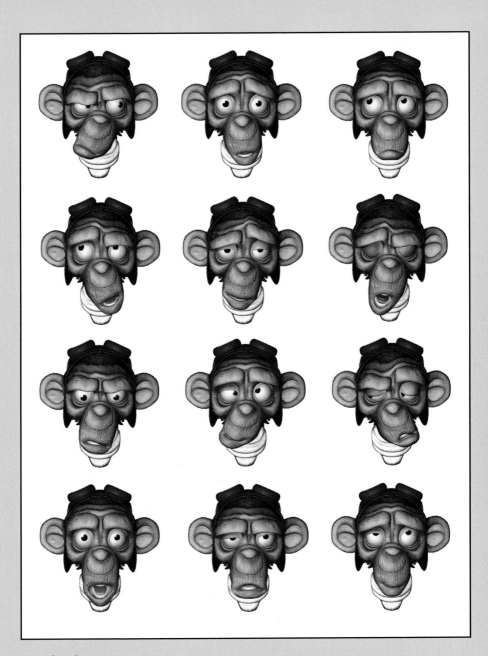

figure 37

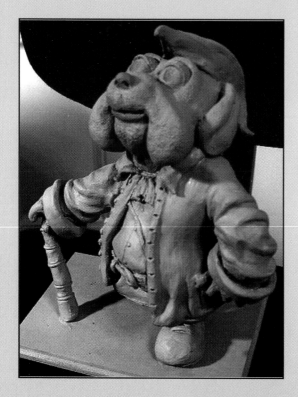

figure 38

figure 39

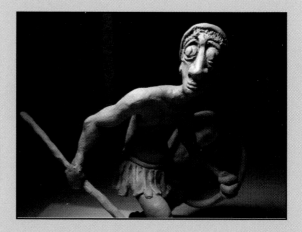

Sean Palmer created these two
maquettes out of clay as character
studies. Jean Petite is the dog-like
character, and Trojan is the other.

figure | 40 |

Kishore Vijay created these thumbnail
sketches of expressions for his tiger.

figure | 41 |

figure | 42 |

Here are Kishore's studies of an old man. First he
created him in sculpey, then in Maya.

figure | 43 |

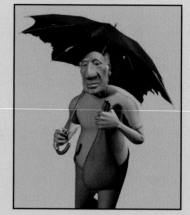

Kedar Dagade created
these old man studies.

figure | 44 |

figure | 45 |

Kevin Williams drew this sample layout page.

figure | 46 |

figure | 47 |

figure | 48 |

figure | 49 |

Scott Wells is working on this art for his thesis about children and grief. More of his work can be viewed at www.animax.com.

figure | 50 |

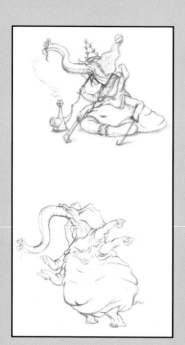

figure | 51 |

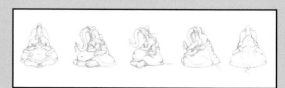

figure | 52 |

figure | 53 |

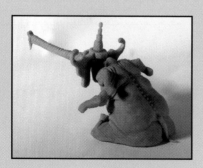

figure | 54 |

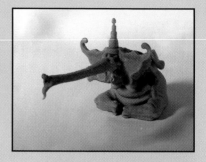

figure | 55 |

figure | 56 |

Scott Wells uses Asian, Indian, and Celtic influences in his character design. Here are studies of an elephant character.

figure | 57 |

figure | 58 |

Here are concept sketches for the thesis film that Scott Wells is creating.

figure | 59 |

figure | 60 |

figure | 61 |

figure | 62 |

figure | 63 |

figure | 64 |

figure | 65 |

figure | 66 |

SAVANNAH COLLEGE OF ART AND DESIGN PRESENTS A DAMITRA PRODUCTION

MOTEL 4

figures | 67–75 |

Three weary travelers stop at a motel for the night, only to find there are no vacant rooms to be had. With some persuasion, the old motel clerk puts the three up for the night in his room, the cellar. Lit only by candlelight, the three turn in for the night. Realizing the candle is keeping them from a good night's sleep, each has a go at blowing it out.

These are images showing the
progression of the Old Man's character
design.

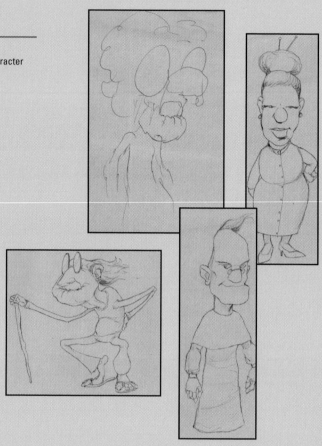

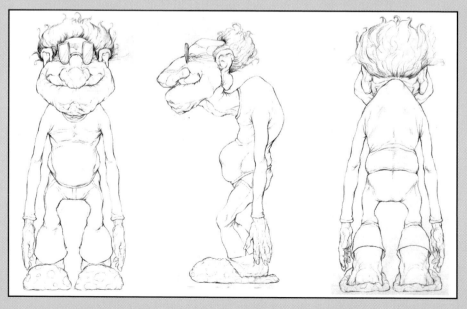

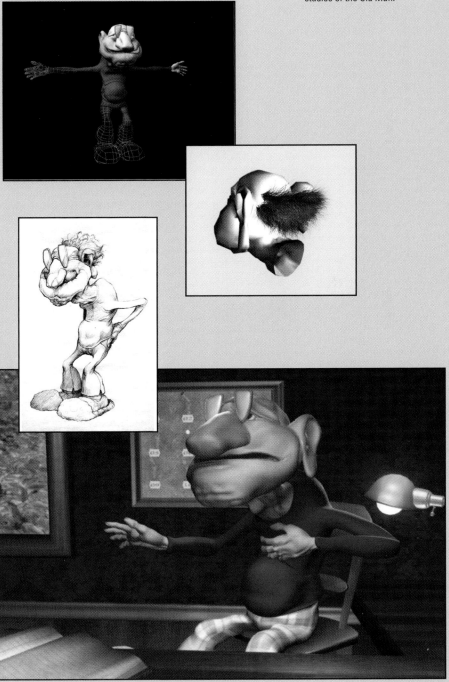

These are additional character studies of the Old Man.

figure | 87 |

figure | 88 |

The 3D animatic is an important reference guide. It is always good to go back and compare original storyboard ideas against the animatic to see if certain shots are going to work. These pages show a couple of examples where the original idea held up throughout the entire production and one where there were some camera shot changes.

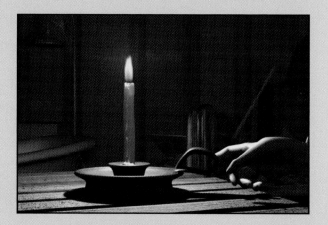

figure | 89 |

figure 90

figure 91

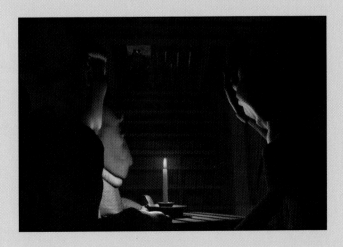

figure 92

figure | 93 |

Josh Burton created this short, called "Much Ado," in Maya. He used a number of traditional animation techniques to create the movement, completing several pages of storyboards and character design before beginning production.

figure | 94 |

figure | 95 |

figure | 96 |

figure | 97 |

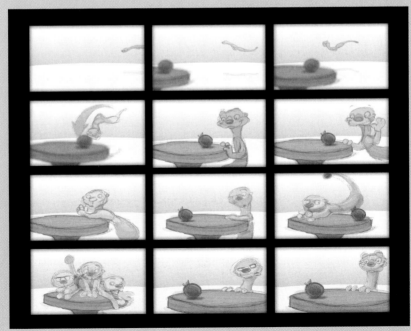

figure | 98 |

figure | 99 |

figure | 100 |

figure | 101 |

figure | 102 |

figure | 103 |

Ricardo Tobon created "Luka's Hat" as the visual component of his M.F.A. thesis. He experimented with limited animation techniques commonly used in television animation. He used Maya vector rendering to obtain a cartoon-like look. The characters were rendered with outlines—and the background without—so one would stand out more than the other. The character only produced shadows on the ground to keep things visually simple.

figure | 104 |

figure | 105 |

figure 106

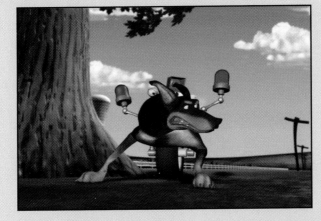

figure 107

figure 108

Marty Clayton created Gumshoe with a team of graduate students as part of his thesis. Gumshoe is half dog and half machine. Here we see him on the job as a traffic cop. Marty created this piece for a children's programming pitch.

figure | 109 |

Christoph Malessa created this dancing frog character. You can see the work in action at www.malessa.de.

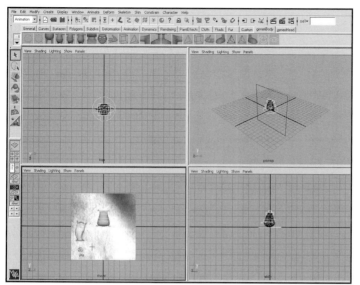

figure | 5-16 |

Ready to begin.

Zoom in to Clyde and check out his controls (see Figure 5-17).

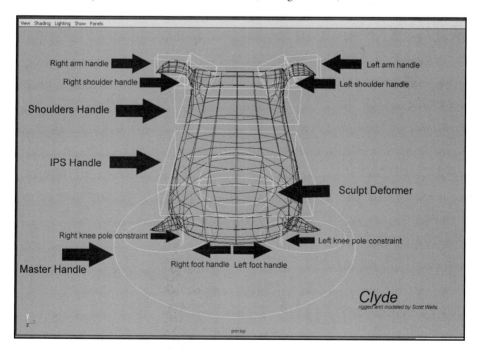

Right arm handle
Right shoulder handle
Shoulders Handle
IPS Handle
Left arm handle
Left shoulder handle
Sculpt Deformer
Right knee pole constraint
Left knee pole constraint
Master Handle
Right foot handle Left foot handle

Clyde
rigged and modeled by Scott Wells

persp

Open the Outliner, and you will see the names of these controls (see Figure 5-18). When you see a + or – sign in front of an item in the outliner, this means it is part of a hierarchy.

LMB on a + sign to see all elements.

figure | 5-17 |

Clyde and his controls, modeled and rigged by Scott Wells.

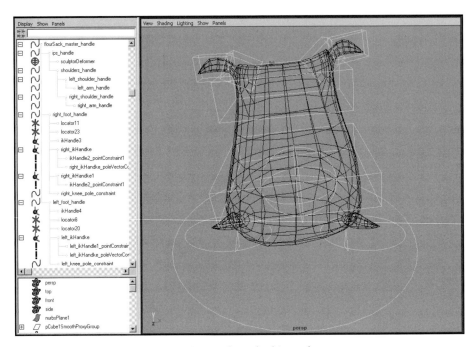

figure | 5-18 |

Controls represented in the Outliner are identified by Curve graphic.

LMB on a – sign to close the hierarchy.

Use the shift key and LMB to open the entire hierarchy at one time.

The sideways S-curves preceding the names represent the handles you should animate with. Do not animate any of the other objects. The main control you will see is **flourSack_Master_Handle**.

figure | 5-19 |

The main control flourSack_ Master_Handle.

To see the entire hierarchy of the puppet, use Shift + LMB over the little plus sign preceding the name "**flourSack_Master_Handle**." You will now see the whole tree (see Figure 5-20). A lot of elements go into the creation of a puppet.

figure | 5-20 |

The whole tree.

You won't need to select your controls from the Outliner. You can select the controls off the puppet itself. You can select the animatable elements directly in the puppet interface. See the boxes over each of the limbs? You can select these and rotate or translate them. Select the boxes to animate this puppet. Make sure you are in object mode, and that your Channel box is open. The Channel box will reveal the attributes available for the handle. You can either plug mathematical values into the channels or you can interactively move the handle. If you want to scale a handle, and Scale is not in the Channel Box, you cannot scale. You can only do what is offered in the Channel Box.

Master handle: The master handle moves the entire puppet. This handle should not be animated. This handle exists so that you can accurately place the fully animated puppet into your scene. When

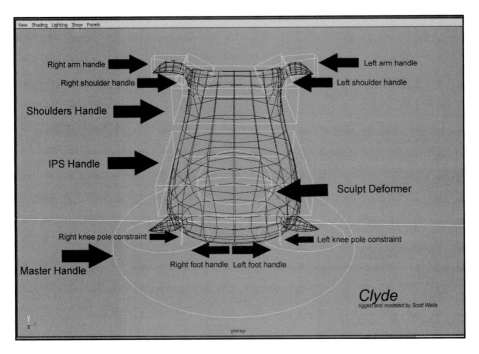

View Shading Lighting Show Panels

Right arm handle → Left arm handle

Right shoulder handle → Left shoulder handle

Shoulders Handle →

IPS Handle →

← Sculpt Deformer

Right knee pole constraint → ← Left knee pole constraint

Master Handle → Right foot handle Left foot handle

Clyde
rigged and modeled by Scott Wells

persp

figure | 5-21 |

Clyde and his
controls, modeled
and rigged by Scott
Wells.

you are done animating, you will be able to import the entire animated puppet into whatever scene file you want.

IPS handle: This is the handle you should use to move the puppet in space. Because it is the main control, it is the first handle you adjust when animating a puppet. Whether up and down or in x, y, z space, this is the correct handle to animate for full puppet motion because it is the parent in control of the shoulders and ears.

Shoulders handle: The shoulders handle moves the upper torso of Clyde. This control is a child of the hips, meaning that it is below the hips in the hierarchy and thus affected whenever the hips are moved.

Sculpt deformer: The sculpt deformer is used to flesh out an area that may be stretched out by a pose. The sculpt deformer acts like air in a balloon. It can inflate an area if placed properly. It needs to be placed within the puppet to work. It can be left outside of the puppet when you don't need it. It requires key frames like any other handle.

Shoulders handle: This will give you control over the shoulders, or the "head" of the puppet. It will not affect the lower extremities. The arm handles are parented to this shoulder handle, so they move whenever the shoulder is moved.

Right/left shoulders handles: These controls let you move the arms of Clyde. They are parented to the shoulders and move when the shoulders are moved.

Right/left arm handles: These controls let you move the outermost arms of Clyde. They are parented to the shoulder handles and move when the shoulders are moved.

Right/left foot handles: These handles move Clyde's feet. They can translate and rotate. When they are key-framed, they are constrained to an area in space and do not move when the rest of the body is moved. Successful positioning of the feet relies heavily on the correct placement of the right and left knee pole constraints.

Right/left knee pole constraints: These constraints tell the knees where to point. They are necessary for keeping the geometry in the right place when animating.

Go to frame 1 in the timeline. Select the reference plane and move it upward so that the first drawing of Clyde sits on the graph line and Clyde is lined up (see Figure 5-22).

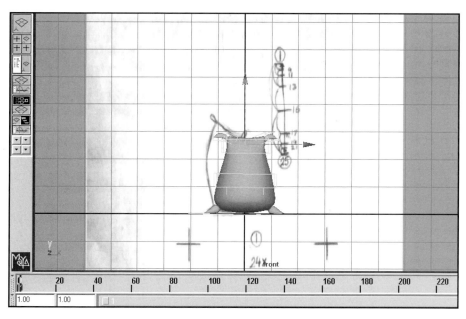

Notice at the bottom of the reference image that a timing notation has been specified. The key framer wants this animation to run at 24 frames per second (24x = 24 frames per second).

figure | 5-22 |

Lining up the
reference plane.

figure 5-23

The Preferences icon.

You need to make sure your animation is timed correctly, so go to the Preferences and check. Select the Preferences icon in the lower right of the interface (see Figure 5-23).

This will open up a new interface window (see Figure 5-24).

Make sure your interface looks like Figure 5-24. Be sure to select 24 fps as the playback.

figure 5-24

The Preferences window.

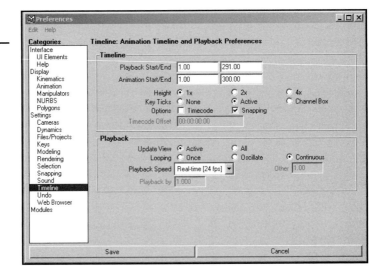

Set up your Maya interface like Figure 5-25 to make the maximum use of your "real estate" (the viewing space on your screen). You want to be able to see all the controls influencing your movements while you work. Refer to Chapter 3, The Bouncing Ball if you have forgotten how to do so.

Now you are ready to make Clyde shake, rattle, and roll!

First, Check Out the Controls

The sculpt deformer is used to add "meat" to the puppet when poses stretch it too far out. Open the file Clyde_deformed.mb on the enclosed CD. This contains Clyde in a pose that could benefit by the use of the sculpt deformer (see Figure 5-26).

The reference image shows Clyde in a very rubbery pose. This is often hard to achieve with puppets when just using the basic rig. Fortunately, this rig was built with squash and stretch, and you have access to a sculpt deformer.

figure | 5-25 |

The proper setup for this tutorial.

figure | 5-26 |

The sculpt deformer used on Clyde.

figure | 5-27 |

LMB click over
the V.

Go to reference image 57, on key 57. Look at this scene and see how Clyde is posed. Turn off Clyde's visibility by going to the Layers box and turning off the V next to the Flour Sack smooth layer (see Figure 5-27).

The image gives Clyde a little meat up in the facial area. Turn Clyde's visibility back on.

Go to the perspective view and select the sculpt deformer. It is a large sphere inside Clyde.

Make sure you are using the Move tool

Move the sphere left and right, away from Clyde (see Figure 5-28). Notice how Clyde shrinks and grows in response to the sphere?

figure | 5-28 |

Clyde with and
without the sphere
deformer.

Move the sphere around Clyde and notice the influence. Scale the sphere up and down.

This will assist you in shaping the puppet when the skeleton deforms Clyde too much.

The left and right knee pole constraints are very important. They are used to point the knees of Clyde in the correct direction. If they are out of place, the puppet will crease or fold over itself (see Figure 5-29).

Posing Clyde

The main control you will use with this puppet is the ips_handle. You will pose this first and then follow with the feet and then the shoul-

figure | **5-29**

Poorly placed knee pole constraints.

ders. Then you do the ears. You never use the flourSack_master_ handle. That is only used for placing the character into a scene.

You will begin by posing Clyde against the reference picture (see Figure 5-30).

figure | **5-30**

Reference picture 1.

Clyde has a nice lean to him in the first image. Begin by selecting the IPS Handle and sliding it left (see Figure 5-31).

Then slide the feet left a bit to line up with the feet in the image by selecting each foot handle individually. Also select and rotate the shoulders handle until the figure looks like Figure 5-32.

figure | 5-31 |

Slide the IPS handle left.

figure | 5-32 |

Clyde in stance.

TIP

If you find that your manipulator icons are too large or too small, go into your Preferences and change them. Go to **Window > Settings/Preferences > Preferences.**

In the new window, select Manipulators from the sidebar and then scale down the global scale to about .5 (see Figure 5.34).

figure | 5-33 |

The path to your
Preferences.

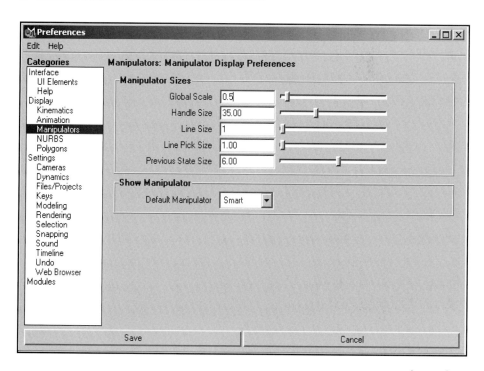

figure | 5-34 |

Preference settings.

Now go to the shoulders and arms. Give Clyde a little bit of attitude. He is a confident guy, after all.

Now select each handle independently and set a key frame for it. In the Channel Box, select every channel that you want to animate and then RMB over the channels to set a key frame. Remember this from the bouncing ball chapter?

Look at your Graph Editor. You should see curves started for every item for which you have set a key frame. These beginnings are demonstrated by a small black dot on the graph at frame 1.

Go through every key pose and set up Clyde against the reference image. Be sure to move to the selected frame in your timeline before setting the pose. (You will be forced to get into this habit, as the reference image will not appear unless you move to the selected frame.) Make key frames for each pose on every handle, even those you don't move.

Staging

You will find reference images on these frames: 1, 25, 43, 57, 67, 75, 79, 87, 95, 99, 109, 113, 117, 121, 129, 143, 155, 167, 179, 189, 199, 211, 219, 223, 229, 235, 249, 255, 259, 261, 265, 267, 269, 271, 273, 275, 277, 279, 283, 287, 291. Set key poses on all of these frames.

While you are setting these poses, study them. They all give the viewer a piece of information. No pose should be wasted. Think of animation as a silent film or newspaper cartoon—most story-telling is done with the pose.

If you ever get into trouble, you can zero out the numbers in the Channel Box to get back to the starting position (see Figure 5-35).

As a final housekeeping step, go to **Edit > Delete All by Type > Static Channels** (see Figure 5-36).

This cleans up your Graph Editor by deleting any unanimated curves from the editor. The procedure saves you time editing and in the final render.

Now make a playblast. Select the window view you want to see the animation in, and use the command **Windows > Playblast (options box).**

figure | 5-36 |

The command to
delete channels with
no animation.

Set your controls as in Figure 5-37, but create a new path for the output of the file. You will find your movie in this file after it is created.

figure | 5-37 |

Playblast interface.

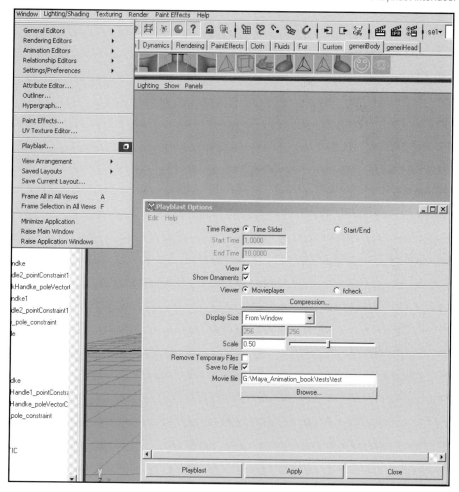

You can play the file through any of your movie players on your computer.

Save your file. Save another copy and name it **version 2**. Work with version 2 on the next assignment.

Timing Check

Now that you have entered all the key poses, you must do a timing check to see if it "reads." In production, this would be the point at which you wave down the director and get his input on the scene. If he gives you a thumbs up, it is on to the next step.

Suppose you don't get a thumbs up? Well, editing is easy at this stage because your curves are all stepped. Revisions won't be as painful here as they will be when you have set the arcs of your motion curves.

Let's try a little editing. Make sure you have saved a version of your file with a different name before trying this next step.

Editing Curves 101

We will use this time to experiment with editing. Open up the file practice_editcurves_start.mb on the enclosed CD—or, use your file from the last exercise.

Editing the Slow Out, Fast In

Here you will practice creating in-betweens between two poses.

This is where those scribbled notations on every reference image gain critical importance. These are the timing references.

Look at the two timing charts in Figures 5.38 and 5.39.

These timing charts are notations on the timing and spacing of the scene. They are frequently the only communications you will receive from the animation director.

As previously mentioned, objects that are closer together over a series of frames appear to be moving slower than a series of objects that get farther and farther apart over a series of frames.

figure | 5-38 |

Frame 99.

figure | 5-39 |

Frame 109.

At frame 99, you see notations for frames 99, 101, 103, 105, and 107. 99 is the first key pose, and 107 is the last key pose. Any tick halfway between these two poses represents a character pose exactly halfway between the two keys. Which frame does this happen on? 107. Why? Because frames 101, 103, and 105 are used to ease into the halfway point, which is 107.

Which frames are closer together on the chart? Frames 99, 101, 105, and 107. What is the next farthest? Frame 107 and then 109. This tells you that you are going to animate the key frames with a slow out and a fast in. Why? Because the first five frames are slowly approaching the midpoint position.

Frames 101, 103, and 105 are not evenly spaced either—look at how they gradually ease away from each other. This is called a slow out. The image will change only slightly from frame to frame.

Because there are no keys between the midpoint and 109, this is called a fast in. The image changes greatly between these two frames.

Now look at the second graph. This graph just represents three frames. Two key poses and one in-between. This in-between is directly between the two key poses.

Select the ips handle. Now go to the Graph Editor. Select all the curves for the ips handle by drawing a marquee around the curves (see Figure 5-40).

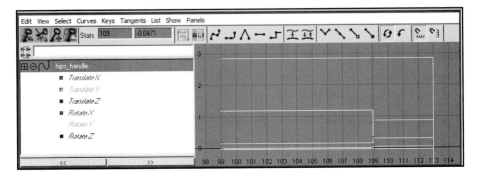

figure | **5-40** |

Stepped curves.

In the drop-down menu bar of the Graph Editor, select **Tangents >
Clamped** (see Figure 5-41).

Your curves will change.

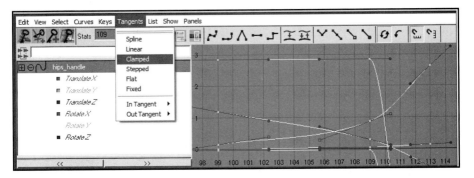

figure | **5-41** |

Linear curves.

Do this to every handle. Once the entire puppet is changed to lin-
ear, play the animation. This will give you a rough idea of your tim-
ing. Play it frame by frame to make sure you have no crossing
geometry. See the file practice_edit_curves.mb if you have any
questions.

Now let's go back to the timing charts.

Look at the timing chart for 99. You are told here that Clyde has a
slow out. Knowing that the left side of the Graph Editor represents
value and the bottom numbers represent time, a slow out means
the graph curve will stay close to the original value as it passes
through time. Also happening during this slow out is a furiously
quick stepping motion in the feet.

You will first work with the lps handle. It appears that the most
noticeable movement is in the X Translate curve. This is the first
thing you will modify.

Select the key frame at 99 for the X translate curve. Break the tangent (see Figure 5-42).

figure | **5-42**

Now select the outgoing tangent, the red bar leading from the key frame. Select the Move Nearest Key Picked tool and use the MMB to move the out tangent (see Figure 5-43).

The Break Tangent tool.

The curve needs to be close to the initial value until it reaches 107, then rise sharply. Right now, this process is not enough. You need to use one more tool. Make sure the X tangent key at 99 is selected and then press the Free Tangent Weight tool.

figure | **5-43**

Your tangent bar will appear different—it now has a square box on the tip. Select this box and pull. You can now make a much more efficient curve between the two key frames. An example is shown in Figure 5-45.

The Move Nearest Key Picked tool.

This example also broke the tangent at frame 109 and used the Free Tangent Weight tool to get this curve.

figure | **5-44**

Next, you will work on the shoulder handle. The shoulders move down and to the right. Which curves would this motion require?

The Free Tangent Weight tool.

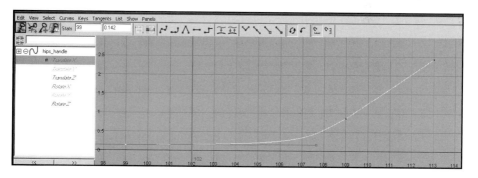

The correct answer is the Y Translate and the X Translate. You will edit the curves to look like Figure 5-46, to represent the slow out.

figure | **5-45**

Spline with weighted tangent edited.

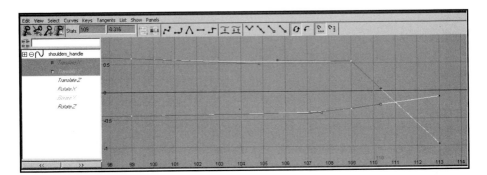

figure | **5-46** |

Curves for X and Y
Translate on the
shoulders handle.

The next handle will be the right foot handle. Most of this handle's movement is also in X, Y Translate. The curves look like Figure 5-47.

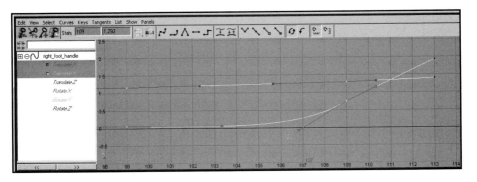

figure | **5-47** |

Curves for X and Y
Translate on the
right foot handle.

Here is the left foot handle (see Figure 5-48). Again, the X and Y Translate.

Do the same process on the L/R arm and L/R shoulder handles.

The next timing chart represents an even interpolation between frames. I like that. Since all the curves are linear, your work here is done. Linear curves create, by default, an even staging between frames. See the preceding to check out my curves.

Animating the Flipper Feet

Look at the key pose on frame 109. Those feet are moving very fast. You can animate these separate from the preceding curves, now that you have all the geometry in place. Check with your director

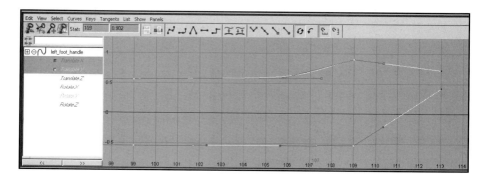

figure | **5-48**

Curves for X and Y
Translate on the left
foot handle.

to make sure of his intent with the sketch and then proceed with
your interpretation. You do not have to do it just like this, but read
it as an example.

Start the feet moving at frame 104 to give Clyde a chance to ease
out of his shock pose. First, go to your animation Preferences and
change your tangents in and out to Clamped (see Figure 5-49).

figure | **5-49**

Change tangent
values to Clamped.

Begin with the right foot handle and set a key frame for all values
in the Channel box at frame 103. This is so that the next key frame
you create does not influence the previous curve as much.

Set poses at frames 104, 105, 106, and 107 of the foot rotating in a
circular arc (see Figure 5-50).

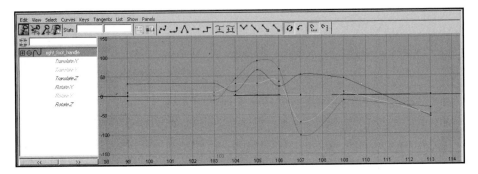

figure | 5-50 |

Right foot handle
curves.

Then move to the left foot handle and set a key frame for all values in the Channel Box at frame 103. Set poses at frames 104, 105, 106, and 107 of the foot rotating in a circular arc (see Figure 5-51).

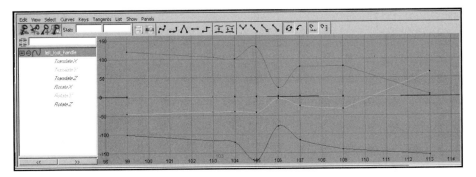

figure | 5-51 |

Right foot handle
curves.

Create a playblast and check with your director for approvals.

From here on, do further tweaking based on notes you get from your director. More than likely, he will request an additional extreme pose at frame 111 to accentuate the speed and loss of balance. Check your work against practice_edit_cuves_final.mb on the attached CD.

More Ways to Edit in the Graph Editor

Suppose your director wants the entire scene to slow down. Argh— do you need to redo all of the key frames?

Select all your handles. The names show up on the left hand of the Graph Editor (see Figure 5-52). Every animated curve on all of these handles shows up on the right in the Graph Editor.

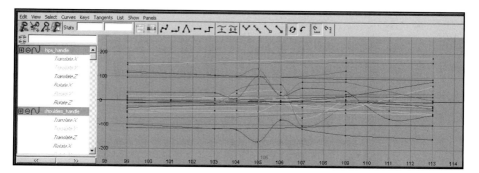

Now turn on the Scale tool by going to **Edit > Transformation Tools > Scale Tool (options box)** (see Figure 5-53). Make sure "manipulator" is checked in the options box.

figure | **5-52**

Graph Editor with curves.

figure | **5-53**

The Scale tool.

figure | **5-54**

A box surrounds all of the curves (see Figure 5-54).

The Scale tool in Graph Editor.

If you LMB-drag on one of the circles in the scale box, you can scale the values of the curve up and down.

Now your director wants one part of the animation to be offset from the rest.

You can use the lattice tool to scale the animation curves to offset frames (see Figure 5-55). This is a quick and dirty way to do it, under the pressure of deadline. For high-quality work, pick and choose the offset animation manually. There *is* a method to the madness, and you can tell when an animator does not know the method. Go to **Edit > Transformation Tools > Lattice Deform Keys Tool (options box).**

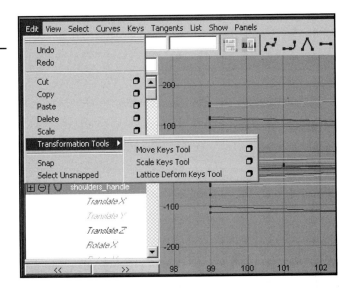

figure | 5-55 |

The Lattice Deform Keys tool.

This places a lattice around all of your key frames. Each circle on the lattice can be moved to adjust the curves beneath it. You can adjust how many sections are available in your lattice by adjusting the Columns and Rows in your Lattice tool options box. (See the right of the image.)

SUMMARY

Congratulations! You have animated your first multihandle puppet down to the slow out of the curves. Now you have a 300-frame scene. Practice your new skills by finishing the animation against the reference images.

Once you are done, let another pair of eyes see it. Look for floaty movement. If something looks like it is moving too evenly, check the curves.

The chief mistakes apparent in a beginner piece of CG animation are as follows:

- **Floaty movement.** This often is caused by simply changing your curve tangent to Spline after setting the key poses with Step. Major beginner mistake.

- **No weight.** This often caused by not animating the slow in or fast out as required by the action and a lack of follow-through. These curves are crucial to establishing weight.

- **Too many poses.** The character flies around the scene with no set purpose. The arms flail, the eyes wander, all because the animator wants to avoid making the puppet appear static. There are other ways to do this, which you will explore later.

- **Too many key frames:** You ought to be able to read the action in your scene just by looking at your curves. Too many key frames dirty the curve, making it jump and kitter when it is meant to be a smooth arc. If you can edit the curve with the handles to achieve the motion, do it—avoid excessive key framing.

> ▶ **TIP**
>
> When the reference images of Clyde go below the line, this means Clyde must move forward in Z space. Do no move Clyde below the line—he will appear to go through the floor.

in review

1. How do you set a key frame on just one channel?

2. Which handle is the main handle to animate with Clyde?

3. Which handle is saved for when the puppet is imported into another scene and needs to be repositioned?

4. What does a translate curve with a slow out and fast in look like in the Graph Editor?

5. When you first block out the animation with key poses, what should the default curves be set to? Should they be weighted or unweighted?

6. When you are ready to decide the speed of the curves, after setting the key poses, what should the curves be changed to?

7. What is inverse kinematics?

8. What is a sculpt deformer?

9. How do you delete curves that have no animation on them?

↗ EXPLORING ON YOUR OWN

1. Finish setting key poses for the entire 300 frames of animation.

2. Edit the curves leading into each pose. Choose which curves represent the most movement and animate those first. Make sure to pay attention to the timing charts.

3. Import images captured off of old cartoons and animate against them to learn timing.

notes

ADVENTURES IN DESIGN

AID2/MAKING THE ANIMATIC

In this exercise, you will adapt your storyboard to After Effects, making a moving animatic as the skeleton of your short. An *animatic* is a moving storyboard with sound, a movie that helps you decide the length of your shots before you commit to animating sequences. It is imperative that you create this before beginning a short film—it can save you a ton of work!

I encourage you to learn After Effects or any other compositing program, as you must be able to edit your movies and add titles and credits once you

have animated them. I am going to assume a basic understanding of the software in this exercise, as compositing in After Effects requires a whole book in itself. Learn to render in passes and composite your elements. This way, you will only have to re-render elements that need improvement, instead of entire shots.

Begin with a storyboard on paper.

Scan each panel as a separate image. We will bring these images in one by one to After Effects.

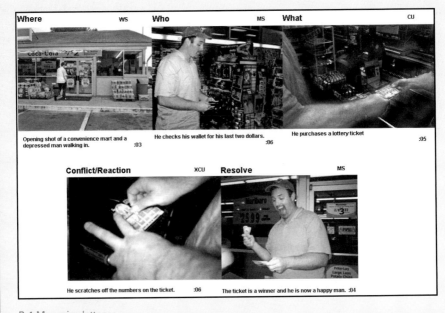

Where WS Who MS What CU

Opening shot of a convenience mart and a depressed man walking in. :03

He checks his wallet for his last two dollars. :06

He purchases a lottery ticket :05

Conflict/Reaction XCU Resolve MS

He scratches off the numbers on the ticket. :06

The ticket is a winner and he is now a happy man. :04

B-1 Man wins lottery.

B-2 Creating the :24 composition in After Effects.

Open After Effects.

Set up your composition so that it is long enough to contain the timing of your intended animatic. Our example is :24.

Import the five scans that make up your five-panel storyboard. After importing, they will appear in your Project folder.

Place them on the timeline. Adjust the timeline for each shot, to match the timing you created in the initial storyboard.

Import the soundtrack and place it into your timeline. I have found that sound created as a .wav works best.

Render the movie.

You now have a basic animatic for production. As you create shots, render them out and replace the storyboard drawings/photos in your animatic with the new images. Your film will then create itself, and problems can be spotted before committing too much work to a shot.

B-3 Images appear in the project folder.

152

B-4 Images placed in the timeline corresponding with the time allotted for each shot.

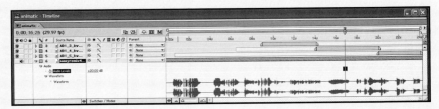

B-5 Audio imported into the timeline.

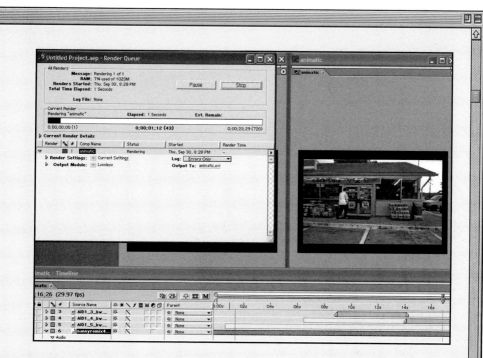

B-6 Rendering the movie.

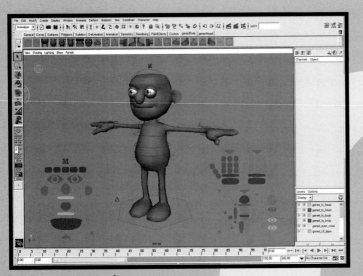

the generi rig

 charting your course

Get to know your puppet before you do any complex animation exercises. Make sure you can identify the main body masses and what controls are available for each mass. A technical director is usually assigned to create such a puppet, but it is well worth your while as an animator to learn as much rigging as you can.

On the job, you will be in constant communication with a technical director. Get to know the basics of what you need in a puppet so that you can communicate effectively. That entails working with multiple rigs and training yourself in some basic rigging.

 goals

In this chapter, you will:

- Learn how to work with a prerigged character.

- Learn how to toggle between a hi-res and lo-res model.

TOOLS USED

- **The Generi Rig.** You will explore your first complex character rig. Generi has the capability to switch between (IK) and (FK), be lip synched, and refer to locators.

- **Switching between IK and FK.** You will have the ability to use both forward and inverse kinematics on the arms. You will practice going between them.

- **Locators.** The knees and elbows can be manipulated so that they are pointing in the right direction when limbs are animated.

- **Hi-res vs. Lo-res models.** Lo-res models exist to make animating faster. Hi-res models are for the final render. You will learn how to use each.

THE GENERI RIG

figure | 6-1 |

The Generi Rig by
Andrew Silke.

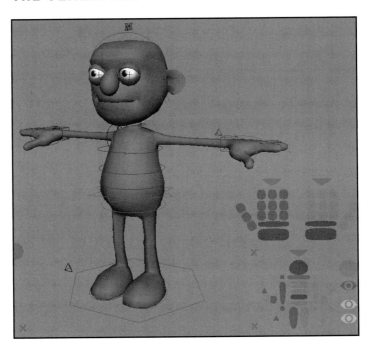

Generi is a complex rig, but it's nothing a little practice won't master. You can already start animating when you learn the first basic controls. Once you understand these, you will then appreciate

some of the more subtle attributes available. Andrew includes most of the following directions in his read me file, found in the generi_rigv1.1.zip file.

Basic Setup

Unzip the file generi_rig_v1.1.zip using WinZip or some other decompression software.

Follow these directions to set up your Maya software interface to look like Figure 6-2.

1. Unzip the file (keep the directory structure when unzipping). I use the software WinZip. An evaluation copy of WinZip can be found at www.downloads.com.

| NOTE |

Andrew Silke generously created the Generi rig as a free rig for all practicing animators. Additional Mel scripting and rigging was contributed by Hamish McKenzie. You can see more of their work at www.cane-toad.com. They allow animators to use this rig as a learning and practice tool, but it may not be used for commercial production.

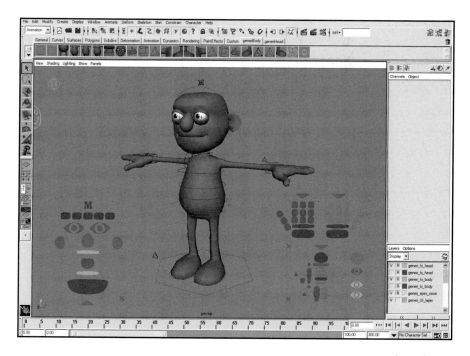

2. Move both the .mb and .ma files to your project's scenes directory (see Figure 6-3). If you do not know how to find this directory, refer to Chapter 1 of this book.

figure **6-2**

Interface ready for animation of rig.

figure | 6-3 |

Moving files.

3. Move the contents of the prefs\icons folder to your icons directory (see Figure 6-4). You will typically find your icons directory under C:\Program Files\Alias\Maya6.0\icons.

figure | 6-4 |

The icons directory.

4. Move the contents of the prefs\shelves folder to your shelves directory (see Figure 6-5). You will typically find your shelves directory under C:\Program Files\Alias\Maya6.0\shelves.

5. Move the contents of the scripts folder to your scripts direc-
tory (see Figure 6-6). You will typically find your scripts
directory under C:\Program Files\Alias\Maya6.0\scripts.

6-5

The shelves
directory.

The rig will work without any scripts; however, the trigger
User Interface requires scripts to run.

You are done loading your files.

figure 6-6

The scripts
directory.

6. Start Maya and load both shelves. To load the shelves, go to the
left side of the shelf and click on the black triangle and then
Load Shelf (see Figure 6-7).

figure | 6-7 |

The Load Shelf icon.

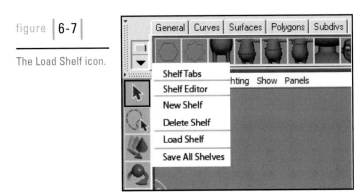

Then navigate to the shelves folder where you moved the shelves: C:\Program Files\Alias\Maya6.0\shelves (see Figure 6-8).

figure | 6-8 |

The shelves folder.

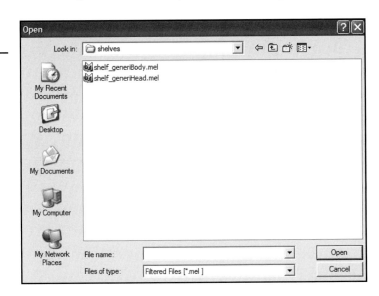

Click on the files you have just placed there: shelf_ generiBody.mel and shelf_generiHead.mel. Select open. You are done loading your shelves.

7. In Maya, open generi_referenced.ma. This setup uses referenced files. When you reference a file, the actual model/rig is in another file and cannot be damaged whatever you do to the referenced rig in your scene. Also, you can update the original rig at any time in the animation (like changing textures, moving CVs) by working on the puppet in the original file.

Generi 101

Once the file has loaded, it's best to show only polygons, nurbs, handles, and curves in your view window.

It is also recommended to change the select priority of nurbsCurves higher so that you don't accidentally click on the mesh when you try to select a curve. To do this, go to the **Window>Settings/Preferences> Preferences** window and click on the Selection category. Then go to the Priority Presets drop-down and switch to Custom. Scroll down to nurbsCurve and change its priority value to **10**. If you are using the trigger interface, you might also set nurbs to **11** so that you don't select through the UI objects. Click on Save.

figure **6-9**

Turn on NURBS, handles, and curves.

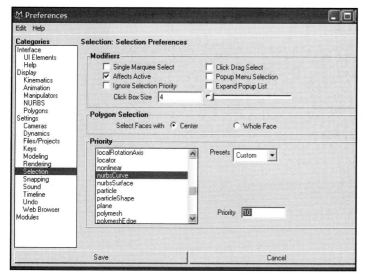

figure **6-10**

Change the nurbsCurve preset to 10.

Selecting the Controls

You have three ways to select the puppet controls:

1. Select the curves/handles on the rig.

2. Select the trigger interface objects.

3. Use the shelf icons (see Figures 6.11 and 6.12).

figure **6-11**

Shelf buttons for body.

The shelf buttons toggle on/off so you can select more than one object at a time. Be careful—once you select something, it is selected until you deselect it. If your shelves are not filled with pictures, your icons are not loaded properly. Repeat that portion of your setup.

figure **6-12**

Shelf buttons for face.

The animatable attributes for each control are in the Channel Box. In Figure 6-13 the head is selected, and the animatable controls show up in the Channel Box.

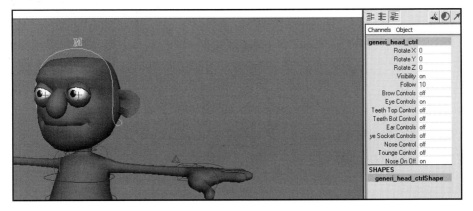

figure **6-13**

The Channel Box shows what can be animated.

It's important to use the middle click + drag functionality of the Channel Box. To do this, click on the attribute you wish to change (found in the Channel Box) and then hold MMB click and drag left/right in the 3D viewport. This provides slider-like interactivity. Important!

Toggle Hi-Resolution/Low-Resolution Model

A low-resolution body and head are included to speed up animation playback (see Figure 6-14). Figure 6-15 shows another version for comparison.

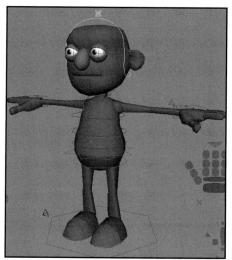

figure | 6-14 |

Low-res body.

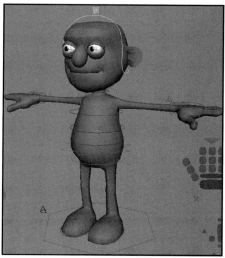

figure | 6-15 |

Hi-res body.

They look a lot alike until you move them. Then you will notice that the low-res model is chopped up. The hi-res model is smooth all over. When you animate, work with the low-res version, as it will be quicker. The low-res version is made with polygons, so it will render quicker and use less CPU to play Blast. Change over to the hi-res version when you are ready to render.

To switch between hi- and lo-res toggle the visibility of the layers in the layer bar (see Figures 6-16 and 6-17).

figure | 6-16 |

Lo-res visibility toggled on.

figure | 6-17 |

Hi-res visibility toggled on.

To Smooth the Hi-res Mesh

Click on the cog_ctrl (red star) at the waist (see Figure 6-18).

figure | 6-18 |

The cog_ctrl is found at the hips.

Change the Smooth Head, Smooth Body and Smooth Lids attributes (see Figure 6-19). You can also change the opacity of the Trigger UI here.

figure | 6-19 |

Attributes available for the cog_ctrl.

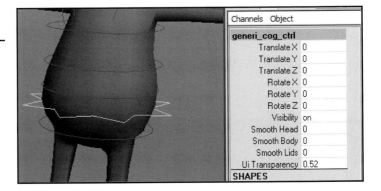

Moving the rig around

There are two ways to move Generi through space:

1. If Generi is animated and you want to position him in a scene you have just imported him into, use the moveAll_ctrl (see Figure 6-20). This is the hexagon-shaped control at the bottom of the puppet.

figure | 6-20 |

The moveAll_ctrl.

Do not animate this control when creating a walk or other repositioning movement. This control is your safety net. You only use this to reposition your character in the scene.

2. If you want to start blocking out a walk cycle for your character and you need to move him across the scene, use the cog_ctrl (see Figure 6-21). This way you are still able to use the IK on the legs effectively.

figure **6-21**

The cog_ctrl.

Fingers

With Generi, you must rotate finger joints individually. You can use the selection sets in the Outliner to select finger joints, but it is much easier to use the Trigger UI controls (see Figure 6-22).

If you want to use selection sets, they are found in the Outliner just below the geo files (see Figure 6-23). The sets are __anim_fingers_L and __anim_fingers_R. Make sure you have sets visible in the Outliner. Open each set in the Outliner for easy access. Rotate the finger bones accordingly.

You can easily build your own set-driven keys if there are some common hand positions you would like to animate. We will discuss set driven keys in an advanced animation book.

Arms

Arms can be either forward kinematics or inverse kinematics. The IK/FK switch is found on each hand rotation control (see Figure 6-24).

figure **6-22**

Trigger UI for fingers.

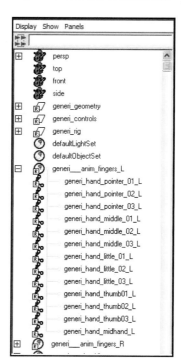

figure **6-23**

Look in the outliner for the finger controls.

The controls will show up in the channel box (see Figure 6-25).

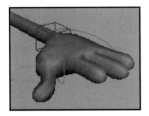

figure **6-24**

Hand control is the curved object on the hand.

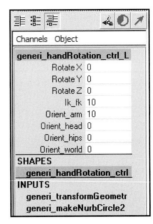

figure **6-25**

See IK_FK.

A setting of 10 means IK is on, and you can select the box at the wrist to move the arm. A setting of 0 means FK, and a circle control will appear at the shoulder. This circle leads you to a Channel Box wherein you can access the rotate controls for the arm and elbow (see Figure 6-26). We will do FK in Chapter 7.

figure **6-26**

Use the box for IK.

Inverse kinematics: The IK box will not appear at the wrist if you are set for FK.

figure **6-27**

Elbow pole vectors.

Use the triangular pole vectors to point the elbows (see Figure 6-27). Often the arms will twist around on themselves due to something called a "pole vector," which you will learn about in your rigging studies. The pole vector allows you to limit this twisting and even animate the way the elbow points.

Look at the Orient controls on the hand. These allow you to set the hand orientation, which keeps the hand from twisting around when you move the puppet. I like to keep Orient_arm at a value of 10.

Forward kinematics: FK shoulder control will not appear if you are set for IK. You only get the shoulder control if you turn the FK value to 0.

The elbow bend is found on the shoulder control. Use the middle drag functionality of the Channel Box to change the values for the elbow bend, or just type in a new value.

figure | 6-28 |

The controls for FK.

Channels Object	
generi_shoulder_ctrl_L	
Rotate X	0
Rotate Y	0
Rotate Z	0
Orient_world	0
Orient_chest	10
Orient_hips	0
Orient_clavicle	0
Elbow	0

figure | 6-29 |

Use the arm control for FK.

Most of the arm controls have parent constraints, so the hierarchy of animation can be altered. These attributes can be animated midway through an animation. The attributes start with Pos_ or Orient_. Make sure the values of these attributes on each control add up to a total of 10 to stop weirdness from occurring.

You can also animate between FK and IK within the same scene by key-framing the IK/FK value.

Legs

You have the same FK/IK options available in the legs. Use the triangular-shaped knee constraints to point the knees (see Figure 6-30).

You also have a few controls available to assist you with animating the role of the foot

figure | 6-30 |

To point the knees, move these.

when walking. Notice the options available for heel, lift heel, toe, and bank (see Figure 6-31).

figure | 6-31 |

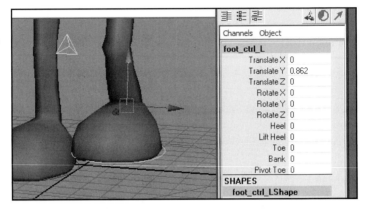

Change up the values here to see what happens to the foot. You will work with these in depth when you do the walk cycle.

Spine, Neck, and Hips

The spine, neck, and hips can only be rotated (see Figure 6-32). These are purely FK.

figure | 6-32 |

The face controls will be described in Chapter 9 when you try a bit of facial animation.

SUMMARY

Generi is a wonderfully complex rig. You can just deal with the basic controls for simple animation, or you can dive into the advanced controls for more specific gestures. Make sure to experiment with the different controls a bit before you attempt any animation. Use this rig for the following chapter exercises.

in review

1. How do I switch from hi-res to low-res?

2. Why would I want to work in low-res?

3. When would I use hi-res?

4. Which appendages have pole vectors?

5. What UI control is visible on the puppet when you have set the limb to IK?

6. What UI control is visible on the puppet when you have set the limb to FK?

7. Can you animate between FK and IK?

⤢ EXPLORING ON YOUR OWN

1. Try a simple hand wave.

2. Pose the rig a few different ways to gain an understanding of the controls. Make Generi sit, lie down, or appear to leap in midair.

3. Make Generi achieve a few ballet positions.

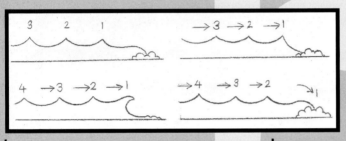

practicing principles of a wave pattern

 charting your course

Believable character animation requires an innate understanding of follow-through and overlapping action. In this chapter, you will practice these skills with a few short exercises in preparation for our eventual walk cycle.

 goals

In this chapter, you will:

- Understand forward kinematics and how it differs from inverse kinematics.

- Learn about ghosting.

- Practice follow-through and overlapping action.

- Successfully edit a more sophisticated set of curves.

- Learn how to set motion blur.

TOOLS USED

- **Forward kinematics.** Forward kinematics involves moving each individual skeleton joint to achieve movement. It works a lot like stop-motion animation. Imagine a doll that has movable joints, such as GI Joe. Move the arm at the shoulder for an upward arc, then move the elbow, and cock the hand in a wave. This is how forward kinematics works.

- **Ghosting.** Ghosting is a technique that allows you to see the entire animation in one image. A wireframe of each image in the animation is composited onto one frame and can be interactively edited.

- **Motion blur.** You can add the illusion of speed with a wee bit of motion blur. Motion blur smears the moving parts of the image to infer speed.

FORWARD KINEMATICS

Open the file ArmFK.mb on the enclosed CD (see Figure 7-1).

figure | 7-1 |

The interface of the whole_shoulder file.

This is a basic skeleton rig for an arm. You are expected to animate it using forward kinematics. Here you will do a simple demo, so set your tangents in Preferences to spline, weighted, and use the S key to set your key frames.

First, look in the Outliner window. You will see a skeleton object named whole_shoulder (see Figure 7-2).

figure **7-2**

The whole_shoulder object.

This is the top node of the skeleton rig. If you select the top node of the skeleton and then Shift + LMB over the plus sign, the entire hierarchy will be displayed.

Go to the first frame of the animation. Select the top node (whole_shoulder) and set a key frame at frame 1 by pressing the shortcut key S or by using the interactive tool **Animate > Set Key** (see Figure 7-3).

Then open your Channel Box. Go to frame 30. In Rotate Z of the Channel Box, type **70** (see Figure 7-4). Create a key frame.

figure **7-3**

Set a key frame for the shoulder.

Now play your animation using the controls at the bottom of the interface (see Figure 7-5). They look like those on a VCR.

figure **7-4**

Rotate Z at 70.

The arm rotates. Now you will work with the elbow and the hand. Go to frame 2 and select the elbow joint. Set a key frame.

figure **7-5**

Playback Controls.

Go to frame 28 and select Rotate Z in the Channel Box. Set the value to **45** in Rotate Z. Set a key frame.

Select the hand and go to key frame 22. Set a key frame.

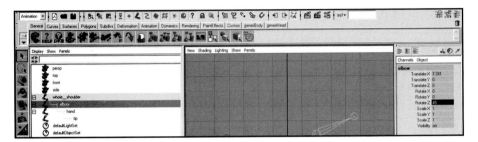

figure | 7-6 |

Rotate Z at 45 on frame 28.

Go to key frame 26 and, in the Rotate Z Channel Box, enter the value **70**. Set a key frame. At frame 30, set a key frame for Rotate Z for **–20**. Play the animation, and you will have a little wave (see Figure 7-7). Before ghosting it, I tweaked my Graph Editor curves, like a good animator should. It needs work, but for the sake of FK demonstration, it's okay.

figure | 7-7 |

A wave, using ghosting.

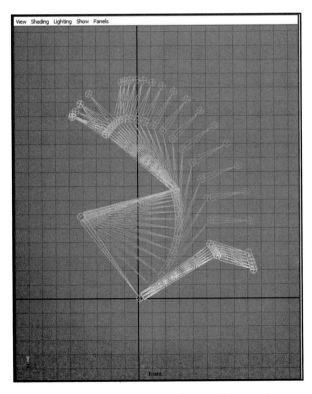

That is how you animate using forward kinematics.

For character animation, arms are usually animated using forward kinematics. They tend to look more natural. When inverse kinematics is used on arms, they tend to look like marionettes. The hand tends to direct the movement of the arm. With forward kinematics, the shoulder leads the arm, which is more natural to human movement.

Legs tend to use inverse kinematics. IK has a built-in constraint that locks the limb to a point in time. If the torso or body moves, the limbs still stay locked to the point in time to which they were key framed. You can pull them away, but the limbs will always point to the constraints. FK does not have a constraint, so the limbs move with the torso.

Think of it like this—with IK, it is like using tacks to hold your limbs in place, and the body follows. With FK, it is like animating limb by limb in stop motion.

GHOSTING

Open the file ball_bounce.mb on the attached CD.

Here you have a 13-frame bounce. If you press Play, you see the bounce. Now you will ghost it.

Make sure you are in the Animation module. Select a Camera view as your active window. Select your ball as the ghosted object.

Select **Animate** > **Ghost Selected** > **options box** (see Figure 7-8).

The new interface that pops up has several options for ghosting. Choose the option Keyframe so that every key pose is viewable (see Figure 7-9).

You can change your key poses and watch the changes automatically update. Go to a key pose and translate the ball up or down. Notice that the curves leading in and out won't change. This is because you are not viewing the interpolated images.

figure | 7-8 |

How to get the
ghost.

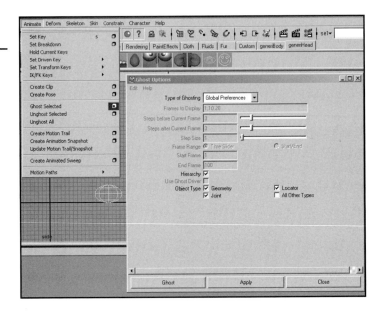

figure | 7-9 |

Ghosted key frames.

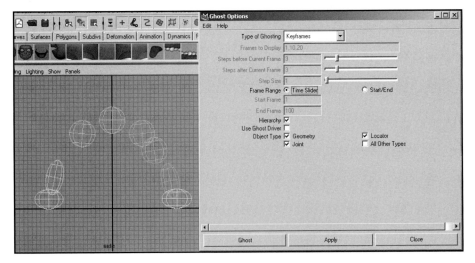

To view the interpolated (in-betweens that the computer creates) images, change your ghosting preferences. In the options window, select Global Preferences (see Figure 7-10). You will now see a ghost based on the images interpolated three before and three after the image.

If you want to see more, go to your Preferences under Animation and increase the steps. Now move your key frame. The interpolated images leading in and out will change in accordance with the key pose.

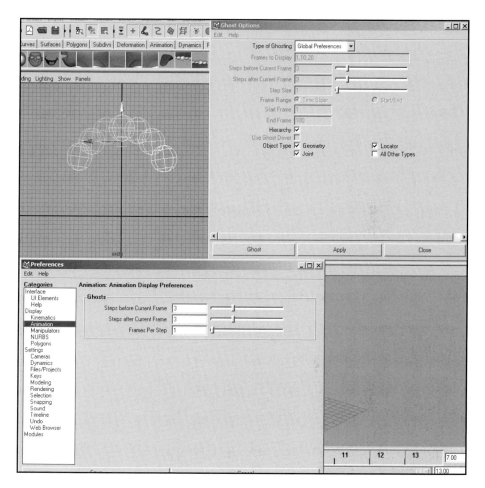

figure | 7-10 |

PLAYBLAST

Global preferences.

Open the file ball_bounce.mb on the attached CD. Select **Window** > **Playblast** > **options box** (see Figure 7-11).

You will get the Playblast Options box (see Figure 7-12).

figure | 7-11 |

How to get to
Playblast.

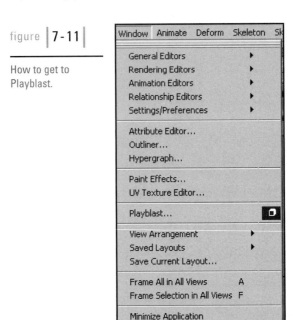

figure | 7-12 |

The Playblast
Options box with
default settings.

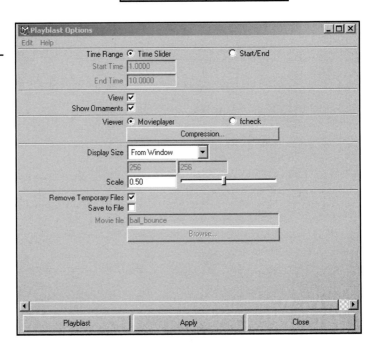

I prefer to make a series of images I can then play in Fcheck. To set up my options to allow this, I select Fcheck, and Save to File, and then I find my directory path to store these images (see Figure 7-13).

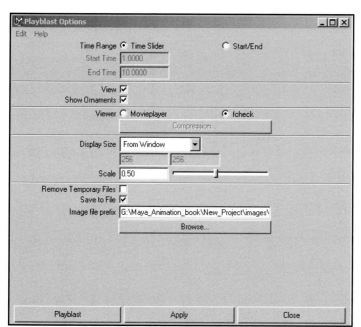

figure | 7-13 |

Change the options.

I then click on Playblast to create the files. A player should automatically pop up in your window on completion.

SKELETON, JOINTS, AND SKIN

How do the skeleton, joints, and skin work in Maya? This section will show you the basics. You also are encouraged to study rigging in addition to movement.

Don't enter the field of animation with the sole expectation of getting a job as a character animator. The understanding of movement is only one part of the job. You should also have an understanding of rigging, modeling, texturing, and story. When the deadline for a project hits, it is all hands on deck. Your employer will need you to fill multiple positions in a pinch.

First of all, let's get to know what a joint is all about. "Joints" is the technical term for the "bones" of the puppet. They make up the skeleton. The actual puppet is attached to these bones through a process called skinning.

Skinning involves attaching the model to these bones. These bones then aid in controlling the puppet. This is done by creating clusters from the control vertices (CVs) that make up the model and attaching them to the bones.

Close this file and create a new file.

Let's make a simple cluster from control vertices and attach them to a joint. Make a NURBS sphere. Look at it in Component mode with control vertices visible (see Figure 7-14).

figure | 7-14 |

NURBS sphere in component mode.

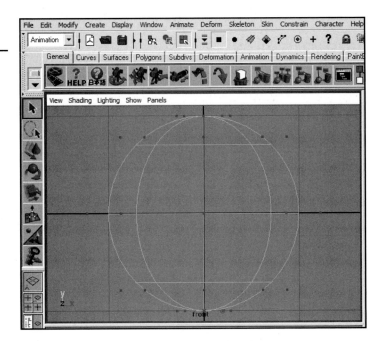

Select the upper two rows of control vertices (see Figure 7-15).

You will group these vertices into a cluster. A cluster operates like a ponytail holder. When hair is loose, it moves as the head dictates. When you gather it into a braid and enclose it with a ponytail holder, individual hairs move as one, even though they are still attached to the head.

Use the command **Deform > Create Cluster** (see Figure 7-16).

figure | 7-15 |

Select CVs.

figure | 7-16 |

Deform > Create Cluster.

Now look at your sphere. Look also in the Outliner (see Figure 7-17).

figure | **7-17** |

The letter C appears, and a grape cluster shows in the Outliner.

You will see a letter C in the middle of your manipulator icon in the sphere. In the Outliner window, you will see a green cluster of grapes called cluster1Handle.

Select the cluster1Handle in the Outliner and move this cluster upward in the Y Translate (see Figure 7-18).

figure | **7-18** |

Moving the cluster.

See how the rest of the sphere is stationary, though the cluster pulls the grouped CVs easily to a new destination? Now delete the cluster. Your sphere is back to normal (see Figure 7-19).

Joints work with clusters (see Figure 7-20).

After the skeleton for a model is built, the model is attached to the skeleton. Maya groups the CVs of the model and connects them in clusters to the nearest joint. The joint then controls

these clusters in weighted percentages. If you delete the skeleton and clusters, the original model still remains intact.

figure | 7-19 |

The deleted cluster does not affect the original model.

A lot of cleanup must happen after skinning. As with anything created by default in Maya, it must be tweaked to serve the end user's purpose. Clusters must be reassigned and weights altered.

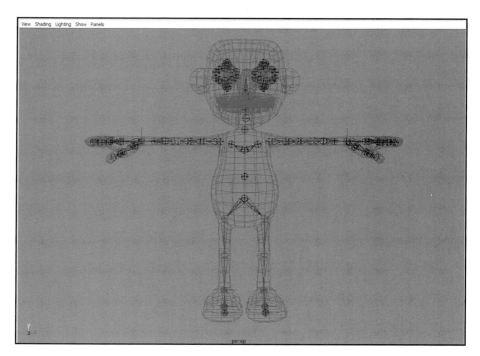

figure | 7-20 |

Generi's joint skeleton.

Often extra tools like lattices are used to make a cleaner bind. Again, try to pick up some rigging after you have tried out your animation skills.

In larger studios, animators work with technical directors responsible for creating rigs. They work closely together, translating the storyboard into an actual scene. In smaller studios, the animator must know how to build his or her own rig.

INITIATION OF MOVEMENT THROUGH CONNECTING PARTS

Now you'll consider some principles of movement and how they work as the force of motion travels through an object or a series of objects in a process called a "wave pattern." This pattern runs consistently through all things connected with articulated or flexible parts and passes from primary actions into overlapping or secondary actions.

A fundamental example of a wave pattern can be seen in a cracking whip. In the whip, you find the movement initiated from the handle being put through a quick movement at one end, and the movement then follows the length of the whip to the other end, causing a loud "pop" as the tip suddenly reverses as its inertia is broken (actually a miniature "sonic boom"!).

figure | 7-21 |

A whip cracking.

Here's another good example of a wave pattern. Forgive the use of the obvious, but this example is quite literal: the action of ocean waves traveling shoreward and resulting in surf breaking on a shoreline. As easily seen in Figure 7-22, the pattern of waves can be tracked as they flow to the shore (we'll use numbers at the top of each wave), and the end result once again is an exhibition of power, in this case the surf pounding the shoreline.

Now you'll apply the wave pattern illustration to a living being, and you'll find similarities to the other examples shown, as well as marked differences. The body is a series of connected, articulated parts. Although there are solid, nonflexing pieces within some bodily parts, there are also a multitude of flexible joints and soft tis-

figure | 7-22 |

A wave in motion.

sues, allowing this structure to demonstrate the same sort of wave action in its movements.

Realize that the wave patterns in the whip and the ocean waves were produced outside of those subjects and were involuntary in those bodies. Wave patterns in a living organism are likewise initiated at one end of a connected chain, transmitted through successive parts and effectively producing a resulting reaction. The main difference is that in the motion demonstrated here, the action is voluntary and produced with a thought to accomplishing a result.

Try It in Maya

Open the file whip.mb on the enclosed CD. This simple rig will allow you to animate the wave pattern using forward kinematics. You will see a simple skeleton comprised of 10 joints.

Set your window to look like Figure 7-23, and set up the timeline from 1 to 30. For practice, also set your tangents to linear and stepped.

Select the entire skeleton. You will be setting key frames for each individual joint, so you will need to get used to moving up and down the hierarchy. With the entire skeleton selected, press the downward arrow key on the keyboard.

You will notice that one less joint is selected. Press the downward arrow key again. One less is selected.

When you set key frames for each wave pose, you will need to go down the hierarchy and set key frames for each joint. Yes, there is an easier way to do this, but you are learning the basics. One day, knowing this method and how it works will save you from some problems when working with a more complex rig. Use Figure 7-21 as reference for this exercise.

At frame 1, set a key frame for each of the 13 joints. You do not need to repose the skeleton at this time.

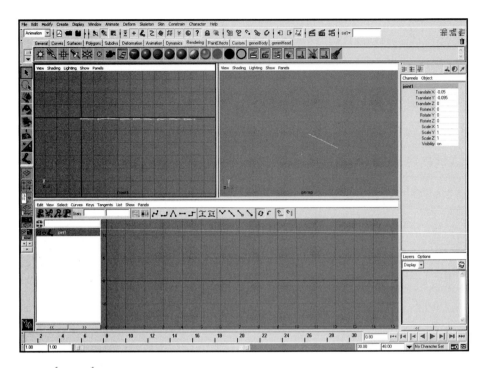

figure | 7-23 |

The whip.

Go to frame 8. Again, set the same key frames for the 10 joints for pose a.

On frame 22, set the pose for a. You will work on twos. This means the next pose you set will be on frame 10, and you will set pose b (see Figure 7-24).

figure | 7-24 |

Frame 10.

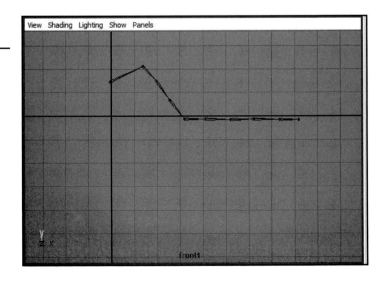

To set this pose, grab the root (joint1) and translate it up in the Y. Select the joint2 joint and rotate it to .77 in the Z. The third and fourth joints will not need to be rotated. The fifth joint will be rotated 50 in the Z. Using your up and down arrows, set key frames for the Y Translate and the Z Rotate of each joint.

On frame 12, using the same process, set the pose for c. Using your up and down arrows, set key frames for the Y Translate and the Z Rotate of each joint.

On frame 14, set the pose for d. Using your up and down arrows, set key frames for the Y Translate and the Z Rotate of each joint.

On frame 16, set the pose for e. Using your up and down arrows, set key frames for the Y Translate and the Z Rotate of each joint.

On frame18, set the pose for f. Using your up and down arrows, set key frames for the Y Translate and the Z Rotate of each joint.

On frame 20, set the pose for g. Using your up and down arrows, set key frames for the Y Translate and the Z Rotate of each joint.

Play the animation using playblast. You now have a loop of animation for a cracking whip.

Select the skeleton and turn on ghosting. Now you can analyze your motion curves by looking directly at a stop-action frame of movement.

Throwing a Ball

Here's a simplified breakdown of the processes used to accomplish the pitching of a ball, taken step by step through each part of the chain from start to finish.

Always use the best reference material you can get your hands on. You can always elaborate on the visuals, but without reference material, you can likely miss important details.

Initially, the motion starts with the initiation of an anticipation move in the central part of the body, as the shoulder moves backward and the elbow comes up, the hand following. See A (see Figure 7-25).

Now the elbow drops as the hand continues to rise to the top of its arc. See B.

figure | 7-25 |

The pitch in motion, steps A–E.

The elbow now leads as the forearm comes forward. The hand reacts by tilting back in reaction to the move. See C.

The wrist begins to lead the move at this time. The momentum keeps the hand at a right angle to the forearm. See D.

The arm has extended into its full length, bringing about the final "snap" of the throwing action as the hand quickly straightens and releases the ball. See E.

At this point, we can once again introduce the concepts of follow-through and overlapping action. This is one of the points where, as animators, we have the opportunity to enhance our work, unobtrusively making the action feel flowing and natural. Let's use the example of a batter hitting a ball and see what follows the actual hit.

As you've learned from the discussion of basic animation principles, an action presented successfully is not just a matter of getting from point A to point B and stopping. If you constructed the batting sequence in that manner, you'd see the batter ready to swing, then the ball speeding in, then the swing, then the hit, and that would be the whole story. The batter could freeze right at that point, with the bat in the middle of the arc of the swing (see Figure 7-26).

figure | 7-26 |

The swing.

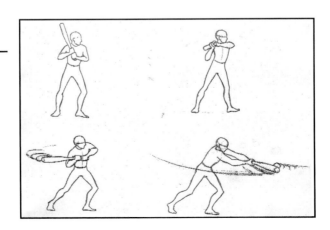

Now let's try it with points C, D, and so on added to finish the move.

One of the first things many animators discover in this type of action is that the actual "contact" drawing (the bat hitting the ball) is totally irrelevant in producing the desired effect. The dynamic of this kind of action is actually enhanced by an uninterrupted swing through the entire arc, letting the ball react to an implied hit, as shown in the following sequence. Here's how the whole action would play:

The batter is ready, with the ball having been pitched. See A in Figure 7-27.

figure | 7-27 |

The batter gets ready.

As the batter gets ready to swing, he steps in the direction of the ball, bringing the bat back in anticipation. See B.

Now comes the swing, quickly through the entire arc, with the reaction of the ball indicating the contact. See C in Figure 7-28.

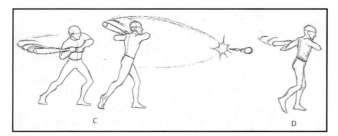

figure | 7-28 |

The batter swings.

At the extreme point of the swing, the batter's arms are wrapped around his body, his trailing hand having released the bat. See D.

The hand holding the bat continues back in the opposite direction as the batter's body goes into anticipation for his run. See E in Figure 7-29.

Finally, in an example of interconnecting, overlapping action, the batter starts his run to first base, his hand continuing to swing to the rear in the same direction and releasing the bat. See F.

figure | 7-29 |

Overlapping action.

EDITING TIPS

Try the following tools to enhance your acting skills.

Editing in the Timeline

The timeline can actually function as a handy editor. There are secret tools available to you if you know where to look. RMB over the timeline to reveal a few (see Figure 7-30).

figure | 7-30 |

The timeline and some of its secret controls.

Highlight a key and select Cut from the secret menu. The key is no longer on the timeline. Select a new frame and then select the Paste tool. You have taken the frame you cut from the last position and placed it in the new.

You have already used most of these tools before. Follow the arrows to the right of the tool to view your options. This menu is merely a shortcut, as Maya often stores tools in multiple places to speed your work process.

More editing tools exist in the timeline. Press the Shift button on your keyboard. Then LMB-select a frame on the timeline and move your mouse to the right. You will see a red line take over your timeline (see Figure 7-31).

This red area represents a workspace in which you can edit the placement of key frames. Everything inside the red area will be affected.

figure | **7-31**

Editing in the timeline.

LMB the arrows in the middle of this red area to slide it back and forth. If you have key frames in this area, you will be moving them to a different place in time, but they will maintain their proximity to each other.

LMB the arrows on the outer limits of this red area to scale the frames up or down. The side you are not editing will not move; it will act as a pivot, and the frames will scale to it.

Click anywhere in the timeline to get rid of the red area.

Practice the use of this tool with your bouncing ball exercise. Try cutting and pasting key frames first. Then try to move the key frames.

Editing in the Graph Editor

Sometimes you will want to hold on a key pose. You only have one key frame for the pose, and you need to create a hold over six frames. What is the best way to create the hold? Create another key frame of the same value, six frames later in time.

You will use the ball_bounce.mb file for this example.

figure | **7-32**

The Insert Key tool.

You want to hold the bounce in midair for three frames. You do not want the ball to move up and down in this time. Thus, you want to create holds in the Y Translate three frames after key frame 7.

Select the Y Translate curve and use a tool in the upper left of the interface called Insert Key (see Figure 7-32).

Then insert a key by MMB-clicking the curve and dragging the curve to where you want to insert the key. You can also use the Add Key tool (see Figure 7-33).

figure | **7-33**

The Add Key tool.

For Add Key, middle-click the curve where you want to insert the key. All keys added to the curve will have the same tangent type as adjacent keys.

Suppose you want to move an entire section of keys to a different point in time. New tools have been introduced in Maya 6 to make this easier.

In the Graph Editor interface pull-down menus, select **Edit > Transformation tools.** You will see three new sets of tools available (see Figure 7-34).

figure

Transformation tools.

The Move Keys tool lets you select a group of keys and move them as a unit to a new place in time (see Figure 7-35).

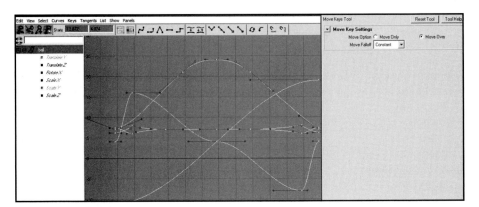

figure | 7-35 |

Move Keys tool.

The Scale Keys tool lets you select a group of key frames and scale (see Figure 7-36).

Figure 7-37 shows the Lattice Deform Keys tool.

figure | 7-36 |

Scale Keys tool.

figure | 7-37 |

THROWING WITH MAYA

Lattice Deform Keys tool.

Open the file Generi_rig.mb. Try to place the rig in the poses previously described. Follow the timing charts in Figure 7-38.

Use forward kinematics on the arms and inverse kinematics on the feet. You will notice that you have many more parts to keep track of. Just concentrate on the motion of the figure in this exercise.

Timing charts for the
throw.

figure | 7-39 |

The Animation
module.

| NOTE |

The more complex the rig,
the more bouncing balls are
in motion. Every workable
joint will require curve man-
agement. Work your way up
and get used to all the new
buttons. Animation can get
very complex very fast.

Set up your interface to look like Figure 7-40. Under Panels, choose
Three Panels Split Top and turn the lower window into the Graph
Editor. Make sure to set up your tangency curves as linear and
stepped.

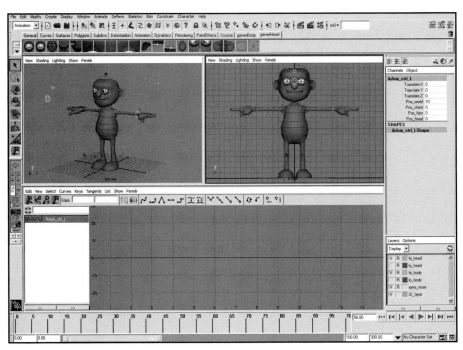

figure | 7-40 |

The interface to
begin the throw
exercise.

Now sketch a series of thumbnails for a throw. Select your key
poses. Refer to the drawings (see Figure 7-41).

Create a timing chart (see Figure 7-42).

Now pose your character in relation to the thumbnails.

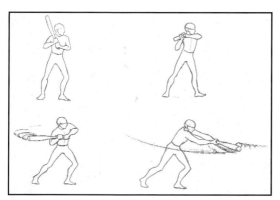

figure | 7-41 |

The drawn poses.

figure | 7-42 |

A timing chart.

Use the following process for beginning your full-body animation. You will identify the big leading motion first and then go down the chain of responding motions to the final affected limbs.

1. Set the key poses with linear, stepped curves. Be sure to work in the low-resolution version of the puppet—look for the lo_res selection layers in the Layer Editor and turn on their visibility. Turn off visibility for hi_res. The torso is the leading mass in this activity.

2. Play the animation for a timing check.

3. Edit key pose timing until approved.

4. Select Curves for Leading Motion and change these to Clamped. You should be using the cog_ctrl for this action on Generi because it is the parent control of the spine. Pay attention to the rotate and translate curves. These are the most important elements in your puppet for implying weight and strength for this exercise.

 "The motion starts with the initiation of an anticipation move in the central part of the body."

5. Create the anticipation by setting a few extra key frames before the key pose. Tweak the in/out of each curve in reference to the timing chart. Think about where the speed and momentum are at each frame. Be careful that you do not have any parts of the rig "floating"—aka slowly moving from one keyed point to another with no reason. Make definite movement choices.

6. Take the next large controlling mass—the three spines—and change these curves to Clamped. You are now working with spine01_ctrl, spine02_ctrl, spine03_ctrl. Notice that you can only rotate in the X, Y, and Z. Think of the wave principle

when animating the spine. You may want to take your key frames and move them up one frame on each spine control, to create a wave of motion responding to the initial force.

7. Tweak the in/out of each curve in reference to your timing chart. Think about where the speed and momentum are at each frame. The cog_ctrl is leading these spines, and this motion precedes the motion in the arms. Make sure the movement is smooth for the entire swing.

8. The head is next. Select head_ctrl, the retainer-like object wrapped around the head. You can only rotate the head. Notice that it is at a different angle and rotation from the spine, and it may even rotate in reverse of the spine because the eye will always be on the target—in this case the batter.

9. Arms are next. Use forward kinematics. Remember to set IK_FK to **0** in the handRotation_ctrl_L and handRotation_ctrl_R so that you can access the shoulder_ctrl_L and shoulder_ctrl_R. Note how the right shoulder and arm rise through the throw. Anticipation at the start. Slow out, slow in—and fast as heck in between. Remember the hard accent at the end. Remember the weight of the ball as it is released.

10. Elbows are the next concern. They are reacting to the shoulders, which are reacting to the torso. Select the l_elbo and r_elbo. Notice that you can only rotate in the X. Set curves to Clamped and tweak the in and out speed.

 "Now the elbow drops as the hand continues to rise to the top of its arc. The elbow now leads as the forearm comes forward."

11. Now address the follow-through and thinking of the character with the hands. Take this time to address the basic wave principles and apply them to the hand and fingers. The hands begin to lead as the batter comes in contact with the ball, and then they fall back as the momentum of the body takes over.

 "The hand reacts by tilting back in reaction to the move. The wrist begins to lead the move at this time. The momentum keeps the hand at right angles to the forearm. The arm has extended to its full length, bringing about the final "snap" of the throwing action as the hand quickly straightens ad releases the ball."

Play back the scene for a timing check. Is it too slow or fast? Edit your Graph Editor to make fixes. Now you should understand that

poses are easier to fix in the stepped-curve phase, where less damage is done to curves already edited.

How Can I Imply Speed?

Sometimes the timing and movement are just right, but something is still missing. Film captures motion blur, and you are used to seeing it. In Maya, you must ask for it. You can add motion blur during the render in Maya.

Motion blur is found in your Render Globals (see Figure 7-43).

When you are ready to render out the scene, you can set these to On.

You may be beginning to pick up that animation is hard. It requires as much, if not more, time as rigging, modeling, and texturing. Too often I see people's use of all of their time constructing the scenario and the puppets, and then they rush through the animation.

A great deal of information can be gleaned from traditional animation and applied to 3D. Take the time to draw things out and study them before entering the 3D phase.

figure | 7-43 |

Motion blur.

To save yourself rendering time, only set motion blur for the objects you want blurred. To change motion blurs per object, go to the attributes window for the actual geometry and check or uncheck the settings as per your preference (see Figure 7-44).

figure | 7-44 |

Motion blur is under the Render Stats.

SUMMARY

The wave pattern applies to a great deal of animation. A base object determines motion, and all attached objects follow. Often there are multiple leading objects. Physics step in after initial propulsion and participate in the overlapping action and follow-through.

Work through your 3D puppet to determine the main thrust, and then work through the hierarchy to define the wave pattern to achieve believable motion.

REFERENCE IMAGES

If you're interested, the reference images for the preceding traditional throw are on the attached CD. Load them in as reference images and practice your timing against them. Then get used to thumbnailing out your own reference images.

An excellent resource for thumbnailed animation is *The Animators Survival Kit* by Richard Williams. He has some beautiful, hand-drawn sequences that can be scanned and posed against in Maya.

I use a cheap web camera to take stills of my thumbnail references. I photograph them using the timing charts I create, and then I play them back using the Maya Fcheck. This helps me save a great deal of time, as I can finesse my timing before even opening the Maya package. Your art director will appreciate your increased productivity.

in review

1. What is forward kinematics?

2. How does it differ from inverse kinematics?

3. What are interpolated images?

4. What is ghosting?

5. What is Fcheck?

6. What is the wave pattern?

7. How do you draw in an Fcheck window, and why would you?

8. What kind of editing can you do in the timeline?

9. How do you set motion blur?

↗ EXPLORING ON YOUR OWN

1. Go back to the flour sack animation in the last chapter and look for opportunities to practice follow-through and overlapping action. Create smaller timing charts to add in between the larger ones and edit your curves to accommodate them.

2. Go back to the flour sack animation and look at the timing on your weight opportunities. Do you see anything you would fix?

3. Add motion blur to the flour sack in chosen areas where speed may be emphasized.

4. Try a hard accent and a soft accent with the ArmFK.mb file.

·notes

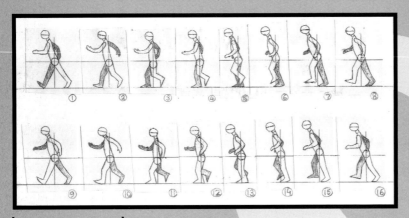

the walk cycle

 charting your course

A walk cycle is one of the most difficult exercises that a beginning animator can take on. Every joint is moving, and the character must be an identifiable personality—*while* all these limbs are translating and rotating and showing weight—not to mention having a purpose to the walk. How does an animator give life and still keep his sanity?

Think of masses in motion.

 goals

In this chapter, you will:

- Learn how to work with a prerigged character.
- Examine the traditional construction of a walk cycle.
- Apply wave theory to the walk cycle.

TOOLS USED

- **Switching between IK and FK.** You will have the ability to use both forward and inverse kinematics on the arms. You will practice going between them.

- **Locators.** The knees and elbows can be manipulated so that they are pointing in the right direction when limbs are animated.

- **Hi-res vs. Lo-res models.** Lo-res models exist to make animating faster. Hi-res models are for the final render. You will learn how to use each.

- **Foot controls.** You will practice using the Heel, lift Hell, Toe, Bank, and Pivot Toe controls found in the Channel Editor for the foot.

- **Extra arm controls.** You have access to a few more controls in the arms that haven't been discussed yet. These will help you gain more control over the rig.

THE WALK CYCLE

Building Animation in Layers

Now you've arrived at what many animators consider to be one of the most complex issues in the animation process—the walk. For the purposes of this exercise, which will be a basic introduction to the mechanics of the process, you'll be staging the figure in the center of your field of vision and in profile, held there throughout. In other words, the character will be striding along in place as the "background" slides along behind. In this way, you'll get used to all the dynamics of the walking motion, and you'll also be able to put down a series of poses representative of one step with each foot, which you'll then be able to repeat for as long as you require.

This process, although complex, will become clear through the "hands-on" process as you go through the exercise, so stay with it and execute each step as delineated, and you'll get through it with no bruises!

To begin, you need to learn about "animating in layers." This will be an approach to utilize as you get into the more complex exercises you'll be confronting throughout the rest of your time as an

animator. It's best to get used to layering right at the outset, as you're going to need to rely on it as a way to check the various elements within your work as you get into more advanced acting and movements.

A Traditional Walk Cycle, Animated in Layers

The first thing you need is a sheet to establish guidelines to use as a template for your animated figure to move within. This guide sheet will be underneath your series of animation drawings and will remain on the bottom of the stack to refer to for alignments.

Ground Plane

This will represent the surface on which your animated figure will walk. Place this line at the bottom center of the sheet (see Figure 8-1). In Maya, you will use your grid as this ground plane.

Vertical Centerline

The figure will need a line to represent a center of gravity for the up and down motion of the hips during the walk cycle. The hips will be represented in each drawing as a sphere. In Maya, you will use a curve for the vertical centerline (see Figure 8-2).

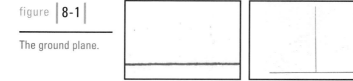

figure | 8-1 |

The ground plane.

figure | 8-2 |

Vertical centerline.

This up-and-down movement in the hips and body is the most important item to include in an animated walk, as it implies weight. Without this feeling of weight, a walk cycle will seem stiff and floaty. Lack of weight is the single most characteristic oversight in an amateurish-looking presentation, whether in traditional or CG animation.

Horizontal Centerline

This line will intersect the hips in the "neutral" position in order to establish the center of the up-and-down motion. In Maya, you will use a curve for the horizontal centerline (see Figure 8-3).

figure | 8-3 |

The horizontal centerline.

You'll be using 16 drawings to animate your two-step walk cycle. As you become more experienced in animating walks, you'll find that there is no single "right way" to do it. This basic walk is merely a way to get something moving, and it is a fairly simple process for a beginning animator. The first way we will demonstrate is how it is done in traditional animation.

Here is a schematic drawing of the entire cycle to refer to as you go through the process of drawing it (see Figure 8-4). You can see why it is called a cycle, as number 16 hooks up perfectly back to number 1 with no interruption. If the concept is a bit foggy at this time, don't worry—it will become clear as you work through it.

figure | 8-4 |

The entire cycle.

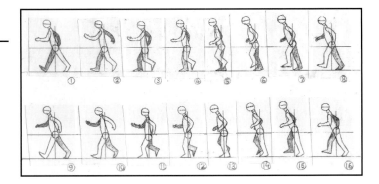

DON'T GO THERE!

Don't set four key poses for the walk cycle in 3D and assume you are done. There is so much more to consider when constructing the walk. In addition to everything else, there is overlapping action between all the limbs that requires offsetting keys. It can be one of the most complex movements to re-create in 3D.

Take the extra time to dissect the masses in motion. The art is in the subtle observations you are able to imitate.

Beginning the Drawings

You've arrived at the point where you can start the step-by-step process of making the drawings for your walk cycle.

1. Establish contact drawings (#s 1 and 9; see Figure 8-5) for the right and left lead foot (hips sphere in "neutral" or center height). These are the most important drawings to establish at

the beginning of your cycle. They determine the widest part of the step and can be used later to determine how many steps it will take to get from one location to another on a layout. (More on that later.)

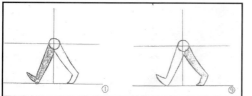

figure **8-5**

Contact drawings.

It will help at this time to shade the upstage leg in all drawings to keep a clear idea of which is where at all times. You *will* find this an issue as you work on walk cycles. Also, numbering each drawing—as well as notes on the drawing indicating "high," "low," and any other thing about a particular part of the cycle—are well worth the effort and should become a habit. It's very easy to become lost animating this sort of thing.

2. Establish crossing drawings (#s 5 and 13; see Figure 8-6) for each leading foot (hips center height).

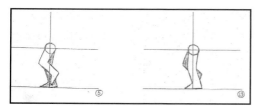

figure **8-6**

Cross drawings for 5 and 13.

3. Establish low extremes for each foot (see Figure 8-7). This is the point at which the leading foot catches the weight of the body in its forward movement, and the body undergoes a drop downward. These are drawing #s 3 and 11.

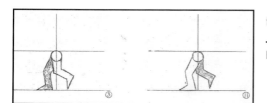

figure **8-7**

Low extremes.

4. Establish high extremes for each foot (hips at highest position), as seen in #s 7 and 15 in Figure 8-8. This is the point at

which the body is pushed to its highest position for the lead foot to be clear for its forward swing.

figure | **8-8** |

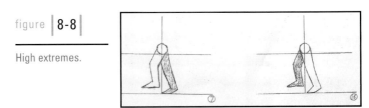

High extremes.

5. Complete the cycle by adding one drawing between each of the drawings. These extra drawings smooth out the action and make the timing about right to simulate a real walk. The numbers will be all the even numbers: 2, 4, 6, 8, 10, 12, 14, and 16. The charts will all be even timing; meaning each drawing will be exactly in the middle position between two extremes (see Figure 8-9).

figure | **8-9** |

The cycle with timing charts.

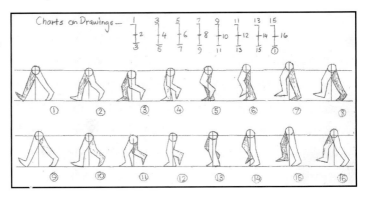

Now you've got all the drawings you'll need for your walk cycle. You can shoot the drawings and take a look at the action of the body from the hips down. Then, it's on to the next steps in completing your walking figure.

6. Add bodies (see Figure 8-10). Establish neutral position on the upper bodies. A walk is a forward movement; therefore, the neutral body should be leaning forward a bit. The drawings to receive the neutral body will be the contact poses (#s 1 and 9), followed by the crossing poses (#s 5 and 13).

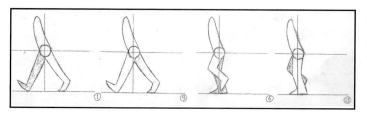

figure |8-10|

Add bodies.

7. Now add bodies to the lowest and highest positions. First look at the lowest body position, which you'll find by looking for the hip sphere below the horizontal centerline (see Figure 8-11). In this case, these will be #s 3 and 11. In these drawings, the body will achieve its most vertical attitude. The reason for this will be seen when running the animation. (Bear with us!)

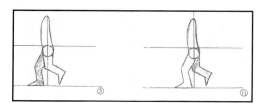

figure |8-11|

The hip sphere below the centerline.

8. Adding the bodies to the highest drawings, the ones with the hip sphere above the horizontal centerline (#s 7 and 15), you'll reverse the procedure, making these the drawings with the farthest forward tilt (see Figure 8-12).

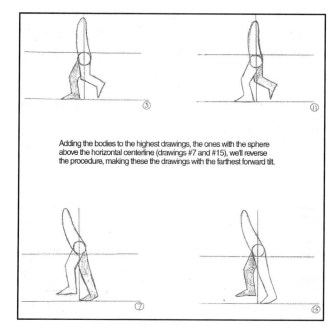

figure |8-12|

The farthest forward tilt.

Adding the bodies to the highest drawings, the ones with the sphere above the horizontal centerline (drawings #7 and #15), we'll reverse the procedure, making these the drawings with the farthest forward tilt.

9. Once again, complete the cycle by adding bodies onto all the even-numbered in-between drawings, being careful to watch the arcs.

It's time to shoot the drawings and look at the cycle again. Adding the body in this manner has automatically given you overlapping action. It's starting to be fun now, isn't it?

10. Time now to add heads! Attach heads to the bodies, starting with the contact drawings, (#s 1 and 9; see Figure 8-13). The neck makes a slight angle forward, as shown in figure A. Figure B shows the incorrect way of attaching the head.

figure | **8-13**

The correct way of attaching heads.

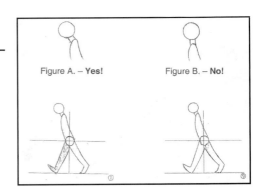

Figure A. – **Yes!** Figure B. – **No!**

11. Now add the heads to the crossing drawings (#s 5 and 13), then the low extremes (#s 3 and 11), and then the high extremes, (#s 7 and 15). You now have heads on all the odd-numbered drawings (see Figure 8-14). The next step is to in-between the heads onto the even-numbered bodies. In this way, the action of the heads can be made smooth, and it eliminates the jumps and jerks that might happen otherwise.

figure | **8-14**

Adding heads.

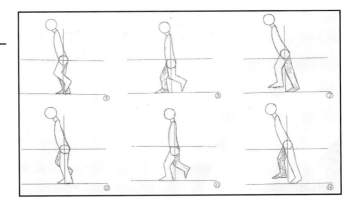

Now, here's where you get a bit more adventurous with over-lapping action, delaying the head's reaction to the movement ever so slightly to indicate the wave action (remember?) flowing from the central body outward, in this case to the head.

12. Now add a horizontal eyeline through the center of the cranial sphere. The first ones to address will be completely level, and they'll be added to the first drawing past each high and low position in the cycle; in this case, those will be #s 8 and 16 on the high end and #s 4 and 12 in the low position. Explanation: By delaying the action of the head by one drawing, you have automatically instituted the wave action, in the walking figure, slightly delaying the overlapping action as you get into the fur-thest articulating parts from the hips, which are the primary motivator.

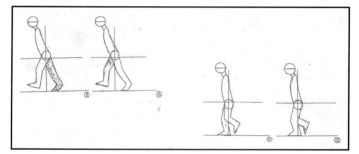

figure | **8-15**

A horizontal eyeline on 4, 8, 12, 16.

Once again, we beg your indulgence and ask you to bear with us if the concept still seems foggy. Once you've carefully fol-lowed the instructions and shot the resultant drawings, you'll begin to see the method to our madness.

13. Next, you'll need to locate the points at which the head will react to the up and down motion of the walk by tilting to its maximum positions for forward and back. Following the logic that the high and low points of the cycle are the most level posi-tion, then the middle (or neutral) positions would be the loca-tions of the greatest tilt. (Stay with us!) This means that you need the two contact drawings and the two crossing drawings. But wait! Remember our one-drawing delay! So, going one drawing forward, you'll pull aside drawing #s 2, 6, 10, and 14.

14. In #s 2 and 10 the body is dropping downward, so you'll tilt the head back in reaction to the drop (see Figure 8-16). (Not too much—this head action is a subtle thing!)

figure | 8-16 |

Tilt the head back at
2 and 10.

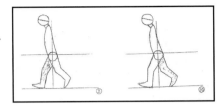

15. As the body is rising in #s 6 and 14 (see Figure 8-17), you'll tilt the head forward in reaction to that motion (about the same amount of tilt as the back tilt).

figure | 8-17 |

Tilt the head forward
at 6 and 14.

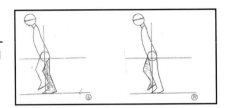

16. At this time, you'll need to make charts for the heads (see Figure 8-18). The overlapping action you've used has made it necessary to consider all the even-numbered drawings as extremes so you can in-between the head action correctly. Make a note above each chart that says "head" so you'll be able to keep track. Also remember that you're not in-betweening head position, just the angle of the eyeline. So, chart 'em and draw 'em. (Don't question it—just do it!)

figure | 8-18 |

The whole chart.

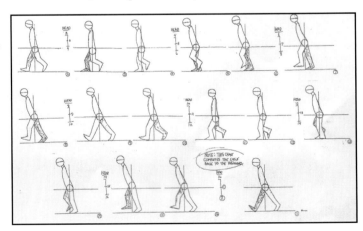

You now have a nifty overlap on the head action during the walk cycle. Remember to keep the tilt forward and backward subtle so that you don't end up with the character looking like he's trying to snap his head off while he's walking!

At this point, the only necessary part remaining is to add arms to the individual. In a straight profile shot like this, the motion of the arms needs to be thought of in the simplest form: right leg forward, left arm forward; left leg forward, right arm forward. Once again, use shading on all drawings to help differentiate the upstage arm from the downstage.

17. Locate the contact drawings. Now go *one drawing past* those and add the arms at their most extreme front and back positions, remembering that it's always the opposite arm forward from the leg (see Figure 8-19).

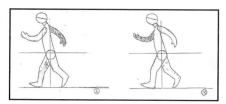

figure | **8-19**

Contact drawings, one frame past.

18. Now find the crossing drawings. Go *one drawing past* and add the arms at their closest middle position (see Figure 8-20).

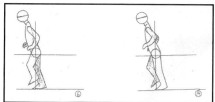

figure | **8-20**

Crossing drawings, one frame past.

19. Now for the final step! The four drawings on which you just added the arms (#s 2, 6, 10, and 14) are now the extremes for the arm movements. Accordingly, you need to put charts on them as you did on the heads, this time specifying "arms" at the top of the charts. This time there will be three drawings between each extreme, and the charts will be done as shown in Figure 8-21. Chart and in-between all remaining drawings as indicated.

figure | 8-21 |

Arms and charts.

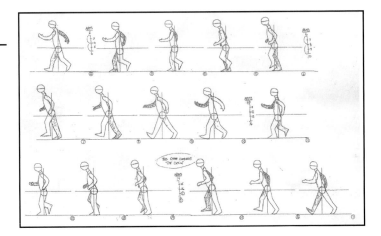

That's it! Now shoot the drawings in the proper sequence, put them on a loop, and you can view the walk you've just animated as long as you want. Be critical, look for "glitches" (small jerks and pops in your walk pattern), and take the necessary steps to smooth them out. Generally, this can be accomplished by putting the offending section of drawings on the pegs, looking to see which ones seem "out of whack," and adjusting them to a smooth flow. This will become a routine part of the process, as there are usually small touches that can help any animated scene become better.

Armed with the things you've learned about the walk pattern, you're now ready to start experimenting with individual walks, turning a character in three-dimensional space and having it travel from one part of a layout to another. A number of good animation texts are available that lay out some interesting variations. Go forth and enjoy!

TECHNIQUES

The traditional method of animating is still important for CG animators. You will adopt many traditional techniques to the 3D platform as these theories are based on movement, not the type of tool you use.

IK and FK Blending

Sometimes you will want to use IK and FK on one control in the same scene. There is a very easy way to achieve this.

An animatable channel exists in the Channel Box when you select the handRotation_control (L or R; see Figure 8-22).

figure | 8-22 |

The FK_IK channel.

A value of 10 means IK, and a value of 0 means FK. Open your rig and select the handRotation_ctrl. Give yourself 10 frames to work with in the timeline. Go to frame 1. In the IK_FK channel, key frame a value for 0. Go to frame 10. Key-frame a value for 10. Change the position of the FK arm and elbow and set a key frame.

You will see the arm respond to the FK_IK animated settings. The arm is changing from FK to IK control. See the file fk_ik_demo.mb on the enclosed CD. You can have this action happen over one or multiple frames.

You can also have an animation of a swinging hand in FK and the animation of a swinging hand in IK on the same limb. Animating between FK and IK will allow you to switch from one to the other in the same scene. This is handy when you want your walking man to grab hold of a tree or some other locked-down element.

IK controls do not travel with FK-animated limbs, so when you view your IK handles in wireframe, they will be static when FK is in use. The limb will travel with the control when IK is in use. Check the color of the joints: The blue joint chain represents the skeleton with pure FK animation, the brown joint chain represents the skeleton with pure IK animation, and the magenta joint chain represents the animation blend.

Both FK and IK controls will be available for your use when a value greater than .01 exists in the Channel controls. Be careful with this setting to avoid confusion.

figure | 8-23 |

Foot controls.

The Foot Controls

The foot controls contain some extra controls for the heel and toe movements (see Figure 8-23).

- Heel lifts the entire foot on one pivot.

- Lift Heel controls the back part of the foot, effectively lifting the ankle and not moving the toe.

- Toe moves the front half of the foot and does not affect the heel.

- Bank pivots the foot left and right on its axis.

- Pivot Toe does what it says—it pivots the foot on the toe axis.

These controls give you an increased flexibility in the foot for walking motion. You will heavily rely on these controls in the following walk exercise.

Locators

Locators exist to help you control which way the joints point, and they assist in reducing "joint flipping" (see Figure 8-24).

figure | 8-24 |

Locators in front of the knees.

Your locators on this rig are named leg_Pole_V_ctrl_R, leg_Pole_V_ctrl_L, arm_Pole_V_ctrl_R, and arm_Pole_V_ctrl_L.

The leg poles affect the knees, while the arm poles affect the elbows. Go ahead and select one and then move it around. Notice how the elbow or knee follows. These can be animated just like the limbs, and they are valuable in posing the character believably.

TUTORIAL

Open generi_walk_setup.mb on the enclosed CD and set up your interface to look like Figure 8-25. This figure shows a Side view open, a Perspective view, and the Graph Editor. You should be

using the lo-res version of the model. Be sure that your Graph Editor curves are set to Linear and Stepped. Make sure you are in the Animation module.

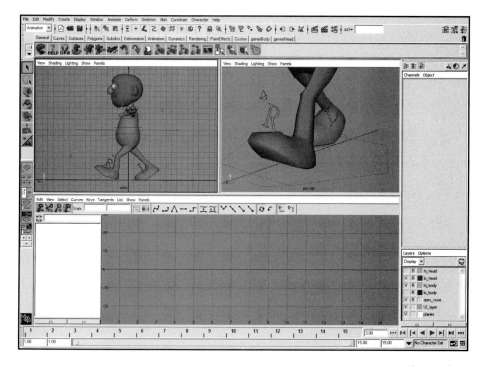

figure | 8-25 |

Set the timeline from 1 to 15 (see Figure 8-26). This animation is shortened to 15 frames to compensate for the looping. If you kept it at 16, you would have an extra frame, which would add a stall to the animation.

The interface as it should now look.

figure | 8-26 |

Notice the vertical and horizontal centerline created using the EP (edit point) curve tool. Curves do not show up in the final render.

The timeline set to 15.

Notice we differentiate between the left and right foot by attaching an L to the left foot and an R to the right foot. These letters are made of curves, so they will not render.

figure | 8-27 |

Left and right feet.

figure | 8-27 |

Left and right feet.

The Extremes

You will need the same beginning and end pose. Go to frame 1 and create the pose referenced in Figure 8-20, the contact drawings. The file on the enclosed CD already has poses 1 and 9 in effect.

You will need to position the heel and toe. The numbers I used for this position are detailed in Figure 8-28. You can use your MMB and drag to change the numbers, or you can enter a numeric value. Notice the values in the Heel and Toe channels.

figure | 8-28 |

Channel values for left and right foot at frame 1.

Channels Object		Channels Object	
foot_ctrl_L		**foot_ctrl_R**	
Translate X	0	Translate X	0
Translate Y	0.089	Translate Y	0
Translate Z	3.094	Translate Z	-4.764
Rotate X	0	Rotate X	0
Rotate Y	0	Rotate Y	0
Rotate Z	0	Rotate Z	0
Heel	-16	Heel	-0.8
Lift Heel	0	Lift Heel	10.8
Toe	25	Toe	0
Bank	0	Bank	0
Pivot Toe	0	Pivot Toe	0

Set contact key frames for 1 and 9. Select the cog_ctrl and tilt the body forward in the direction of your walk using X Rotate.

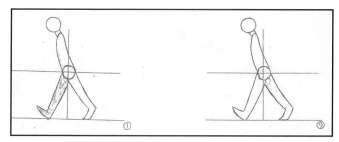

figure | 8-29 |

Drawings for frames
1 and 9.

Rotate in the Y Rotate channel to allow the body to rotate in the direction of the step. Remember that your hips rotate and sway when you walk. The hip matching the leg moving forward should rotate forward. Set key frames for all Rotate and Translate channels at frames 1 and 9.

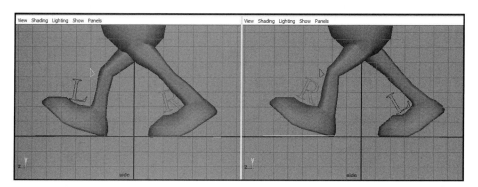

Now set the cross poses for each lead foot at 5 and 13 (see Figures 8-31 and 8-32). Notice that the body is constant at frames 1, 5, 9, and 13; so you are still only setting the controls for the feet.

figure | 8-30 |

Key-framed 1 and 9.

Channels Object		Channels Object	
foot_ctrl_L		**foot_ctrl_R**	
Translate X	-0.326	Translate X	0
Translate Y	2.547	Translate Y	0.06
Translate Z	-4.278	Translate Z	1.554
Rotate X	0	Rotate X	0
Rotate Y	0	Rotate Y	0
Rotate Z	0	Rotate Z	0
Heel	32.7	Heel	0
Lift Heel	25	Lift Heel	0
Toe	0	Toe	0
Bank	0	Bank	0
Pivot Toe	0	Pivot Toe	0

figure | 8-31 |

Channel values for
the left and right foot.

figure | 8-32 |

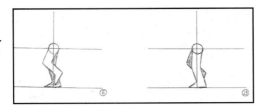

Cross drawings for 5
and 13.

Select the cog_ctrl and notice that the body should be in line with
the legs. Set the Y Rotate to reflect the proper position of the body
over the legs, which means the Y Rotate should be 0 or a value close
to it. Set key frames for all Rotate and Translate channels at frames
5 and 13.

Now, go to the Graph Editor and select the Rotate curves for the
cog_ctrl. Change these curves from Stepped to Clamped. Keep all
other curves on other objects as Stepped.

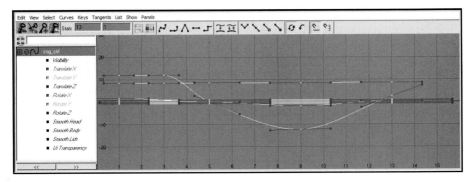

figure | 8-33 |

Channel values set
to Clamped for the
cog_ctrl.

These curves need to represent the position of the body when cre-
ating subsequent foot placement. If the body is still holding a pose
from a forward step and the legs are making a crossover step, you
may overkey the placement of the foot.

Notice that there is a forward lean to the body in poses 1, 5, 9, and
13. The body is most vertical at 3 and 11. The body is tilted forward
at 7 and 15.

The knee locators are placed away from the knees on purpose. You
should be noticing some flopping in the legs. Go back through
your animation and key the locators in their proper position so
that the knees are pointed forward.

Play the animation. You should be seeing the walk in stepped poses.
See the results in the file generi_walk_animatedv2.mb.

You will now set the low extremes at 3 and 11.

First, lower the body below the EP curve to match the drawings for frames 3 and 11 (see Figure 8-34). You can do this by setting the Y Translate value to –2.

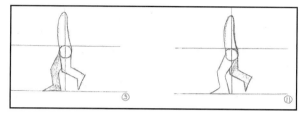

figure | **8-34**

The hip sphere below the centerline.

Look at the drawings. The body is no longer leaning forward. At frames 3 and 11, set the X Rotate value for the cog_ctrl to 0. It also should not have as much rotation in the Y Rotate value.

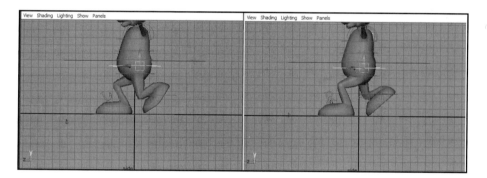

Here are my settings for the feet at frame 3 (see Figure 8-36).

figure | **8-35**

Key-framed 3 and 11.

Channels Object		Channels Object	
foot_ctrl_L		**foot_ctrl_R**	
Translate X	-0.326	Translate X	0
Translate Y	2.547	Translate Y	0.06
Translate Z	-4.278	Translate Z	1.554
Rotate X	0	Rotate X	0
Rotate Y	0	Rotate Y	0
Rotate Z	0	Rotate Z	0
Heel	32.7	Heel	0
Lift Heel	25	Lift Heel	0
Toe	0	Toe	0
Bank	0	Bank	0
Pivot Toe	0	Pivot Toe	0

figure | **8-36**

Settings for cog_ctrl at frame 3.

You can see the results by opening generi_walk_animatedv3.mb. Now set the high extremes at 7 and 15 (see Figure 8-37).

figure | 8-37 |

High extremes
drawn for frames 7
and 15.

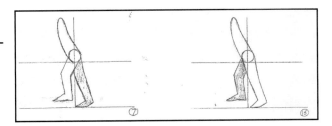

Here you will raise the hip sphere above the horizontal centerline and will also put in the farthest forward tilt of the body (see Figure 8-38). On these frames, the puppet falls forward into its next step.

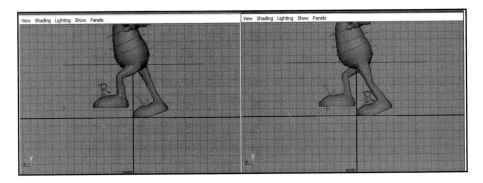

figure | 8-38 |

Key frames for 7 and
15.

This file has been saved as generi_walk_animatedv4.mb.

The Head

You must tilt the head forward. To do so, you need to select the neck_ctrl and set the Rotate X value to **19** (see Figure 8-39).

You do not use the neck control anymore.

Select the head_ctrl and set key frames on 4, 8, 12, and 16. On these keys, he is staring straight ahead. Note that you are not working on the odd keys anymore. You are delaying the action one frame to accentuate the wave theory.

figure | 8-39 |

Neck tilted forward using the neck control.

Now you will address the angle of the eyeline and tilt the head further. On frames 2 and 10, tilt the neck_ctrl back (see Figure 8-40). Change the value in the Rotate X to − **6**.

figure | 8-40 |

Tilt the head back to −6.

To finalize the wave theory, you will tilt the head forward on keys 6 and 14 (see Figure 8-41). Change the value in the X Rotate to **6**.

figure | 8-41 |

Tilt the head back to 6.

Extra Arm Controls

Most of the arm controls have parent constraints so that the hierarchy of animation can be altered. These attributes can be animated midway through an animation. The attributes start with Pos_ or Orient_. Make sure the values of these attributes on each control add to a total of 10. Total values above or below the value of 10 will have a negative effect on the animation.

Basically, these attributes affect what the arms are parented to (position) or oriented to. For example, if the IK control is set as follows:

Pos_ World **10**

Pos_Hips **0**

Pos_Head **0**

Pos_Chest **0**

It will act like it's not parented to anything (that is, world coords). However, if it's set as follows:

Pos_ World **0**

Pos_Hips **0**

Pos_Head **10**

Pos_Chest **0**

It will act like it's parented to the head (that is, when you rotate the head, the hand will move with it). You can also have combinations like these:

Pos_ World **7.5**

Pos_Hips **0**

Pos_Head **2.5**

Pos_Chest **0**

In this scenario, the IK control will be parented 75% to the world and 25% to the head. Be careful when there are values on more than one of these attributes, as the results aren't always predictable. Also, when all of the values are added together, they should equal 10. The following example might not function properly because the values add up to 20:

Pos_ World **10**

Pos_Hips **10**

Pos_Head **0**

Pos_Chest **0**

These hierarchies were set up by the technical director who made the rig. They are created using "set driven key" or expressions.

The Arms

The arm extremes are next. Remember that the arm reacts opposite to the leg on the same side and in synch with the leg on the opposite side.

You will use forward kinematics to animate the arms. To set FK, select the handRotation_ctrl and set IK_FK to 0 (see Figure 8-42).

figure | 8-42 |

Set IK_FK to 0.

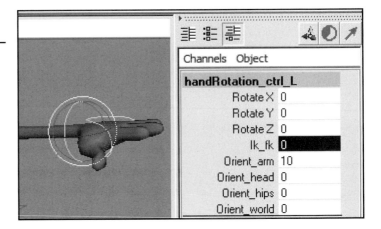

figure | 8-43 |

The shoulder
control.

You must now operate the puppet using the control found in the shoulder area (see Figure 8-43).

Position the arms for the extreme positions one frame past the extremes for the legs (see Figure 8-44). Set key frames at 2 and 10.

figure | 8-44 |

Extreme arms at
frame 2.

Here are the Channel Boxes for the arms at frame 2 (see Figure 8-45).

Channels Object		Channels Object	
shoulder_ctrl_L		**shoulder_ctrl_R**	
Rotate X	-75	Rotate X	-50
Rotate Y	0	Rotate Y	0
Rotate Z	-50	Rotate Z	75
Orient_world	0	Orient_world	0
Orient_chest	10	Orient_chest	10
Orient_hips	0	Orient_hips	0
Orient_clavicle	0	Orient_clavicle	0
Elbow	-50	Elbow	-50

figure | 8-45 |

Channel boxes for arms at frame 2.

Set the arm cross position, the closest middle position at frames 6 and 14 (see Figures 8-46 and 8-47).

figure | 8-46 |

The arm cross position.

Channels Object		Channels Object	
shoulder_ctrl_L		**shoulder_ctrl_R**	
Rotate X	-75	Rotate X	-70
Rotate Y	0	Rotate Y	0
Rotate Z	18.256	Rotate Z	0
Orient_world	0	Orient_world	0
Orient_chest	10	Orient_chest	0
Orient_hips	0	Orient_hips	0
Orient_clavicle	0	Orient_clavicle	0
Elbow	-50	Elbow	-50

figure | 8-46 |

Channel Box settings for the cross position at frame 6.

There's one last step. When you animate in 3D, curves are crucial. Right now, your curves start cold and end dead. You need to copy

some keys into frames –2 and 18. Then, you will have motion going into the scene and leaving it.

Don't start your animations on frame 1. Sure, the scene can start on frame 1, but try to start the motion a few frames before the first frame in your scene. The final result will look more natural.

This is because the shape of the curves entering and exiting the key frame depends on the placement of keys preceding it. If you don't key preceding the scene, you will have much more editing to do.

The file is saved at this point as generi_walk_animatedv5.mb.

GRAPH EDITOR

The key frames are all in place, and the walk already looks pretty good. Since most of your curves are still stepped, it is much easier to make changes to your timing at this stage. Let's presume you are happy with your timing and take the final steps to clean up your curves.

Now select each appendage that was animated and change the curves associated with it to Clamped. At the same time you clamp them, break the tangents and free the tangent weights. You should now have relatively smooth motion when you play the animation. At this point you determine where the fast "ins" and "outs" are applied in order to achieve believable weight. Apply what you learned about weight when you edited the ball. Where do body parts move the fastest and slowest in a walk cycle?

On your own, try to apply the wave theory you learned to the hands.

SUMMARY

The wave theory applies to the walk cycle. Applying it helps you create believable weight and overlapping action.

Creating animation in stages helps you to focus on parts of the body in fluid reactionary motion instead of thinking of the puppet as one stiff GI Joe doll. This is another reason why it is important to thumbnail out the action in a scene: It helps you stage what the primary motions will be.

Thinking in stages will help you once you get the hang of another helpful Maya tool, the Trax Editor, which allows you to capture motions and reuse them multiple times in an animation, thus saving you a great deal of time.

in review

1. When animating in stages, what body mass do you begin with?

2. What is the wave theory?

3. What is overlapping action?

4. How do you animate FK and IK?

5. Why do you use a horizontal and vertical horizon line?

6. What did you use locators for?

↗ EXPLORING ON YOUR OWN

1. Videotape yourself walking and try to re-create it with Generi.

2. Look up Monty Python and learn about the Ministry of Silly Walks. Then see what you can do with this important historical reference.

3. Try animating someone chubby and then someone very thin.

4. Think about what animal a particular person reminds you of. A chicken? A duck? Videotape chickens and ducks and apply their movements to the walk of your character.

5. A few walk cycles are available in the color section of the book for your reference. Pick some attributes and try your hand at re-creating them.

notes

ADVENTURES IN DESIGN

AID3/THE COLLABORATIVE PROJECT

Working as a group is a difficult task. Opposite personality types coupled with disparate interpretations of story, characters, and design can lead to chaos, hurt feelings, and a project that never ends. Graduate students approached the concept of collaborative project with the goal of completing a good experience and a great short film.

Involved in the project were students Diony Cook, Timothy Farrell, Travis Gentry, Hsiang-Yu Hsu, Chih-Te Kan, and Dustin Ryland under the guidance of Professor Patricia Beckmann.

THE GROUP

We met previous to the quarter to discuss the goals of the class and get to know each other. We talked about the expectations and limitations of the class. All were told that if the project was not completed on time, then the whole group would receive a failing grade. (Gasp!)

On the first day of class, we each completed the Jung Personality test and shared our results with the group. This gave everyone an idea about who we were and how we

C-1 Group photo, clockwise from upper left: Professor Patricia Beckmann, Chih-Te Kan, Dustin Ryland, Timothy Farrell, Diony Cook, Hsiang-Yu Hsu, and Travis Gentry.

worked. Interestingly, everyone in our group was classified as an introvert, which could lead to communications problems. Two members identified that they would be likely to be at odds with each other because they were both leaders. One member was identified as a peacemaker. It was good to understand everyone's nature before the stress began. We then created a chart of our weaknesses and strengths in CG Animation and identified what each person would like to contribute and what they would like to learn more about. We identified production jobs and matched likely candidates based on this information, and looked for holes in the production staff that people could prepare themselves to fill.

Collaborative is a 10-week class. The students were made aware that the project had to be completed within ten weeks or they would all fail. Thus, they were aware of expectations at the onset, and warned to tailor the project to fit the 10-week production schedule.

Each student pitched a project to the rest of the class. Each unique project was supported by a storyboard or animatic, and art direction. Once all of the students pitched, they talked about each project, and shared ideas on how each could be improved. They then met outside of class in a casual setting without the professor to make a final selection.

THE PROJECT

Week 1

On the second day of class, they presented a group storyboard and the idea they had all agreed would be the focus of that quarter. All students had chosen a role for the project, and the Producer (Dustin Ryland) turned in a production schedule to Professor Beckmann.

The students decided to create a short one-character piece based on a narrative captured from an interview with a well-liked professor. They would take the narrative and add information to the film through visuals to create an entirely new interpretation of the edited voiceover.

Week 2

The graduate students interviewed four instructors. Assisting the group with recording were sound design graduate students Val Thielker, Joshua Green, and Ricardo Ochoa. They recorded in a professional audio studio. All professors gave a personal and

C-2 Dave Kaul, the voice of the janitor.

character-laden interview, but Dave Kaul was chosen for the character of his narrative.

Tim then took the sound and created an animatic, which is included on the attached CD. Dustin organized the production schedule and took on the role of director/producer. Diony took on art direction. Trevor created the character design and model, while Dustin and Hsiang-Yu finalized the rigging. Hsiang-Yu and Chih-Te modeled the classroom environment. The group built a production pipeline wherein they referenced the developing set and character. All agreed on naming conventions and file management. They met outside of class time to give each other input and ideas.

Week 3

Crisis! Communication was getting stilted due to the mixture of nationalities and English skills on the team.

Solution: The group talked it out and discussed solutions. English speaking members learned Chinese words to further understand the difficulty of understanding English. Communications took on a whole new friendly and effective result.

Week 4

Crisis! The group was getting behind.

Solution: The group put in extra hours and redefined the essential shots. The group met and found some shortcuts and then applied them to the animatic.

THE ANIMATION

Week 5

Keyframes have been added to all the scenes, and students are critiquing each other's work. The film is starting to take shape.

C-3 Character design of Janitor.

C-4 Drawn study of classroom environment.

C-5 Model and classroom test.

C-6 Facial tests.

The group decided on who would animate each shot. The short was broken down into 15 segments, and an animator was put in charge of each one. Students were instructed to supply a playblast of their key poses and camera edit to place in the animatic, so that all could watch and comment on the evolution of the character.

Sadly, we are just halfway through this project as I complete this book. However, if you go to www.bunsella.com, you will find a link to the final animation and a summary of the group progress.

C-7 Test render.

Project Guidelines

Week 1

1. Setup and communications are essential to success. Know who are the members of your group. Take the Jung Personality test and share it with your group.

2. Have the group identify their strengths and weaknesses, then share their portfolios.

3. Decide on a storyline as a group. Allow the story to change based on member input and become an idea the whole group has grown.

4. Create an animatic with sound. Depending on the project, record the sound before or after this step.

5. Watch the animatic as a group. Show the animatic to friends and people you barely know, and ask them if they understand the story.

6. Edit the story. Look for shortcuts. Delete scenes that don't add information to the story.

7. Show the animatic again for input.

Week 2

8. Design characters and environment. Look beyond the obvious. Seek out favorite artists, children's books, and architecture. Make drawings, maquettes, and clay models—whatever helps you flesh out the character. Do not use the 3D program in this step. Get ideas together on color theory and composition.

9. When happy with the results of (8), start blocking out characters and environment in 3D.

10. Reference the set and character so that you can make changes throughout production and have them automatically update.

Week 3

11. Finish low-resolution model and give it to the rigger. Start texture studies for character.

12. Rig low-resolution model.

13. Finish environment tests.

14. Animators must begin improvisational studies of character. Thumbnail animation for scenes.

Week 4

15. Finish high-resolution model of the character and give it to the rigger.

16. Rig high-resolution model along with low-resolution model and finish rigs.

17. Add animator thumbnails to animatic. Animators should be practicing movement studies and study each other's work.

Week 5

18. Begin animating scenes. Do only the key poses for your first draft of animation. Make playblast .avi files and drop them into the animatic. Keep a copy of the original animatic, but keep a progressive animatic of the latest animation as a diary. You will begin to see more problems and solutions as this advanced animatic builds itself.

19. Edit the story. Look for shortcuts. Delete scenes that don't add information to the story.

20. You will begin to feel a lot of stress in the group. Meet and discuss communication strategies and roles.

Week 6

21. After another review, consider the camera, lighting, and pace of editing. Does the camera, lighting and edit add to the story? Is the pace fast or slow, does the camera lead the viewer's eye to what you want them to look at? What kind of mood is present, and how can you heighten it?

22. Continue with the animation and make secondary keyframes. Slide .avi files of these scenes into the animatic.

23. Edit the story. Look for shortcuts. Delete scenes that don't add information to the story.

Week 7

24. Start some rendering tests. Test lighting of the characters as they hit their marks.

25. Animators change curves from stepped to clamped and begin editing the ease-in and ease-outs of character arcs.

26. Slip new playblasts into animatic.

27. Group critique of project so far.

28. Consider Foley sound and extra sound effects.

Week 8

29. Finalize render tests, and begin to render background and characters in layers. Composite them in a compositing package.

30. Refine animations.

31. Finalize sound.

32. Finalize lighting.

Week 9

33. Finish animation and create final renders. Make changes as necessary.

34. Edit the story. Look for shortcuts. Delete scenes that don't add information to the story.

Week 10

35. Make final changes and match Foley sound with narrative sound.

36. Final render and composite.

THINGS TO CONSIDER

A collaborative project is as much a management exercise as it is an animation exercise.

1. Everyone has something valuable to contribute. If a member of the group has an important role and is not living up to your expectations, try changing the expectations. During production is not the time to attempt changing someone into a world-class rigger/modeler/animator. What you enter the group with is pretty much all you are going to have to work with. Find a creative solution.

2. Short cuts are good. If a painted background makes a good environment, then paint the background instead of modeling it. Whatever production time you save can be spent making a better story.

3. Show the animatic to people often. When you get too close to a production, you often lose sight of the story.

4. A sense of humor and forgiveness will help you to find creative shortcuts and solutions. The best art is grown out of limitations. Allow your group's limitations to become an asset instead of a fighting ground.

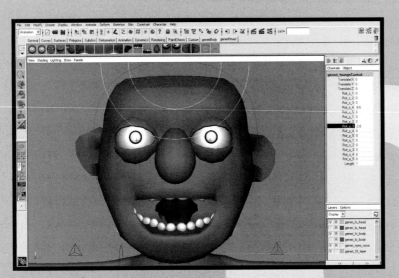

the face

 charting your course

The face is capable of a million subtle expressions. Believability is contained in the fraction of a second that an expression is held. You can capture a great many of these expressions with a few well-keyed deformations.

In this chapter, you will attempt to re-create Generi as a speaking character, in combination with the walk you have just finished.

 goals

In this chapter, you will:

- Learn phonemes (mouth shapes for consonants and vowels) and how to create them accurately.

- Learn how to animate deformers.

- Understand how to work with a sound file.

- Understand how to work with an exposure sheet.

- Master the smooth natural look of phrasing.

TOOLS USED

● **The Generi rig facial controls.**

 Generi has a full-featured facial setup. You can move the eyes, nose, and ears in addition to the deformation-based facial expressions.

● **Deformations.**

 Deformations are a technique of morphing one shape into another. This is the most common way to animate faces.

THE GENERI FACE

You will continue to use the Generi puppet from the last chapter (see Figure 9-1). Let's explore the facial controls. Make sure you are working with generi_reference.mb; otherwise, the shelf may not work for selecting controls.

figure | 9-1 |

The Generi face.

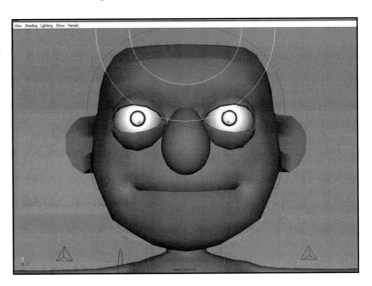

We find the facial controls by selecting the head control. Many of the face controls can be switched on and off inside the head control (see Figure 9-2). The UI for the head control is the purple curve around the head that looks like a headphone.

Here you can turn on or off the tongue, eyes, brows, nose, teeth, or ears. To do so, you just type **on** or **off** in the Channel Box.

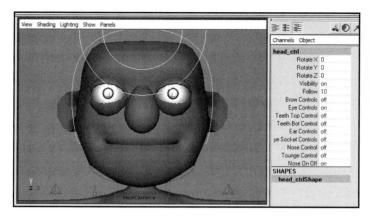

figure | 9-2 |

The controls you can turn on and off inside the head control.

You can also select face controls from the generiHead shelf (see Figure 9-3) or the trigger user interface.

figure | 9-3 |

The generiHead shelf.

Eyes

The eyes can be rotated individually by using the generi_eye_Rot_R or generi_eye_Rot_L found in the Outliner under the generi__anim_FaceControls or in the shelf (see Figure 9-4).

Or you can rotate both at the same time with the aim control (the eye icon; see Figure 9-5).

figure | 9-4 |

Single eye selection in the shelf.

figure | 9-5 |

The eye icon.

By selecting the generi_eye_Rot_R on its own, you have access to the eyelids. You will want to change the eyelid placement to match the acting your puppet needs to achieve.

figure | 9-6 |

The generi_eye_
Rot_R Channel Box
controls.

figure | 9-7 |

Eyebrow controls in
the shelf.

Lid Follow is a value that lets the eyelids automatically follow the eyes (see Figure 9-6). An input value of .4 is suggested, even though the default is '1'.

Brows

The eyebrows can be selected in the shelf as well (see Figure 9-7). You have five brow clusters to choose from that can be rotated and moved for a variety of expressions. They exist on the shelf in the same order that they exist on the face.

Each of these controls allows you to translate or rotate that particular brow region.

Mouth

Selecting the M on top of the Generi head accesses mouth shapes (see Figure 9-8).

You can also select the 2D image of the mouth from the shelf (see Figure 9-9).

figure | 9-8 |

The M at the top of
the Generi head.

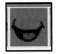

figure | 9-9 |

The shelf icon for
mouths.

Your Channel Box will reveal the controls shown in Figure 9-10.

Sliders are slow and take up too much screen space. Instead, the Channel Box middle-click + drag functionality was constructed to

change shapes. You simply select a channel and then MMB-drag to change the value. You can also use numbers and type in a value. Some mouth shapes should be combined with an open jaw.

The maximum value for each shape is 10, but the values can go higher. Values higher than 10 will probably look odd and may distort the head. Some values also go into the negative. Highlight two values at once and then middle-click + drag in the viewport for changing multiple shapes at once. Some mixing of shapes will work; some mixing of shapes will not.

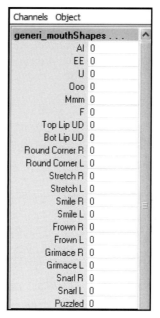

figure | 9-10 |

Facial controls in the Channel Box.

The technical director arbitrarily chose the values 1 and 10. These could be any two values, but the theory remains the same.

The Jaw

The jaw features a three-bone setup. All the bones are controlled through the jaw control (jaw_ctrl; see Figure 9-11).

Use the Top Lip and Chin attributes to mix up the mouth positions (see Figure 9-12).

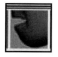

figure | 9-11 |

The jaw icon on the shelf.

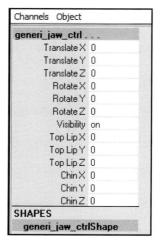

figure | 9-12 |

Channel Box controls for the jaw.

Other Controls

Other controls include ears, eye sockets, nose, teeth, and tongue. These can be accessed through the shelf (see Figures 9.13 through 9.20). Be careful, the teeth do not move with the lips and must be animated separately.

Note all of the extra controls available here for the tongue. The X, Y, and Z rotations allow you to make great use of phonetic positions for the letters s, l, t, and d, among others, as well as a variety of facial gestures such as sticking out and wiggling one's tongue while thumbs are inserted into one's eardrums.

figure | 9-13 |

Ears.

figure | 9-14 |

Ears in the Channel Box.

```
Channels  Object

generi_earJoint_R
           Translate X  0
           Translate Y  0
           Translate Z  0
             Rotate X  0
             Rotate Y  0
             Rotate Z  0
OUTPUTS
     generi_skinCluster11
     generi_polySmoothFace1
```

figure | 9-15 |

The nose.

figure | 9-16 |

The nose in the Channel Box.

```
Channels  Object

generi_noseJoint . . .
           Translate X  0
           Translate Y  0
           Translate Z  0
             Rotate X  0
             Rotate Y  0
             Rotate Z  0
             Scale X  1
             Scale Y  1
             Scale Z  1
OUTPUTS
     generi_skinCluster9
```

figure | 9-17 |

Teeth.

figure | 9-18 |

Teeth in the Channel Box.

```
Channels  Object

generi_teethUpper . . .
           Translate X  0
           Translate Y  0
           Translate Z  0
             Rotate X  0
             Rotate Y  0
             Rotate Z  0
OUTPUTS
     generi_teethUpperCluster
     generi_h_headCluster1
```

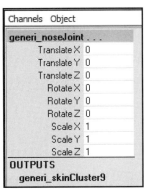

figure |9-19|

The tongue.

figure |9-20|

The tongue in the
Channel Box.

The Length allows you to stick the tongue quite a distance outside
of the mouth.

WORKING WITH SOUND

To get some use out of the face, you need a sound file to work with.
Here is how you import a sound file.

Locate the sound file phoneme.wav on the attached CD.

To import the file into Maya, select
File > Import (see Figure 9-21).

Find your sound file in the directo-
ries and select it.

Now, in Maya, go down to your
timeline and RMB-click in the
timeline. Your hidden menu will
pop up. Select Sound from this
menu and make sure to select the
arrow next to the word Sound (see
Figure 9-22).

figure |9-21|

File > Import.

figure | 9-22 |

Select your .wav file
from the timeline
menu.

You will see the sound file phil_book .wav on this list. Select it. You
should now see the .wav file in your timeline.

figure | 9-23 |

The waveform
shows in the
timeline.

To make sure we are using the same settings, go to your Preferences
and select Sound. Match your preferences to Figure 9-24. Make
sure the sound is turned up on your computer.

Go to Timeline and match the on-screen preferences again (see
Figure 9-25). You are increasing the height of the timeline so that
the waveform is easier to see. This will be important when you try
to see derivations in sound. Make sure your playback is correct by
changing Playback to 24fps in the Preferences. If this is incorrect,
you won't hear your sound when you press Play.

figure | 9-24 |

Match these
preferences.

figure | 9-25 |

Match these
preferences.

Press Play in the control panel.

Look at the waveform as it plays to get used to where the conso-
nants hit.

Now, just hold down your MMB and rub over the timeline. You are
now "scrubbing" the sound. You can target individual sounds and
accurately match your facial poses using this method.

WHAT IS A DEFORMATION?

A deformation is a blend shape. If a sphere is made with 100 con-
trol vertices and a cone is created with 100 vertices, the two objects
can be set up to morph into each other. They just need the same
number of vertices.

LET'S TALK

There are a few points to make now on the art of verbally express-
ing ideas using animation. This chapter will deal with the technical
aspects you need to be aware of when you have a character speak-
ing on-screen. You'll approach it with the goal of making the ver-
balization appear natural and appropriate to the manner in which
the lines are read on the sound track.

The subject of acting won't be specifically dealt with at this time, as that needs a book in itself. Another aspect is facial expression, a subject that can fill volumes and that we won't attempt to get into at this time. Suffice it to say that acting is manifested in total-body attitude when posing out a character's movements, and facial expressions and dialogue can be regarded as the "icing on the cake" when it comes to expressing ideas. For now, we'll deal with getting the words to come out in a natural looking manner.

The Natural Quality

Although there are an endless variation of ways to approach a line of dialogue, think for a moment of some of the ways the subject has been handled in the past.

In the early days of sound movies, animation went into a highly experimental period in which many methods were tried in having cartoon characters speak, with a great variety of results. It was standard practice at some studios to animate the dialogue first and then have the voice actors attempt to synchronize their reading of the lines to the film they were shown—while it was playing! Some of the most spectacularly unsatisfactory efforts were the result of the kind of technical problems that tended to cause the characters to over enunciate the words they were saying. The animation medium was, of course, fairly primitive at the time, and that factor, combined with the search for the right way to get the stuff onto film, made for some results that were humorous in their ineptitude.

The scary part of the story is that it is all too easy for a beginning animator to get into the same groove of over enunciation without intending to. The process of making a story one frame at a time, as you do in this book's process, can sometimes cause a kind of tunnel vision in which you put too much emphasis on each drawing, and suddenly you've created something capable of getting laughs for the wrong reasons! Here's an example of an over enunciated line.

The line of dialogue is "I have nothing to say," and Figure 9-26 shows a series of over enunciated drawings:

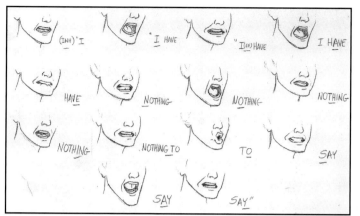

figure | 9-26 |

"I have nothing to say,"

Now, there's a possibility that a character may have a situation that calls for a rather weirdly enunciated version of that line, but chances are it won't be as over-the-top as this example. This approach is going to take the mouth through an unnatural series of gyrations when the drawings are shot as a series. Now you will look at some of the things that will help you to make the right choices.

Know Your Character

Work with the folks who've developed the character to find out as much as you can about the way that individual would analyze and approach a given situation. Listen to the recording of the dialogue several times before you begin any notes or thumbnails. Consider the situation in which the character is delivering the line. Try to form a mental image of the character delivering the line.

Consult the X-Sheet

Check the position of the dialogue in relation to the frame numbers. This is a necessary part of getting the dialogue worked out in order to synchronize the vowels and consonants to the appropriate drawings. The exposure sheet shows the vocal recording in real time as it will be translated onto film. The sheet is divided to show segments of time as well as overall film footage. Figure 9-27 shows the way the dialogue might look transcribed onto the exposure sheet.

figure | 9-27 |

The X-sheet.

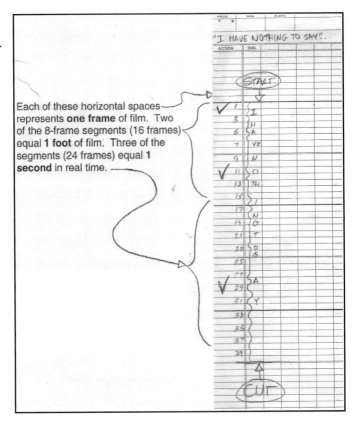

The rule for placing dialogue is to place each vowel or consonant on the frame number in which it shows on the X-sheet. If there is a need to vary that plan, always anticipate, meaning start one or two frames ahead of the frame it hits on—never behind!

Phrasing

This term is used to denote the method for making the dialogue appear smooth and natural in the animation. Basically, phrasing consists of breaking the dialogue, or phrases, into groups as they are spoken. First, play the dialogue several times, lip-synching the voice actor while listening, and begin to experience the feelings of its delivery. Now look for accents or the places where the dialogue is expressed most strongly. (It takes a few times practicing this for it to become second nature.)

Next, mark the accents on the X-sheet in their proper position. Accent points are marked in Figure 9-28.

The accents are where the mouth is going to open to its maximum size in the scene, and the frames leading up to the accents are where, as a rule, the mouth becomes nearly or totally closed (on B, M, and P, for instance).

Now, using a mirror to watch the opening and closing of your mouth, play the recording and lip-synch a few times. You'll now see how you're able to blend words so that you can execute this line of dialogue by opening and closing the mouth smoothly, about three times.

Take a look now at the same line of dialogue utilizing efficient phrasing (see Figure 9-29).

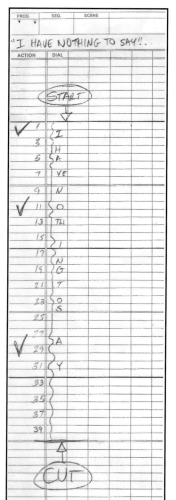

figure | **9-28**

Accent points are shown by the checkmark.

figure | **9-29**

Efficient phrasing of "I have ntohing to say."

figure | 9-30 |

Generi Face.

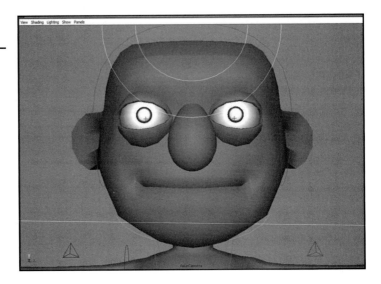

Simplify!

Consult the books available on drawing techniques for animation and learn the most simple, efficient mouth shapes for vowel and consonant sounds. Let the viewer see the accented parts clearly. Remember to exaggerate—it quite often takes a much broader approach to emphasize dialogue than one would expect.

This is animation. Hopefully we have plugged you into some of the techniques to enable you to get started doing some great work.

USING THE GENERI FACE

Open the Generi rig exercise that you animated in the preceding chapter. You will animate Generi speaking using the same file you used to create the walk cycle. Make sure your interface looks like Figure 9-30, and that you are in the Animation module.

figure | 9-31 |

Shelf with facial tool icons.

Select the shelf that has your facial tools illustrated.

Each tool has an icon directly referencing the part it controls (see Figure 9-31).

figure | 9-32 |

The smiley face.

To see the facial deformations available, select the smiley face on the shelf and look in your Channel Box (see Figures 9.32 and 9.33).

Try a couple of these out by changing the values in the channels and looking at the face of Generi. When you open Generi, his mouth may already be open. A UI shortcut to getting these controls in the Channel Box is to select the M over the generi rig head (see Figure 9-34).

Make sure your sound file is loaded and that you can see the waveform in your timeline.

Your file contains a face camera. Look for it under **Panels > Perspective Camera > Face Camera** (see Figure 9-35).

Select it. You have a traveling full frontal view of your face (see Figure 9-36).

Most animators animate the physical motions of the puppet before animating the phonemes. It is important to

figure | 9-33 |

The Channel Box.

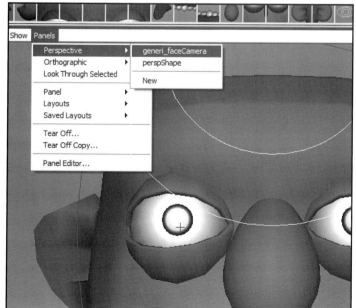

figure | 9-34 |

The M over the Generi rig head.

figure | 9-35 |

How to find the face camera.

communicate the scene physically before adding the facial shapes. Sometimes animators get lazy with the physical expressions once the lip-synch is done, and they fail to achieve the poses needed to keep the scene energized.

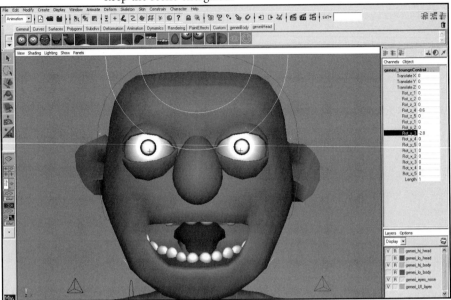

figure | 9-36 |

Camera view of the face.

TUTORIAL

Use the Genri rig you animated walking in the last chapter. Select the face camera so that you are only seeing the face. Here, you will see the effects of your key-framing on the face.

| NOTE |

It is a good idea to thumbnail out the mouth shapes, but I know that this takes a great deal of time. If anything, thumbnail out a typical phrase for your character and make note of any special mouth shapes that differentiate this character from others you are animating. Make note of the channel values used to achieve each default shape. Keep this chart nearby.

When you are done with the facial animations, you will have a character walking and talking at the same time.

Import the sound clip. Offset the sound −22 frames by going into the attributes editor for the sound file. This is detailed at the end of the chapter if you have problems. Go to frame 1. Now, let's consult the facial charts (see Figure 9-37).

If you set the channels values to 10 for each Generi channel, you end up with the facial shapes in Figure 9-38. Analyze these against the drawings. How would you mix and match them to achieve the phrasing shapes? I used the jaw control to open the mouth for some of the poses.

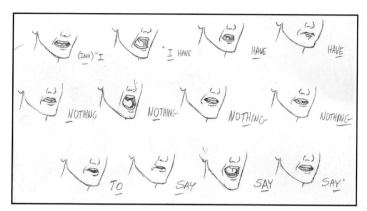

figure | 9-37 |

The correct "I have nothing to say."

Reading the exposure sheet, you have 39 frames in which to complete this exercise. That is how many seconds at 24fps? The answer is almost 2. Set your timeline for an animation taking 39 frames. Remember to add a few frames to the beginning. Your timeline should go from –5 to 39.

You will create 12 basic mouth shapes to accommodate your phrasing.

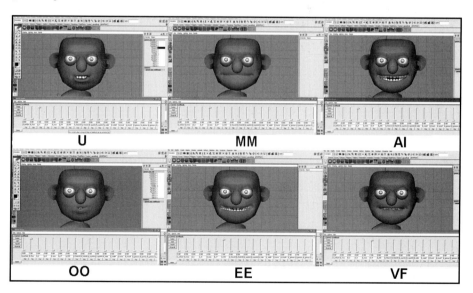

figure | 9-38 |

Extreme poses of Generi.

The first mouth shape takes place between frames 1 and 5 on the exposure sheet. It will begin from a closed mouth, set at –5. Keyframe a closed mouth at –5 by selecting all the channels in the Channel Box and setting a key frame (see Figure 9-39). All the channels should turn orange.

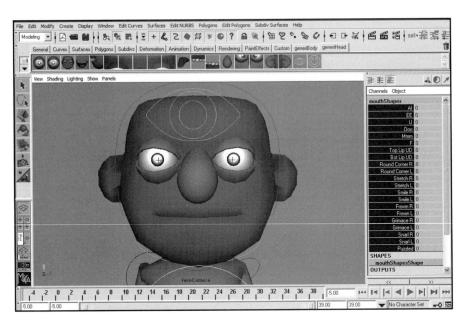

figure | 9-39 |

Key-frame all mouth
shapes to 0 at –5.

Then go to frame 1 and analyze the first mouth shape (see Figure 9-40).

I use my jaw control to open and close the mouth when needed. Often I do that first before setting the mouth shapes.

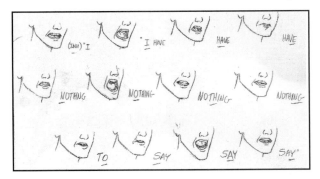

Figure 9-41 shows the mouth shapes I came up with in Maya.

figure | 9-40 |

The exposure sheet
and first mouth pose.

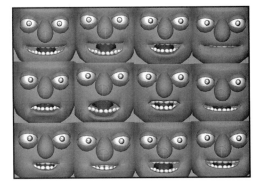

figure | 9-41 |

12 mouth shapes.

Following the exposure sheet, I keyed shape 1 at frame −1 (see Figure 9-42).

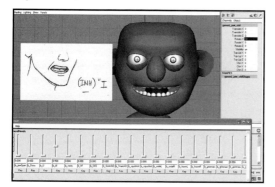

figure | 9-42 |

The channel value for shape 1.

I keyed shape 2 at frame 2 (see Figure 9-43).

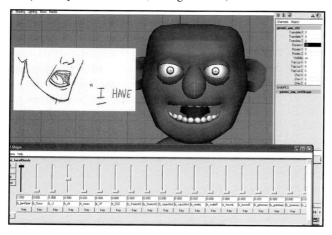

figure | 9-43 |

The channel value for shape 2.

I keyed shape 3 at frame 4 (see Figure 9-44).

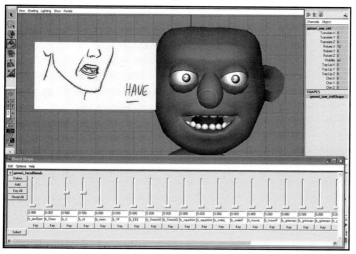

figure | 9-44 |

The channel value for shape 3.

I keyed shape 4 at frame 7 (see Figure 9-45).

figure | 9-45 |

The channel value
for shape 4.

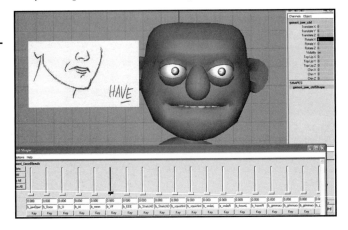

I keyed shape 5 at frame 9 (see Figure 9-46).

figure | 9-46 |

The channel value
for shape 5.

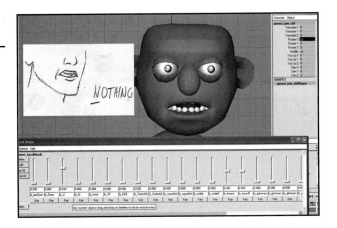

I keyed shape 6 at frame 11 (see Figure 9-47).

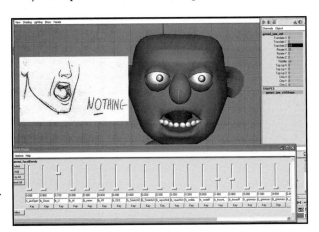

figure | 9-47 |

The channel value
for shape 6.

I keyed shape 7 at frame 13 (see Figure 9-48).

I keyed shape 8 at frame 18 (see Figure 9-49).

figure 9-48

The channel value
for shape 7.

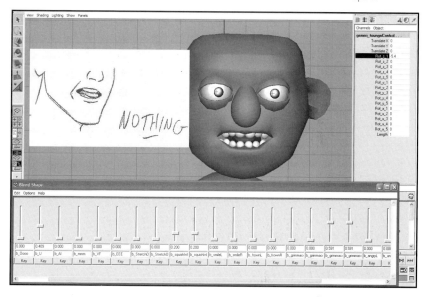

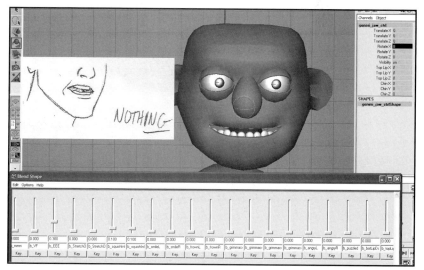

I keyed shape 9 at frame 23 (see Figure 9-50).

figure 9-49

The channel value
for shape 8.

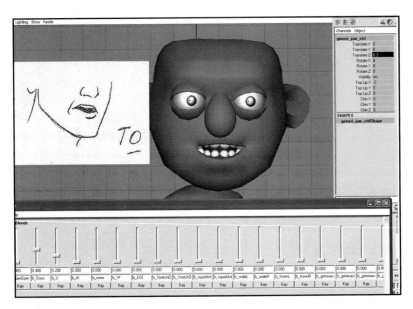

figure | 9-50 | I keyed shape 10 at frame 25 (see Figure 9-51).

The channel value
for shape 9.

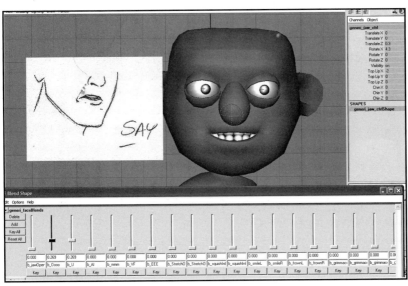

figure | 9-51 | I keyed shape 11 at frame 28 (see Figure 9-52).

The channel value
for shape 10.

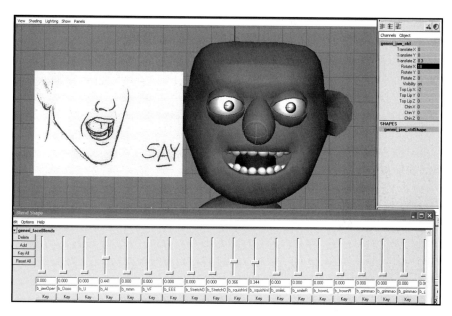

I keyed shape 12 at frame 31 (see Figure 9-53).

My Graph Editor looks like Figure 9-54. I used stepped curves at first, then changed to clamped and edited my ins and outs. Now I can adjust my curves depending on the look I am trying to achieve.

figure | **9-52** |

The channel value for shape 11.

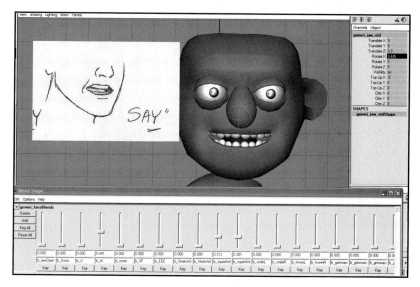

It is okay to use either stepped or spline curves when keying mouth shapes. Always start with stepped, though. Spline tends to cause problems and require advanced editing.

figure | **9-53** |

The channel value for shape 12.

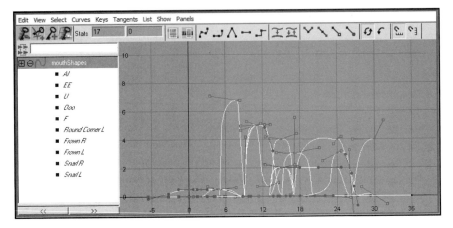

figure | 9-54 |

The Graph Editor for "I have nothing to say."

Be aware of the rules of in/out so that it doesn't look floaty or robotic. Edit the curves like you did in the bouncing ball example to achieve a believable look based on the sound.

Notice that I edited my curves so that they did not go below the zero limit or above the 10 limit. Had I exceeded these limits, the face would have stretched and possibly broken. When you switch from stepped to clamped, you will experience overshoot, where the curve goes beyond the key pose. Correct this.

I also used the command Delete all by type > Static actions to remove the curves for any blend shapes that I did not use. I also deleted any static key frames on each curve. This makes my graph easier to read and edit.

I analyzed all of the facial poses in between the key frames and edited the curves to negate any unappealing crossover effects between facial poses. Mixing two, three, or four mouth shapes can

figure | 9-55 |

The jaw is open at frames 1, 11, and 29—as per the checkmarks on the exposure sheet.

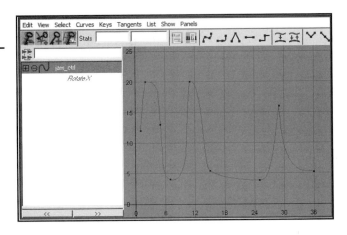

create some undesirable in-betweens. You will notice that I may have moved a few key frames for specific shapes to earlier frames to avoid problems. I also edited my jaw to be open when checked on the exposure sheet.

I edited the ease in and ease out depending on how a word was spoken. Sometimes the mouth moved quickly to a pose or held a shape longer. Had I left the default curves, I would have been left with very even, robotic lip movements.

When I noticed a curve that moved forever (perhaps I missed a key pose), I went in and assigned it a zero value in the statistics box above the Graph Editor and made a key frame where I felt it should stop moving.

Once you have the body poses and the lip synch, you can concentrate on facial expressions. Try your hand at animating the nose, eyes, eyebrows, and ears to add personality to this animation.

How to Offset Sound

Right-click in the timeline and go to Sound>Phil_book, the audio you used for the exercise. Go to the square options box next to the audio clip to access the Attribute Editor (see Figure 9-56). In the Attribute Editor, under Audio Attributes, change the value in Offset to –22. The audio will match this exercise.

SUMMARY

Facial animation is best when simplified. Avoid over enunciating by animating in phrases.

figure | 9-56 |

Offset sound set to –22 in the Attribute Editor.

When you use 3D, watch your curves so that they don't overextend or cross over each other. You can use spline or step curves when animating dialogue, depending on the accent you are trying to achieve.

in review

1. How do you get to the mouth shapes? What icon do you select to get mouth shapes in the Channel Box?

2. How do you avoid over enunciating?

3. What is a deformation?

4. How many frames are in a foot of film?

⬈ EXPLORING ON YOUR OWN

1. Try your hand at animating a sound clip from the www.10secondclub.com web site. Upload it. You will get feedback from your peers here.

2. Try animating one of the extra sound clips available on this book's CD.

3. Record yourself in different emotional states saying the same sentence. Try animating those emotions with lip-synch.

notes

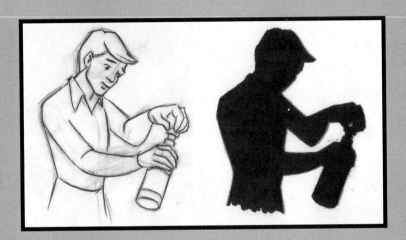

index

INDEX